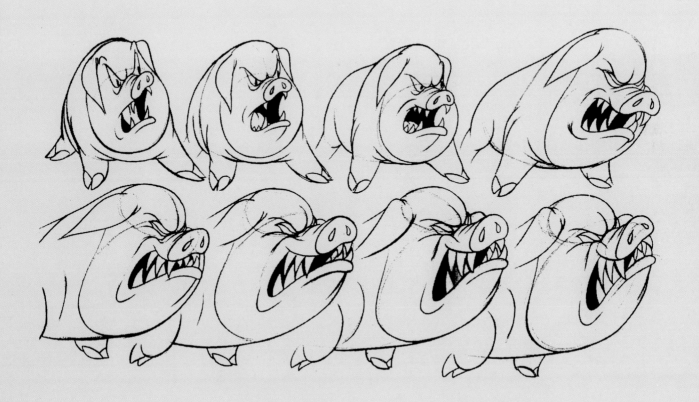

Halas & Batchelor Cartoons

An animated history

Authors:

Vivien Halas
Richard Holliss
Jim Walker
Pat Raine Webb
Paul Wells

Editor:

Paul Wells

Contributors:

Giannalberto Bendazzi
Karl Cohen
John Canemaker
Stan Hayward
Brian Larkin
Dan Leab
Roger Mainwood
Roger Manvell
Nick Park
Alan Stanton
Tamas Waliczky

Special thanks for their help to:

Veronika Bánki (translation from Hungarian)
Kerry Drumm (ARC)
Bob Godfrey
Tony Guy
Paul Halas
Janos Kass
Márton Kurutz
Derek Lamb
Borden Mace
Kati Macskássy
Brian Sibley
Mike Swift
Harold Whitaker

First edition published in 2006 by Southbank Publishing
21 Great Ormond Street, London WC1N 3JB
www.southbankpublishing.com

© The Halas & Batchelor Collection Limited 2006

A CIP catalogue for this book is available from the British Library.

ISBN 10: 1 904915 17 5
ISBN 13: 978 1 904915 17 1

Book design by Mike Swift

Printed and bound by SNP Leefung Printers (Shenzhen) Co Ltd China
All photographs courtesy of The Halas & Batchelor Collection unless otherwise stated.

Contents

For my daughter Sophie and her cousins Danny, Joe and Oliver.

This book is also dedicated to all the artists, animators, designers, composers, technicians, writers and everyone who worked at Halas and Batchelor over the years, and without whom there would be no history.

Foreword

When I was young, experimenting with animation, John Halas and Joy Batchelor were the big names in British animation. I remember their work first from school – animated Egyptians and Greeks livening up a dull maths lesson! I also saw *Animal Farm* a number of times, and was hugely impressed. I realised that it had a strikingly different graphic style from Disney and really was an alternative to the more twee cartoons made for young children at the time.

As a young animator I was eager to find any way of learning about animation and eventually found John Halas' book *Timing for Animation* in my local library. It was a lifeline and an inspiration and I learnt much from it. Surprisingly for me, my dad, a professional photographer, knew about Halas and Batchelor also, not just their work, but because he had employed Vivien Halas for a time and had connections with the studio. I remember him borrowing some Halas and Batchelor educational shorts and a projector, and we watched them alongside our home-made holiday films. The Halas and Batchelor films have a really nostalgic feel for me now.

I first met John Halas at the Cambridge Animation Festival in the early 1980s. He was a highly respected figure, but was always willing to talk to and encourage young students. He talked a lot about the potential for computer animation long before anyone else did. He was a visionary with lots of projects on the go, and was always trying something new.

Halas and Batchelor represent a 'great age' in animation. They document an evolution in graphic expression in this country that spans decades. They made animation more important, and showed how graphics and animation could be used to communicate effectively, making even the most mundane of messages more interesting, palatable or accessible.

Halas and Batchelor are my earliest memory of British animation making a mark on the world stage, and having a distinctively British style. Their work has lasted and remains impressive and important.

Nick Park January 2006

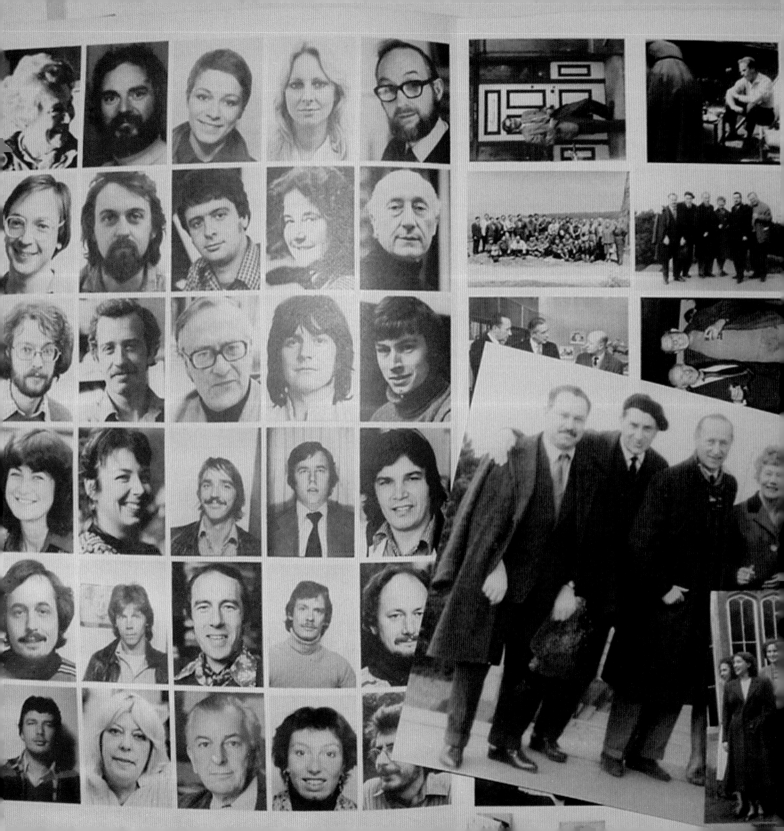

Introduction

Left An archive box from the Collection. Pictures include *from left to right* portraits of some of the studio team in 1980.
Row 1 Joy Batchelor, Joel Bariller, Judi Beake, Alexandra Bex, Brian Borthwick.
Row 2 Ian Cole, John Cousen, Paul Cowen, Dashie Girdlestone, John Halas.
Row 3 Kevin Hingston, Terry Hudson, Jack King, Brian Larkin, Roger Mainwood.
Row 4 Lyn O'Neill, Janet Orrock, Les Orton, Ian Park, Peter Petronio.
Row 5 Graham Ralph, Phil Robinson, Mike Salter, Paul Shardlow, Torq Stewart.
Row 6 Wayne Thomas, Pat Raine Webb, Harold Whitaker, Carol Williams, Hugh Workman.

John Halas and Joy Batchelor, Budapest, 1938.

'Hubris, hubris, all is hubris with your father, dear'.
Joy Batchelor

I have felt compelled to put this book together so that the work my parents and their studio produced over the second half of the twentieth century should not slip away into obscurity.

My parents, John Halas and Joy Batchelor, had an interdependent, symbiotic relationship that kept them together in spite of their infidelities and upsets. They were glued together by their need for recognition, not necessarily the same kind, but nevertheless potent.

To put their lives in historical perspective, John and Joy were born at a critical time in European history. They were small children during the First World War and young adults during the Second. Each was the product of a great empire in decline. John witnessed the end of the Austro-Hungarian Empire that brought about the First World War and the rise of fascism, and Joy the subsequent end of the 'Great' British Empire with the social/political shifts this brought about. These devastating changes had an inevitable effect on their work and thinking (as it did on all their generation, causing major shifts of population from middle Europe to the UK and USA that enriched our cultures as well as destroyed them). They both believed that through the medium of animation they could help to create a better world.

Halas and Batchelor provided work for hundreds of animators, technicians and artists. For John and Joy it was a quest, not just a job. My parents created the largest animation studio in Britain from 1940 to 1995. They pioneered many of the techniques and genres that laid the foundation of the animation industry we know today, and in making *Animal Farm*, the first animated entertainment feature in Britain, they secured themselves a place in British film history.

I, on the other hand, spent most of my adult life living in Paris trying to cut the cord and avoid their influence. It was far enough away to lead my own life as a graphic designer, unhampered by nepotism, but close

enough for a weekend visit. This worked well for over 20 years until Joy's death in 1991. After her death, John tried to carry on as usual, but was increasingly lost. He had already suffered a series of mini stokes but now they got worse. I found myself inevitably drawn back by the umbilical cord of filial duty. In a lucid moment not long before he died, my father looked me in the eyes and said in his thick Hungarian accent 'you are now in the centre of all theeese'. I found myself surrounded by papers and films and facing litigation over film rights.

My legacy

My parents left behind them not just their own work, films, drawings, articles on animation and scripts, but the work of the many other animators and artists who worked with them at Halas and Batchelor. So this book pays homage to my parents and all the other animators who contributed. Animators such as Kathleen (Spud) Houston, Vera Linnecar, Bob Privet, Digby Turpin, Allan Crick, Harold Whitaker, Brian Borthwick, Alison De Vere, Oscar Grillo, Roger Mainwood, Tony Guy, Graham Ralph, and Brian Larkin, to name but some, all started with Halas and Batchelor.

Others were drawn in to collaborate on a particular production or series. Bob Godfrey made several films with my parents, notably *Dream Doll*, the story of a lonely old man's love for a blow-up sex doll. The humour is Bob's, the design, Zladco Gridich, and the production, John's. This was typical of my father, as he liked to bring everyone together. Unkindly, you might call it talent snatching, or in its more positive light, harnessing the right people at the right time. John launched many new talents and he judged every one by their creative potential. For those new employees that were not put off by his confusing instructions, it was a chance to learn their craft. For many others, his Hungarian accent, accompanied by a strange mix of leaving them free to get on alone, but putting his mark on everything that went through the studio, left them frustrated and angry. There are many stories of John's quirks that people at the studio shared with me. Brian Larkin and Paul Cowen, who worked with Halas and Batchelor during the 1970s (when the studio was actually part of Tyne Tees Television, but John still retained the Educational Film Centre, and used both sets of staff), remembered how Roger Mainwood made his first computer animation, *Autobahn*, unaided, until my father came along and insisted upon adding a red dot to the design, thus making his mark.

Such things only indicate how hard it is to know your own parents, because what you know as a child seems so normal. That is probably why so much of twentieth-century literature deals with memories of childhood and parental portraits in a post-Freudian quest for understanding and making sense of our own life. It is my hope to understand my parents by giving a visual overview of their work in this book and to show some of the artwork drawn by a wide range of talented artists that they worked with.

Joy and John were very committed to their art, their passion for animation and their belief in it as an art form that embraced all disciplines. This did not make for an everyday childhood. They hoped somehow to make the world a better and fairer place to live in by communicating through the special and unique language of animated films. To me as a child they were like Prince Charming and his beautiful princess, I was bewitched by them and felt proud to have these charming and clever parents. This book is dedicated to them, their work and their incredible achievement.

Vivien Halas July 2005

Animal Farm 1954.
The animal's burn the
trappings of Farmer Jones
and mark the end of of
an oppressive regime.

Greetings from us all at HALAS and BATCHELOR London & Stroud

Pioneers of British animation

'John Halas and Joy Batchelor have given international standing to the work of animation in Britain. That is a great thing to have done. They will always have a place in the history of British Cinema.'
John Grierson, Founder of the British Documentary Movement and the National Film Board of Canada.

This book is a part-history, part-tribute, part-critical analysis of the Halas and Batchelor Cartoon Studio, Britain's leading and most influential animation company for over 50 years between 1940-1995. It draws upon the materials in the Halas and Batchelor Collection, the recollections and insights of those who worked at the company, as well as associates and collaborators in the variety of projects and initiatives the company undertook, but perhaps, most importantly, draws on the (auto) biographical input of Vivien Halas, daughter of John Halas and Joy Batchelor.

The book seeks to offer a critical and historical perspective, too - from established writers on animation from across the world, to fully address the place and achievements of Halas and Batchelor, not merely in the context of British animation and culture, but in the history of animation per se. Consequently, the book will be characterised by a mix of tone and viewpoint, and will seek to include a range of voices and perspectives offered in a spirit of celebrating Halas and Batchelor, but also, to properly give the studio the critical recognition it deserves.

John Canemaker, one of the most notable writers at the Disney Studio, was one of the first critics to engage with Halas and Batchelor in the early 1970s, and was a continual supporter of the Studio's work. He suggests 'If there were a king and queen of British animation, those crowns would surely belong to the estimable husband-and-wife team of John Halas (1912-1995) and Joy Batchelor (1914-1991), co-founders of the world-renowned Halas & Batchelor Studio. Halas and Batchelor did it all: advertising and educational films, training and propaganda films, theatrical and TV commercials and television series. Most memorably, they pioneered the production of full-length entertainment animated films in England, starting with their remarkable 1954 feature, *Animal Farm*, based on George Orwell's dark satiric novel.'

Canemaker adds 'The exigencies involved in producing large quantities of films led to explorations in techniques as well as style. The films have a more stylized form in look and movement similar to the films of America's UPA. Animator Richard Taylor once wrote of H&B: "They brought to the cartoon world the qualities which - on a more sumptuous scale - Steinberg, Ophuls, and Fritz Lang took to Hollywood." But their mastery of styles also included (when necessary) full animation and a more representational style, as it did in *Animal Farm*. Few studios dared plough the same field, and certainly not with a dark allegory about Russian communism. But Halas and Batchelor took up the daunting challenge and succeeded. The adult subject matter anticipates the sophistication of *Yellow Submarine* (1968) and Ralph Bakshi's adult animated features of the 1970s.'

Canemaker's remarks rightly draw attention to the breadth and quality of the work, and the studio's appetite for aesthetic and technical innovation. Such desire and motivation sustained the company's output and with it the name of British animation. The company's versatility and eagerness to embrace new challenges meant that it achieved a national and international profile, constantly responding to changes artistically, technologically and culturally. In this light, animation historian, Giannalberto Bendazzi, also contributes a view of the company's achievement:

'In the early 1950s, the world of feature film animation firmly belonged to Walt Disney. Not only were his films successful, but every company that tried to go along the same path just copied his formula, be it in the USA, Spain, Denmark, Soviet Union, France, Italy, Germany, Brazil. But in Britain, it was a little different. *Animal Farm* was completed in London in April 1954. It was unique because, as John Halas himself maintained, "it is not a cartoon comedy; it is, like the memorable fable by George Orwell from which it is derived, a serious satire concerning the fate of a group of animals who take possession of the farm where they have for so long been ill-treated and establish their own community". The film was a strong, polemic stance during the coldest years of the Cold War. It appealed to the adults, who could appreciate the almost Swiftian tone of its political metaphor. Snow White, Bambi and Cinderella had grown up; now they could stand against Soviet totalitarianism. Animation had made a great leap forward. John and Joy's option for non-formula films

remained apparent during all of their lifetime and career. John could recognise a good artist almost blindfolded, and never let him or her go away without work to do. The company, in its own way, always functioned like a Renaissance studio or a privately owned National Film Board. Only UPA in the US and Halas and Batchelor in Britain had rid themselves of the assembly line system. Furthermore, John Halas was product-oriented instead of consumer-oriented. He would voyage and preach for decades like a missionary promoting the auteur film, the novelty film, the socially-conscious film. He was also the only producer (the only 'money man') to participate in the birth of ASIFA - the body dedicated to championing the art, culture and practice of animation worldwide - which was collecting dreamers and utopians from all over the world. And a utopian he was. Without John, his example and his devotion to the cause, the entire history of world animation would have been different and much poorer.'

Again, Bendazzi's comments show that Halas and Batchelor were a production house with originality and vision, that did not merely wish to work in the Disney style. Arguably, the company's commitment to diversity; serious, if not politicised purpose; and the promotion of singular rather than signature styles, mitigated against its full recognition, especially in the light of the homogeneity of the Disney aesthetic for many years. The idea, too, that Halas and Batchelor constituted a modern-day renaissance studio is persuasive, particularly in regard to the progressive ethos of the company, the range and scale of its different achievements, and its almost missionary zeal in promoting animation as an art form. It is certainly the case that British animation and the whole art and culture of animation worldwide would have achieved less, and been slower in its development, without the impact of the Halas and Batchelor films, but perhaps even more importantly, without the profound influence of the two unique individuals at the heart of the company, John Halas and Joy Batchelor. This book will explore their art and legacy.

Paul Wells July 2005

Time-line

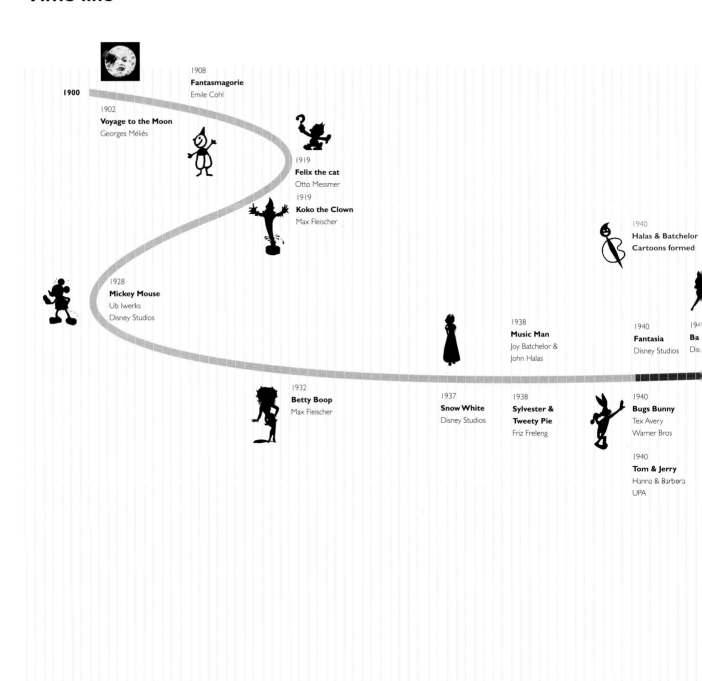

1900

1902
Voyage to the Moon
Georges Méliès

1908
Fantasmagorie
Emile Cohl

1919
Felix the cat
Otto Messmer

1919
Koko the Clown
Max Fleischer

1928
Mickey Mouse
Ub Iwerks
Disney Studios

1932
Betty Boop
Max Fleischer

1937
Snow White
Disney Studios

1938
Music Man
Joy Batchelor &
John Halas

1938
**Sylvester &
Tweety Pie**
Friz Freleng

1940
**Halas & Batchelor
Cartoons formed**

1940
Fantasia
Disney Studios

1940
Ba
Dis

1940
Bugs Bunny
Tex Avery
Warner Bros

1940
Tom & Jerry
Hanna & Barbera
UPA

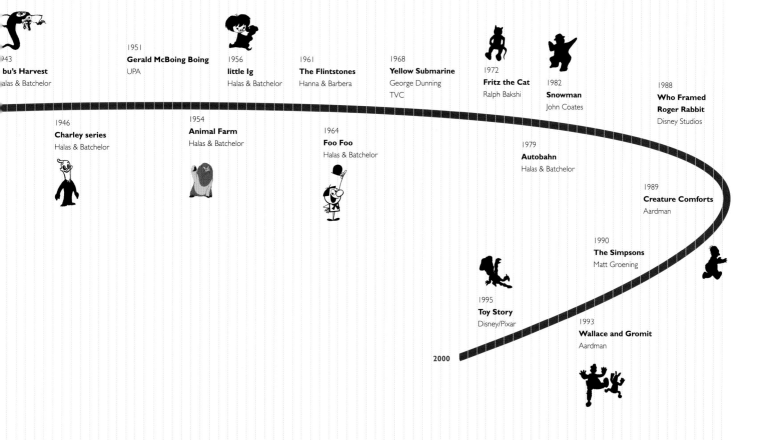

1943
bu's Harvest
alas & Batchelor

1946
Charley series
Halas & Batchelor

1951
Gerald McBoing Boing
UPA

1954
Animal Farm
Halas & Batchelor

1956
little Ig
Halas & Batchelor

1961
The Flintstones
Hanna & Barbera

1964
Foo Foo
Halas & Batchelor

1968
Yellow Submarine
George Dunning
TVC

1972
Fritz the Cat
Ralph Bakshi

1979
Autobahn
Halas & Batchelor

1982
Snowman
John Coates

1988
**Who Framed
Roger Rabbit**
Disney Studios

1989
Creature Comforts
Aardman

1990
The Simpsons
Matt Groening

1993
Wallace and Gromit
Aardman

1995
Toy Story
Disney/Pixar

2000

15

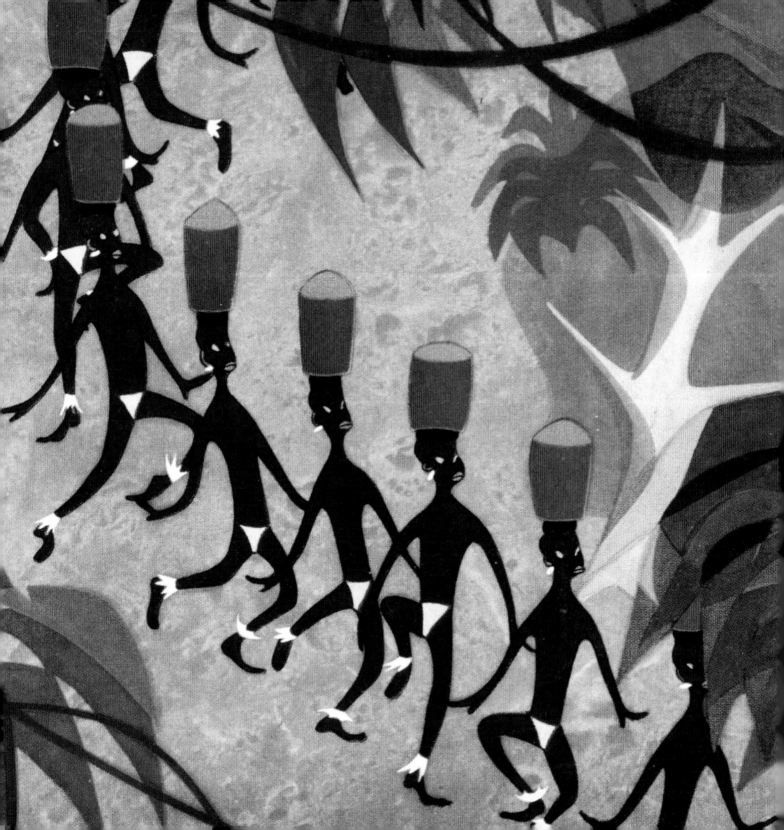

Art and animation

Roger Manvell is an important figure in any history of the Halas and Batchelor studio because he both worked with the company as a researcher, author and screenwriter for three years, working on some 30 or more productions (for entertainment, education, and public relations), as well as writing, in association with John Halas, four books about the form: *The Animated Film* (1954), the story of the making of *Animal Farm; The Technique of Film Animation* (1959), still regularly revised and reprinted; *Design in Motion* (1962) and *Art in Movement* (1970).

Writing in the first survey - *Art & Animation* - of the Halas and Batchelor studio in 1980, Roger Manvell suggested, 'any record of the work of Halas and Batchelor [is] a microcosmic survey of the medium itself, a history of animation concentrated (as it were) under a single roof'. This singular observation, in itself, recognises not merely the achievements of the studio, but also the less acknowledged place of Halas and Batchelor within the history of animation, and specifically, the particular understanding of the ways in which John Halas and Joy Batchelor were aware of, and drew from, the work of other artists in the field. Manvell knew, too, that for readers of the first survey, that in order for them to appreciate where Halas and Batchelor 'fitted', it was important to contextualise their work with an overview of the animation field.

He noted 'the cartoon film, the first, major form of animation, came comparatively late on the scene long after the first trick photographic images producing magical illusions on the screen (primitive cars disintegrating and then re-integrating, as in the early films of the Englishman, R.W. Paul, or the theatrical illusions of the great French prestidigitator, George Méliès) - had introduced the public to the experience of fantasy films. Emile Cohl of France was the first established animator who, from 1908, concentrated on the production of comic incidents involving small, matchstick like figures'. Manvell was right to stress the European model of animated film as the true precursor of the form, as it was the tradition

Halas and Batchelor most readily drew from when putting their own particular 'stamp' on the cartoon, when in the public imagination it had already become defined by the Disney Studio, which had been so successful between the arrival of Mickey Mouse in *Steamboat Willie* (1928) and the crowning glory of the first full-length, sound-synchronised, Technicolor cartoon, *Snow White and the Seven Dwarfs* (1937), that even the great American pioneers, Winsor McCay, with Gertie the Dinosaur, Otto Mesmer, with Felix the

Cat, and the Fleischer Brothers with the Out of the Inkwell and Betty Boop films were already consigned to a lesser place in animation history. Crucially, work by John Canemaker, Donald Crafton, Mark Langer, Leslie Cabarga, Michael Barrier and Norman Klein[1], among others, has been instrumental in recovering these important formative years, and demonstrate why it is necessary to constantly re-engage with, and rewrite, animation history, which remains a 'work in progress'. Inevitably, the extraordinary achievements of the Disney Studio have essentially defined the form, but this has meant that other work of high quality - the films of Halas and Batchelor included - have been to some degree marginalised or absent in the narrative.

Again, as Manvell explained: 'A newcomer to the medium during the 1920s, when films were still silent, (Disney) was, with the coming of sound, to create the first major empire in the field. Cleverly interlinking his much loved screen characters (Mickey Mouse and his girlfriend, Minnie, Donald Duck, Goofy and others) with subsidiary outlets (syndicated press cartoons, toys, advertising) he developed his product during the 1930s with ever increasing visual collaboration until the studio was strong enough to produce, with two years hard labour and a budget approaching $2 million, the feature *Snow White and the Seven Dwarfs* (1937), a film commanding feature rentals and making animation for the first time really pay for itself. He introduced fascinating inter-relations of sound and movement, and pioneered the use of decorative Technicolor. Aesthetically, a certain weakness in Disney's graphics tended to show when he tried to make his human figures too realistic and sentimentalised, and his animal figures too soft and coy. His work was at its best when it was most vigorously stylised and inventively choreographed; his films possessed undoubted power in the dramatic sense, especially at key moments

of threat in such films as *Snow White, Pinocchio* (1940) and *Fantasia* (1941) and *Dumbo* (1941). With time, his figures became increasingly moulded, set against backgrounds of considerable elaboration, with a strong sense of depth and perspective.'

While Disney continued to experiment even as his studio's work entered the mainstream – as animation has done throughout its history – a different kind of experimentation continued in Europe, drawing upon the fine arts and exploring other techniques. Manvell says: 'Parallel with Disney in the 1920s and 1930s, though in a much more specialised field in Europe, came an aesthetic expansion in animation with the emphasis still on stylisation, as distinct from the graphic naturalism that crept over into much of Disney's later work. Silhouette animation by Lotte Reiniger, brought the traditional Chinese shadowgraph theatre to the modern screen; experiments in abstract mobile patterns representing at once musical rhythm and instrumental qualities were developed by Oscar Fischinger; painting abstract patterns direct onto the celluloid was originated by Hans Richter and Viking Eggerling, and later with a music track by Len Lye, anticipating the extraordinary work to come by that greatest of experimental animators, Norman McLaren in Canada. Animation was also introduced to educational films in the form of mobile diagrams, maps, and other forms of graphic demonstration. Puppet animation, in which specially designed and constructed dolls were adjusted by hand and photographed stop frame, image by image, were developed by George Pal in Holland, Ladislas Starevitch in France, and Alexander Ptushko in the USSR. In France again, Bertold Bartosch adapted Reiniger's silhouette technique to produce the first serious political film in animation history, *L'Idée* (1932). Another remarkable form of animation – pinscreen – producing an image like an engraving, was invented by Alex Alexeieff and Claire Parker, in *A Night on Bald Mountain* (1933).'

Illustrations from the cover of John Halas' book *Masters of Animation* published in 1989.

Halas, of course, was in some senses part of this emerging work, especially in his own ambitions to make primitive stop-motion advertisements, the training and influence he gained from George Pal, and, most significantly, in the aesthetic stress on graphic stylisation in the work. While

Manvell's claim for Bartosch's masterpiece, *L'Idée*, as a 'serious political film' is persuasive, like much of the politicised work in Europe that was to follow, it is poetic, metaphoric and philosophic in outlook, and Halas and Batchelor, while also embracing these qualities in their work, were to progress the form by grounding their aesthetics in a socio-cultural reality necessitated by war, post-war reconstruction, and thereafter, the changing climate of democratic flux. They never lost sight, however, of the continuing evolution in animation itself. United Productions of America (UPA), working in a much more self-conscious, 'auteurist' style, drew upon the minimalist terms and conditions of European modern art in its challenge to Disney's near hegemony.

Manvell stresses, though, 'In post-war Czechoslovakia (led by Jiri Trnka) and Yugoslavia (the Zagreb group) newly developing schools of animation revolutionised animated graphics, departing radically from any suggestion of naturalism and evolving a rapid continuity of narrative with wit and imaginative ingenuity. Animation matured with an explosive force, leaving far behind the picturesque folklore of the standardised Russian cartoons of the day or the sentimentalised family entertainments of the post-war Disney studios.' In many senses, though, Halas and Batchelor were astute enough not to dismiss or abandon any style, embracing the approach or tone that was suitable for the projects they were involved with. Both saw all animated film as a repository for a wide definition of 'art', and drew from pertinent sources in the creation of their own distinctive achievements, often combining aspects of 'Disney' or 'UPA' with the aesthetics of Pal or Trnka, and the wider visual culture of modern art and graphic design. In this respect, Halas and Batchelor were highly progressive and, significantly, brought together different participants within related fields, both in the work itself, but, perhaps even more importantly, at the critical level, and as a creative community.

Manvell made the generic point that 'The animator pre-designs the movement of each image and pre-designs the editorial flow of the images in their dramatic sequence. The animation director is a graphic artist with the ongoing rhythmic sense associated with the poet and the composer of music. His images move in time, animation's remarkable gift to twentieth century painting and the graphic arts.' However while this remains true, it undervalues the specificity of Halas and Batchelor in placing a similar emphasis on all the aspects stressed. Design, narrative impact, poetic suggestion, and music were all given equal importance in

Right Matyas Seiber conducting his music for *Animal Farm.*

Below Francis Chagrin conducting the music for the *Tales from Hoffnung* series.

Below right György Ránki, Annus Ránki, Joy Batchelor and John Halas in Budapest 1947. Ránki introduced John and Joy to Matyas Seiber also a Hungarian émigré living in London. Ránki composed the music for *Dolly Put the Kettle On* in the same year.

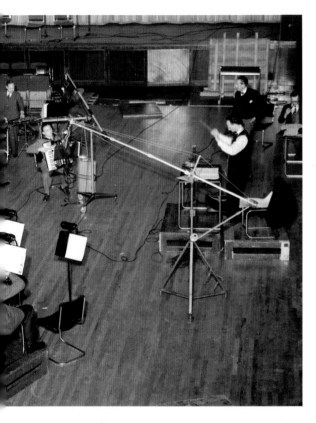

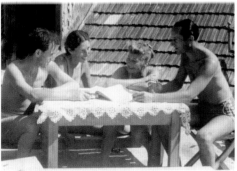

the studio's work, and as such prompted a highly collaborative approach. For example, Francis Chagrin and Matyas Seiber, the two principal composers on Halas and Batchelor films, could create original and high quality 'scores', rather than 'Mickey-Mousing' sound to add emphasis to, or counterpoint character movement, the principal soundtrack device of the American cartoon. Similarly, when Manvell says, 'Animation forms a significant part of modern graphic and (indeed) plastic and kinetic art, in veins that include not only serious caricature (comic and satiric) but also lyrical, dramatic and even at times tragic responses to psychological, social and political themes, as well as purely aesthetic experiments in the more abstract branches of art', he is right, but it was the work of Halas and Batchelor which championed this diversity, and helped to bring the form to a maturity by having a serious approach to both form and content, which did not reject the comic as such, but refined it into a form of wit more relevant to the subject matter explored. Further, the studio embraced technological change, and with it the experimental possibilities to redefine the form as a genuinely, and self-evidently, cross-disciplinary and inter-disciplinary art.

From the cartoon to the computer; from the pencil to the pixel; Halas and Batchelor created work which responded to changes in the arts and culture, remaining pragmatic about the economy and construction of each film or series, while continuing to be inventive and innovative. This is principally because Halas and Batchelor combined their expertise in the traditional core skills of drawing, graphic design and script development for animation, with the possibilities afforded by each creative opportunity and technological breakthrough. In every work there can be traced Halas and Batchelor's love for, and knowledge about, animated film, and their insistent imperative to ensure animation would be seen as an 'art' even in its most commercial or educational contexts. The impact of their work in Britain, and indeed, throughout the world, can therefore not be underestimated, and their efforts in creating 'firsts' - the first stereoscopic cartoon film in Europe, the first British full-length animated feature, the first animated operetta, the first 8mm educational concept films, and the first compilations of animated works from across the world to both preserve and promote the art of animation - have without question advanced animation in all its forms and outlets.

A brief history

What follows is an edited version of Manvell's original contextual history of the studio.

The unit of Halas and Batchelor was formed in May 1940 as an independent part of the J. Walter Thompson Advertising Agency, which had its headquarters at Bush House, Aldwych, London. The Agency's policy was to develop the talents of such young creative artists as were available during the early war years for official propaganda as well as advertising, so that after the war there would be a reserve of skill ready to make motion picture commercials. The first two films to be made by Halas and Batchelor were in fact commercials, *Train Trouble* (1940) (which was scripted by Alexander MacKendrick, later to become well known as a feature film director at Ealing Studios) and *Carnival in the Clothes Cupboard* (1940), a commercial for Lux toilet soap. Even at this early stage the stress on quality was apparent, more especially in inviting the distinguished composer, Francis Chagrin, to provide scores for both films.

It was John Grierson, back in Britain for a period in 1941, who after setting up the National Film Board of Canada, guided the unit into the field of wartime propaganda. During the remaining war period, 1941–45, the unit produced some 70 shorts in fulfilment of various wartime

Tommy's Double Trouble 1945. This drawing is typical of Joy Batchelor's style.

Train Trouble 1940. Scripted and designed by Alexander MacKendrick, later the Director of several successful Ealing Comedies, *Train Trouble*, a commercial for Kellogg's Cornflakes, had a Disney-like familiarity in its characters and outlook, and included a highly suspenseful train chase sequence.

Dustbin Parade 1941. Made to encourage households to recycle their domestic waste in support of the war effort.

Dustbin Parade shows Halas and Batchelor's distinctive mix of Disneyesque character animation and the influence of European modern art and graphic design.

Dustbin Parade 1941.

Handling Ships 1945. Sponsored by the Admiralty, this 70-minute film includes clear schemata in the instruction of navigating ship movement, following increased numbers of accidents by inexperienced sailors. Commander Allan Crick, who served with the Grand Fleet during the First World War, and was a First Lieutenant to the Captain of the Port at Constantinople, became a Lieutenant Commander at the start of the Second World War, responsible for training RNVR Officers, ultimately leading the Naval Instructional Film Section. Crick scripted, directed and edited the film, and later joined Halas and Batchelor as a junior partner and produced and directed many films including a number for British Petroleum.

Water for Fire Fighting 1948. The use of simple moving 3D models in animated sequences proved hugely successful in conveying sometimes quite complex information and instruction in an accessible and enabling way to trainee recruits in the Fire Service.

needs. Several of these films were notable: the newly formed Ministry of Information, uncertain of its role as a source of propaganda during its first year, had begun to discover its function in film under the enlightened direction of Jack Beddington (the brilliant public relations officer from Shell Mex and BP, who had taken over the Films Division in 1940). Halas and Batchelor were invited to bring a breath of fresh air to such pedestrian but necessary subjects as the development of allotment holdings and the saving of scrap metal, bones and paper, and produced *Dustbin Parade* (1941) and *Digging for Victory* (1942). The former, with its beautifully moulded black and white design and its joyful ballet of the parade of much needed refuse homing onto the ever receptive waste bin, was a delight; it was in use non-theatrically throughout the war, while in *Digging for Victory* John Halas and Joy Batchelor employed as composer for the first time Matyas Seiber (student of Bartok and Kodaly), an association, like that with Francis Chagrin, which was to result in over 250 film scores from these two eminent composers. Halas and Batchelor was to become a major patron of British music.

An interesting extension in propaganda was the *Abu* series (1943), directed at Arab audiences in the Middle East. Abu was a small Arab boy in charge of a donkey; both proved highly resistant to the Fascist propaganda of a looming, snake-like Hitler and a massive frog-like Mussolini. The longest of the unit's wartime films was in the area of technical instruction

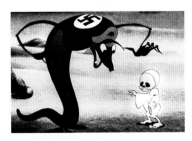

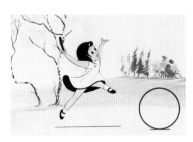

Filling the Gap 1941. Halas and Batchelor's public information and propaganda films during the war represent their first efforts in highly effective approaches throughout their history in using the specific language of animation to educate the public. Animators Wally Crook and Vera Linecar began long careers in animation on this film.

Digging for Victory 1942. The Ministry of Information sponsored *Digging for Victory*. It was an attempt to win public interest in actually participating in the day to day needs of the war effort, when it became increasingly clear that live action films and newsreels were not engaging the audience.

Abu 1943. Halas and Batchelor's bold use of animal symbolism for serious purpose in *Abu's Poisoned Well* was a far cry from the comic animals of the American cartoon tradition. Alexander MacKendrick worked on the *Abu Series*.

Modern Guide to Health 1946. A film training the general public to keep fit.

Handling Ships (1944–45), a 70-minute film sponsored by the Admiralty, which was later, post-war in 1949, to commission a half-hour film of a similar kind, *Submarine Control* (1949). *Handling Ships* demonstrated the intricacies of ship movement with deliberation and absolute clarity, using simplified schematic designs, which were to become a characteristic of many post-war Halas and Batchelor films, demonstrating physical and technological processes. For example, an admirably clear, post-war instructional film sponsored by the Home Office was to be *Water for Fire Fighting* (1948); it was made with three-dimensional, simplified models and was intended to help in the training of recruits to the fire service.

The immediate post-war period led, as anticipated, into an extension of the unit's work into the instructional and public relations field. On behalf of the new Socialist government, Sir Stafford Cripps (then Chancellor of the Exchequer) personally commissioned a series of films to help the public understand Socialist intentions in initiating new legislation affecting Britain's post-war reconstruction. Halas and Batchelor proposed that they introduce a man in the street type of cartoon character called Charley, who at first would voice popular objections to all these reforms but was capable of being won over by persuasion, and Cripps accepted the idea with enthusiasm. The outcome was a series of seven *Charley* cartoons, each playing ten minutes, and shown to audiences estimated at some 30 million in the cinemas during the period 1946-48. For example, working hard for export was the subject of *Robinson Charley* (1947) (for which Cripps himself carried a script credit), while the new Education

No sooner has the Genie spoken
than we can see that the fire
is four times its original size.

Close up as Charley warms his
hands appreciatively. "Ah now!
If I could only have all the
coal I need!"

"Certainly Master" says the
Genie.

Charley hears a sound remarkably
like coal being delivered and
he turns

Act was explained in *Charley Junior's Schooldays* (1947). Other officially sponsored films were a series on the fighting services commissioned by Denis Forman (later Sir Denis Forman of Granada Television), and the marvellously menacing *Fly About the House* (1949), on domestic pollution by the housefly, with a dramatic score by Francis Chagrin. The unit's work extended into the international field when the American government commissioned two films about Marshall Aid and the need for the countries of post-war Europe to cooperate among themselves: *The Shoemaker and the Hatter* (1949) and *Think for the Future* (1949).

The unit had meanwhile turned away from propaganda, public relations and other sponsored films to experiment on its own with films that John Halas and Joy Batchelor made for their own personal satisfaction. The most significant of these in the 1940s was *Magic Canvas* (1948), which John Halas designed in association with Peter Foldes, the artist animator who was to contribute so much to animation later both in Britain and France. Matyas Seiber, who composed the music for this film, has written about it, describing not only the nature of the film, but the contribution the composer was to make to it:

'The film was an abstract project; consequently, I considered that a similarly 'abstract' chamber music piece would be the most appropriate musical equivalent. I chose the rather odd combination of one flute, one horn and a string quartet. The form of the piece is that of a rather free 'phantasy', consisting of several sections. A slow contrapuntal piece covers the first section. At the dramatic moment of the human shape breaking into two the horn enters for the first time. The speed increases, and at the moment when the bird breaks away the flute takes over. Now follows an 'allegro' movement which covers the storm sequence. The next section, the revival of nature, is expressed by a 'pastorale' in the music. This is followed by a 'scherzo', covering the play with the waves. Then a bridge section leads back to the recapitulation of the slow movement, as the bird returns to the human shape. But the slow movement returns transformed: instead of the low pitched, brooding mood as it appeared originally, it comes back now in a higher register, and a solo violin ends the piece, as the bird disappears in the distance.... It was one of the rare cases when, within the framework of the story, it was possible to create an autonomous musical composition, a 'phantasy' consisting of a slow introduction, an allegro, a pastorale, a scherzo and, finally, a recapitulation of the slow introduction.'[2]

Fly About The House 1949. The perils of the presence of flies in the domestic household are highlighted in this amusing tale, which shows the point of view of the flies as they explore a kitchen.

The Shoemaker and the Hatter 1949. Created to explain aspects of the Marshall Plan, the figures of the Shoemaker and the Hatter are deployed to depict the different approaches to consumer economies and the benefits of lifting trade restrictions in the spirit of economic and social co-operation. The script was written by Joy Batchelor with talented American film-maker and writer, Philip Stapp.

The Magic Canvas 1948. Halas and Batchelor's first highly self-conscious personal film, engaging with the artistic and philosophic principles that underpinned the studio's outlook, namely the pursuit of human freedom and aspiration within progressive approaches to art and cultural expression.

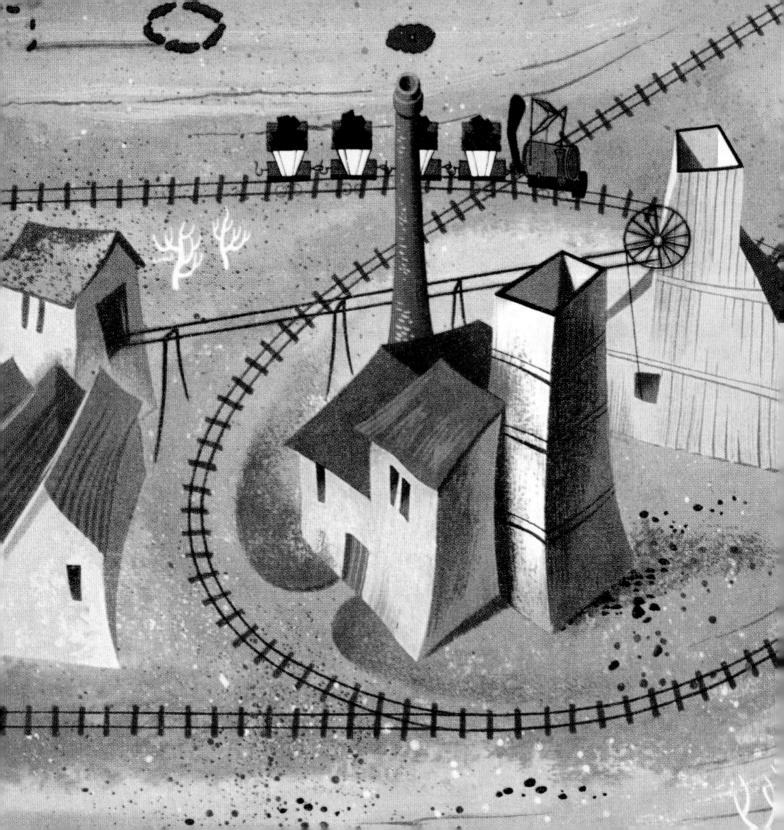

The studio was to continue making personal and commercial projects throughout its history. During the 1950s, BP (whose Public Relations officer, Ronald Tritton, had held a senior position in the Films Division of the Central Office of Information, successor to the wartime Ministry of Information) became one of the unit's principal post-war sponsors of public relations films, in which the emphasis was as much if not more on education than on the advertising aspects of promotion. These films were to include several representing the unit's best and longest lasting work in international distribution, films such as *As Old as the Hills* (1950), *Moving Spirit* (the history of the motorcar) (1951), *We've Come A Long Way* (the

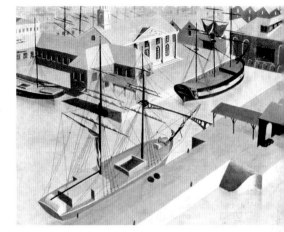

history of tanker ships) (1952), followed by many of the best-known titles in this series, *Power to Fly* (the history of aviation) (1953), *Down a Long Way* (the search for oil) (1954), *Animal Vegetable Mineral* (the story of the overcoming of friction) (1955), *Speed the Plough* (agricultural history) (1958) and *Energy Picture* (the history of energy) (1959). These films brought out the best in schematic design of which the unit was capable, the work principally of designer animators such as Bob Privett, Digby Turpin, and latterly Vic Bevis and Gerry Potterton working in close association with John Halas and Joy Batchelor themselves. Except for *Moving Spirit* and *Power to Fly* (scores by Benjamen Frankel), the music for these films was composed by Matyas Seiber.

Halas and Batchelor were now in a strong position. They had continuity of specially sponsored productions backed by an increasing number of animated commercials for cinema and for television, once commercial television was introduced in 1955. Their best work in the sponsored field during the 1950s, in addition to the BP series, included *All Lit Up* (1956), made for the Gas Council, and *For Better for Worse* (1959), a sharp satire on television viewing habits made for Philips of Eindhoven. An excellent officially sponsored film was *To Your Health* (1956) designed and directed by Philip Stapp, on the nature of alcoholism, made for the World Health Organisation.

The Owl and the Pussycat 1952. The studio's adaptation of the famed Edward . Lear nonsense poem was made as a stereoscopic film for exhibition at the Festival of Britain, once again featuring the technical expertise of Brian Borthwick in making the film from two different optical points.

The quality of such films lies in the ability to show things which live-action could not. Bob Privett and Brian Borthwick, with Allan Crick as producer and Mullard as sponsor, for example, made a 20-minute technological film, *Linear Accelerator* (1952), which showed the properties and functioning of X-ray equipment, impossible to demonstrate by live-action.

The Festival of Britain in 1951 offered another opportunity for the studio to showcase its work. Under the general charge of the late Sir Gerald Barry, formerly editor of the *London News Chronicle*, the Festival (a centenary celebration in the spirit of the Great Exhibition of 1851), was intended to put new heart into post-war Britain, with the tragedies, deprivations and rationings of war and post-war still fresh in the memory during the period of struggle to rebuild bombed cities and rehabilitate the depleted economy. It was intended to be cheerful, even frivolous, and to bring into prominence British architects, artists and craftsmen. It enabled the British Film Institute to found what was to become the first form of the permanent National Film Theatre, opening its doors in one of the many temporary structures erected by the Festival on the South Bank, the exhibition centre. The BFI also sponsored a considerable number of films, among them experiments in 3D production and exhibition under the creative supervision of Norman McLaren of the National Film Board of Canada, who in turn asked John Halas for help on the technical level in his stereoscopic programme, which included the 3D colour films, *Around is Around* (1951) (a semi-abstract film in which the colour base changed for each sequence in a successive flow of patterns) and *Now is the Time* (1951). These films, viewed in the theatre with anamorphic spectacles, exploited images that advanced and retreated from the frame of the screen to the horizon, and came forward from the screen towards the spectators in the auditorium.

The following year, 1952, John Halas, in association with Brian Borthwick, experimented independently with a seven-minute stereoscopic film, *The Owl and the Pussycat* (1952), based on Edward Lear's poem, with music by Matyas Seiber. The character design was highly stylised to match the nonsense fantasy of the poem. This was Europe's first stereoscopic cartoon film and, although available in normal, two-dimensional form, it was shown in many parts of the world in 3D. With further sponsorship from the BFI, John Halas made a series of eight *Poet and Painter* films (1951) for the Festival - the poets were both traditional (Shakespeare, Nashe, Cowper) and contemporary (David Gascoigne, Kathleen Raine,

The Poet and the Painter series

Two Corbies Michael Rothenstein

Check to Song Owen Meredith

Sailor's Consolation John Minton

Spring and Winter Mervyn Peake

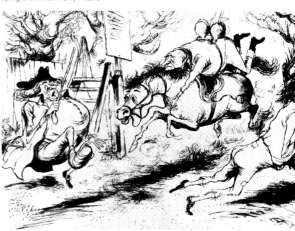

John Gilpin Ronald Searle

The Poet and Painter Series 1951.
In one of the studio's most ambitious projects, Halas and Batchelor proved its credentials not merely as an animation house noted for its public information and propaganda films, but as an arthouse studio playing a key role in British arts culture. Made in four programmes it featured the art of Michael Rothenstein illustrating the poem, *Two Corbies*; Mervyn Peake's response to Shakespeare's *Spring and Winter*; Barbara Jones' interpretation of David Gascoigne's poem *Winter Garden*; John Minton's work on Dibden's *Sailor's Consolation*, read by British Music Hall favourite, Stanley Holloway (voice of Anson Dyer's *Old Sam* films in the 1930s); Michael Warre's engagement with Owen Meredith's *Check to Song*; and perhaps, most notably, Michael Ayrton's work on Thomas Nashe's *In Time of Pestilence*, Henry Moore's take on Kathleen Raine's *The Pythoness*, and Ronald Searle's lively illustration of William Cowper's *John Gilpin*.

Sailor's Consolation John Minton

The Pythoness Henry Moore

Spring and Winter Mervyn Peake

TELEPHONE:
MUCH HADHAM 66

HOGLANDS,
PERRY GREEN,
MUCH HADHAM,
HERTS.

October 5th 1950.

Dear John Hallas,

Thank you for your letter of yesterday, which I've just received, telling me that you got the photographs safely.

I rather think that the two prints I'm now sending you, are sharper & better than the ones of these drawings I sent before — Could you compare them, & use whichever you think are the better prints for your purpose.

yours sincerely

Henry Moore

Owen Meredith). Specially produced artworks were also created for filming, including material by Henry Moore, Ronald Searle, Mervyn Peake, Michael Rothenstein, John Minton and Michael Ayrton. Distinguished actors and actresses such as Mary Morris, Cecil Trouncer, Stanley Holloway and Michael Redgrave, with Peter Peers singing Shakespeare's 'Spring and Winter', recorded the verse. The basis for the *Poet and Painter* series was created to reflect cinematic action or atmosphere. For example, the action for William Cowper's *John Gilpin* (spoken with a sardonic appreciation of its humour by Cecil Trouncer) was recreated in a whole succession of caricatures lasting ten minutes on the screen over which the rostrum camera panned and tracked until these numerous drawings, subjected to skilful editing, seemed to explode into dramatic life, whereas Rothenstein's work for *Two Corbies* and Ayrton's for Nashe's poem *In Time of Pestilence* (both very brief on the screen) were wholly atmospheric. The music for the series was composed by Matyas Seiber.[3]

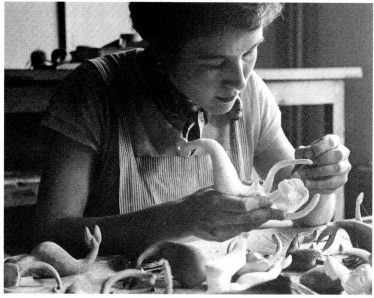

The Figurehead 1953.
Left, below and below right
A 3D stop motion animated puppet film made to a score previously composed by Matyas Seiber and using the Allan Crick devised technique of 'drawing and painting with light', using shifting transparent coloured filters.

In 1953, Halas and Batchelor made *The Figurehead* (1953), which the unit sponsored itself, again with Seiber as composer. In this case, Seiber

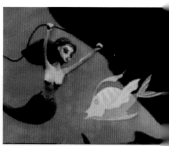

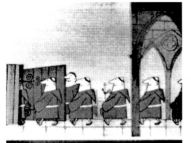

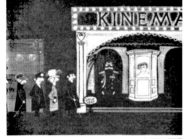

History of the Cinema 1957. John Halas' satiric take on the film industry, principally animated by one of Britain's most notable but unsung animators, Harold Whitaker. He had worked as a commercial artist in the pre-war period, and later at the Anson Dyer studio, joining Halas and Batchelor as they embarked on *Animal Farm.* Whitaker worked on most of the studio's projects between 1954-72, then wrote *Timing for Animation* with Halas, and continued to work with Halas and Batchelor in its latter incarnations, and with Animation People and TVC and the BBC until his retirement in 1994.

was asked to compose and record the score in advance of the animation, which was then carefully synchronised with his musical rhythm structure.[4] The film was a fantasy about Neptune's daughter falling in love with a wooden figurehead of an old ship, and taking this handsome but unresponsive love down to her sea bed. The experimental nature of this puppet film lay mainly in what John Halas has called a technique of 'drawing and painting with light' devised by Allan Crick, a technique based on the use of transparent celluloids, polaroid screens and filters. By the adjustment of polaroid filters the colours of the transparent celluloids could be automatically changed.[5] Other one-reel entertainment films sponsored by the unit itself during the 1950s included *History of the Cinema* (1957) and *Man in Silence* (1959). Both *The Figurehead* and *The History of the Cinema* were chosen for inclusion in the annual Royal Command Performance of their year.

It was during the early 1950s that Halas and Batchelor began to receive increasing recognition in the United States, following the Marshall Aid films of the 1940s. This resulted in the sponsorship of *The Sea* (1954) by the Ford Workshop of New York and the production of five one-reel films, reviving for American television, Fleischer's character, *Popeye the Sailor* (1955), films sponsored by Rembrant / King Features and designed and animated by Tony Guy (some years later to become animation director of the feature *Watership Down*). The Lutheran Church Federation sponsored a religious animated story film, *The Candlemaker* (1956), while NBC funded the amusing experiment of making cartoon entertainment out of Stone Age characters in *The World of Little Ig* (1956).

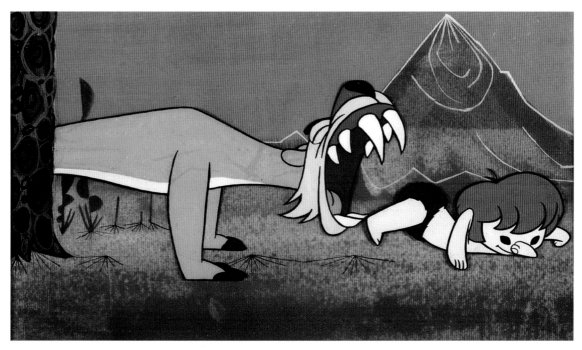

The Candlemaker 1956.
Made for the Lutherian
Church Federation in the
United States, this som-
bre piece about Christian
Stewardship was written
by Philip Stapp with Joy
Batchelor and scored by
Matyas Seiber.

Christmas Visitor 1958.
Based on a classic
Christmas poem, this film,
scripted by John Halas
and Joy Batchelor, was
designed by Ted Pettingell
with music by Matyas
Seiber.

For Better for Worse 1959.
The Eindhoven-based
Philips Electrical
Industries commissioned
a film about the benefits
and drawbacks of televi-
sion, given its increasing
influence and effect by
the end of the 1950s. The
company wished to stress
television's potential.

importance for education
and this very much
accorded with Halas'
views concerning the
uses of animation,
too. The film features
animation by Halas' fellow
émigré, Peter Sachs, who
had achieved prominence
at the W.E. Larkins Studio.

The principal sponsorship from America was Louis de Rochemont's funding for Halas and Batchelor to make the first seriously intended feature length graphic animation film to be produced in Europe, the dramatisation of George Orwell's tragic political fable, *Animal Farm*, which was originally published in 1945.[6]

To make *Animal Farm* (1954) alongside their normal, and expanding, sponsored work, Halas and Batchelor became the largest animation studio in Western Europe with a creative and technical staff of nearly one hundred. No one unacquainted with an animation company at work can envisage at all easily the creative and administrative work involved in the production of a film of this kind, although its running time is only 75 minutes. 300,000 hours (almost a complete individual lifetime) were required to create 250,000 drawings and some 1,800 coloured backgrounds. Two tons of paint were needed for the vast series of coloured drawings which presented the illusion on the screen of continuous action.

Animal Farm is a book with a very strong idea. It is a fable about animals but these animals are as serious in their attitude to life as any cow or pig or dog or fowl you may meet on a real farm. They are not sentimentalised to suit human prejudices, nor are they cutely humanised like most animals in cartoon films; for Orwell's fable is symbolic, and the result is a political satire full of deep feeling. The animals on an ill-kept farm revolt against its cruel and drunken owner, drive him out by means of an organised revolution, set up their own form of democratic community, led by the pigs, who prove to be the most intelligent of the animals. But although they begin with democracy, it gradually develops into a dictatorship in which the pigs are the *herrenvolk* and Napoleon, the most powerful and evil of the pigs, is the dictator. In the book, the final stage is the saddest, for the pigs wear human clothes and banquet with the enemies of animal-kind, the cunning and cruel exploiters of their wealth and labour. In the film a happier twist is given to this situation by showing that the animals are yet again capable of organising resistance against the leaders who have betrayed them.

Animal Farm is about animals who are not merely story-book creatures; their life on the farm is presented by an author who knew both farm life and animal life well. There is in his writing not only a lyrical feeling for the countryside, but also a down-to-earth realism; the animals are quite uncompromising in their behaviour. Matyas Seiber's music was able to

Animal Farm 1954.
Drawing for Old Major.

help the audience respond to the emotions of the animals as they pass through their bitter experience in exchanging one cruel yoke for another of their own making. They must hope and suffer, they must sing and weep and they must learn by hard experience what happens when they are too optimistic, simple-minded and trusting.

The initial work on the treatment, graphic design and character sketches was carried out by John Halas and Joy Batchelor together. They constructed the dramatic flow of the story into a succession of 18 sequences of variant mood and accompanied their first visualisation of the principal characters with such descriptions as that for Old Major, the wise old pig who leads the initial revolt: 'Old and dignified. Ponderous. As always seen lying down, drawing must suggest his size and weight within limited movement allowed.' At this stage Philip Stapp was engaged to help develop the storyboard of some 350 drawings, with a more exact breakdown. The dialogue came entirely from Orwell's book, direct, simple and confined to essentials. The sound-effects, on the other hand, were all used to increase the impression of naturalism, the real sounds of a farm, the cries of animals, the creaking of wheels and machinery; the sounds, in fact, which would be made by the natural counterparts to the drawn images on the screen.

The musical structure was being planned, composed and recorded by Seiber prior to the animation. Interpretation and emphasis of mood remain at certain stages the chief purpose of the score, allowing the music to develop its own unique qualities in the expression of emotion. It serves to bind together the various sequences and add to the sense of continuity in the film. Many of the individual sections of the score form long compositions of some minutes' duration. At other stages in the film the composer had to be prepared completely to subordinate the nature of his work to the details of the action, permitting it to become a colourful elaboration of a sound effect. The composer had obviously to work in the closest association with the filmmakers, or his work, however beautiful or atmospheric in itself, would tend to draw away from the immediate needs of the film. The orchestration of the score for *Animal Farm* was designed for performance by 36 instruments. Jack King, who had been in charge of sound at Halas and Batchelor since the early 1950s, used multiple tracks with extraordinary skill so as to enable a single actor, Maurice Denham, to voice nearly all the animals in turn, and, with the Dorian Singers, even sing, as it were collectively, their first revolutionary anthem.

 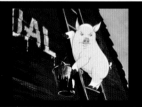

 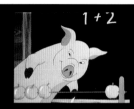

 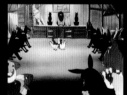 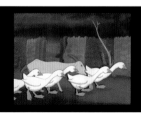 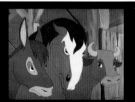

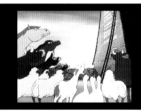 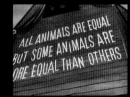 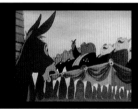 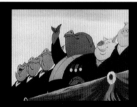

 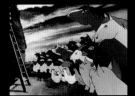 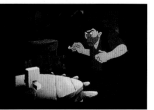

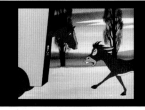 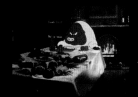

The design for *Animal Farm* was informed by the view that the animals had to be, partially at least, anthropomorphised, in order to engage audience sympathy over the full extent of a feature presentation. They had to be drawn in a developed, moulded form. This humanisation of the animals led, in effect, to the principal dramatic problem – how to end the film. If it were to follow exactly the mood of Orwell, then it must end in total defeat of those animals representing decency and animal 'humanity'. Louis de Rochement was averse to this, insisting on at least some degree of hope being introduced at the end. To this extent, then, the animals representing freedom are shown as preparing to defend their rights. Many critics took exception to this, holding that since Orwell despaired of the survival of human rights in the face of increasing invasion by anti-democratic bureaucracy, the film should have remained uncompromisingly faithful to his view.

Cinerama Holiday 1953. Louis de Rochemont invited John Halas and Joy Batchelor to produce bridges between the episodes of this wide-screen feature which was shot in Europe and the USA. John Halas, Joy Batchelor and artist Digby Turpin spent several months in New York painting and animating on site.

Midsummer Night's Dream 1957. Planned as a prestigious feature length film, it was later abandoned in the light of other developments at the studio. Character designs developed by George Him and Joy Batchelor.

Halas and Batchelor undertook two other unusual assignments during the earlier 1950s; the first, at the invitation again of Louis de Rochement, was the initial development of animation for the original Cinerama screen. The other venture was the combination of animation and live action cinematography with the presentation of live actors on the stage in shows called successively 'Magic Lantern' and 'Living Screen', and produced originally in Prague with multiple screens, and later in Brighton, England, and again in New York at the World's Fair in 1964. John Halas worked in association with the stage designers, Joseph Svoboda of Prague and Ralph Alswang of New York. Film projection came from both the back of the theatre and the side of the stage, and the production was controlled with an exactness of synchronisation achieved by computerised timing to one-twelfth of a second.

Projects for further full-length animated films, including *Pilgrim's Progress* and *A Midsummer Night's Dream* (the latter already having been produced in feature-length puppet form by Trnka in Prague in 1959) were abandoned because of the pressure of other work, including sponsored public relations films for the Gas Council, BP, Esso, Philips, Seagram and Monsanto. Sponsorship also extended in entertainment, begun initially with support by ABC-TV for 33 cartoons, each of six minutes, involving a new cartoon character - *Foo Foo* (1960), an indomitably cheerful, though utterly incompetent, bowler-hatted, slightly Chaplinesque caricature, graphically simplified almost to the point of being a Cohl-like matchstick figure, but capable of elastic stretching and contraction. Parallel to these, ABC sponsored six *Habatales* (1960) of seven minutes each, equally stylised but somewhat more elaborately developed as individual stories, including the prize-winners, *The Cultured Ape* and *The Insolent Matador*. An animal character developed at the same time was *Hamilton, the Musical Elephant* (1961), distinguished because his instrumentation was provided in two films by Johnny Dankworth. In order to short-circuit work on this large number of films, the unit experimented successfully with a new technique of fluid animation, that is animating directly onto the cel with coloured chinagraphs, thus avoiding tracing and painting while at the same time retaining the original freshness of the key animators' work.

Hamilton the Musical Elephant 1961. Anticipating the more developed *Hoffnung* series, *Hamilton*, directed by John Halas himself, incorporated the music of the saxophonist, Johnny Dankworth, *above*, and appealing animation from Harold Whitaker.

Foo Foo 1960. Made as 33 six-minute episodes, *Foo Foo*, designed by Alan Smith, proved extremely popular on ABC TV in the early 1960s. It featured one of British animation's typically put-upon 'little men', who eventually triumphs in the face of adversity.

Habatales 1960. *Above and left* The six ABC-sponsored *Habatales* made by the studio - the first British animated entertainment series - included the voices of leading actors Sam Wanamaker and Warren Mitchell (later very popular as Alf Garnett in Johnny Speight's series *Til Death Us Do Part*). It told amusing stories in a simplified graphic art style, using chinagraph pencil directly on to cel. *The Cultured Ape* and *The Insolent Matador* won Festival prizes.

Classic Fairy Tales 1966. *Far right* The Joy Batchelor scripted and directed *Classic Fairy Tales*, sponsored by the Encyclopaedia Britannica, included *The Frog Prince, Rumpelstiltskin, Hansel and Gretel, Sleeping Beauty, The Ugly Duckling* and *Little Tom Thumb*, and were well chosen for their scenes of transition and transformation, so suitable for the animated form. Designed by Swedish graphic designer, Sunniva Kellquist, for an international audience, the films were animated in cut-out collage by Harold Whitaker.

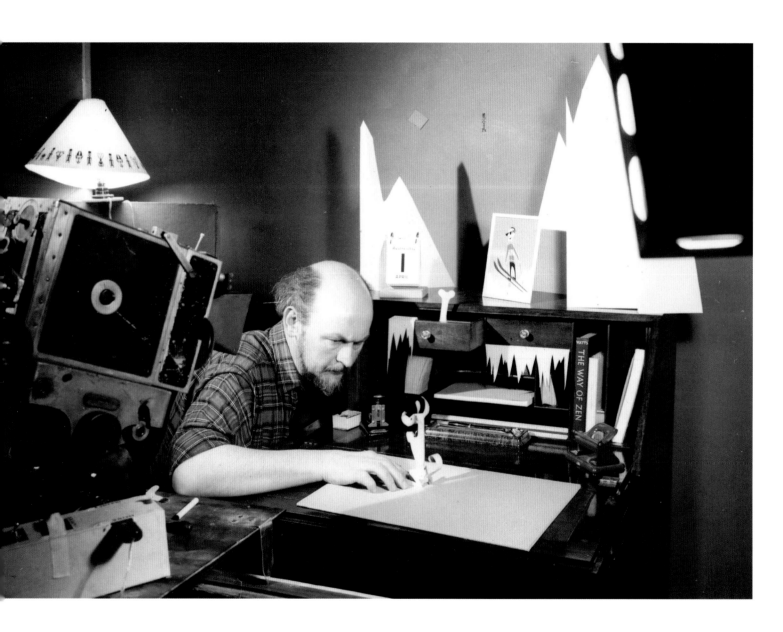

Snip and Snap 1960. One of the most innovative of Halas and Batchelor's children's TV series, *Snip and Snap*, animated paper-sculpture characters by a Danish artist called Thok, was seen in over 76 countries worldwide.

More experimental in developing a new branch of animation, was the *Snip and Snap* series (1960), sponsored by ABC TV. On a lecture visit to Copenhagen, John Halas discovered a toy-maker, Thok, who was trying to animate little models in the form of paper-sculpture in brief strips of film. Thok was immediately invited to Britain to develop this work, and out of this came a series of paper-sculpture films featuring two characters – Snap, a perky, adventurous little dog, and Snarl, the perpetual villain who tries to thwart him. These figures, made from folded paper, were provided with a range of heads of differing expression and their quick and lively movements were animated by stop-frame exposure on miniature sets about 2m square. So subtle and expressive were the best of these films that three of them won awards at international festivals.

The 1960s were indeed to be characterised by several very varied developments in the series film, both for entertainment and instruction. Apart from subjects in the American *Barnaby* series (1962), sponsored by the Westinghouse Broadcasting Corporation, and Joy Batchelor's six-minute *Classic Fairy Tales* (1966) for Encyclopaedia Britannica, the main entertainment series were to include some of the most popular films to

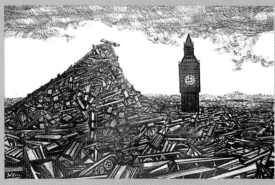

be produced by the studio - *Tales from Hoffnung* (1964), directed primarily by John Halas and adapted from Gerard Hoffnung's drawings, with music by Francis Chagrin. They were part-sponsored by the BBC. One of these seven films, *The Symphony Orchestra* (director, Harold Whitaker), won four major international awards and diplomas, while *Birds, Bees and Storks* (featuring the voice of Peter Sellers as an unctuously embarrassed father explaining sex to an invisible son) received a British Film Academy nomination and a special accreditation at Oberhausen.

One of the most successful entertainment films Halas and Batchelor ever produced was the one-reel cartoon, animated by Harold Whitaker, *Automania 2000* (1963). It was directed by John Halas and scripted by Joy Batchelor. This set out with fearful logic to show the growth of a barbaric civilisation based on a glut of self-perpetuating automobiles which eventually destroy mankind. This film was to win more awards than any other in the unit's history. Another prize-winning satire was *The Question* (1967) with a storyboard by Stan Hayward, in which a highly stylised figure, representative of 'ordinary' Man with an enquiring mind, picks up a question mark and presents it in turn to a priest, a politician, an artist, a scientist, a financier, a psychologist, and an army commander – all in vain; only when he meets a woman do they put two question marks together

The Tales from Hoffnung 1964. The BBC-produced *Tales of Hoffnung*, seven cartoons based on the musical caricatures of Gerard Hoffnung, were a significant contribution of the reinvigoration of the cartoon form in the 1960s. Largely animated by Harold Whitaker and Tony Guy, and directed by Halas, the series is memorable for its eclectic classical scores by composer, Francis Chagrin, one of the studio's key collaborators. The *Birds Bees and Storks* episode was voiced by Peter Sellers *above*.

Automania 2000 1963. Halas' bleak vision of a world overtaken by cars, warning against the ways in which humankind was being undermined by the growth of late industrial capitalism.

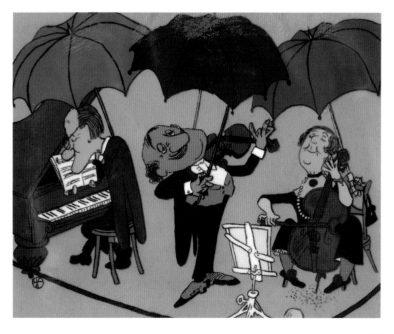

to form a heart. It was at this period that Jack King, who had been in charge of sound and effects since the early 1950s, came forward as a notable composer for animation, writing the music for these two films and numerous others in the 1960s and 1970s.

Two special productions in the field of entertainment involved the unit in a new kind of undertaking. The first was a wholly live-action film, *The Monster of Highgate Pond* (1960), sponsored by the Children's Film Foundation, which specialises in producing entertainment for younger children. Conceived and scripted by Joy Batchelor, and directed by the celebrated filmmaker, Alberto Cavalcanti, this charming fantasy was, even as late as 1975, voted, by children attending the special matinees in London's cinemas, the best live-action feature. The other production, also primarily the work of Joy Batchelor, was a one-hour animated feature based on Gilbert and

Ruddigore 1964. *Right* Joy Batchelor's hour-long adaptation of the Gilbert & Sullivan operetta brought together Dufy-like design with the performance of the D'Oyle Carte Opera Company and the music of the London Philharmonic Orchestra, successfully making the work of contemporary relevance, and achieving another 'first' for the studio in producing an animated opera.

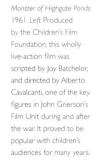

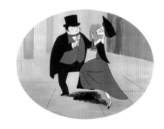

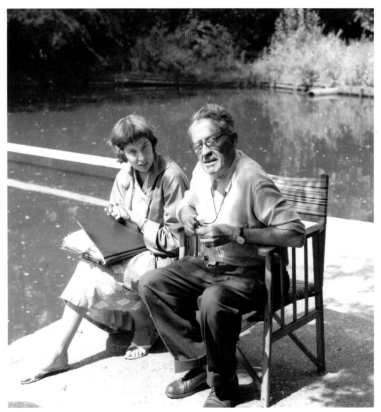

Monster of Highgate Ponds 1961. *Left* Produced by the Children's Film Foundation, this wholly live-action film was scripted by Joy Batchelor, and directed by Alberto Cavalcanti, one of the key figures in John Grierson's Film Unit during and after the war. It proved to be popular with children's audiences for many years.

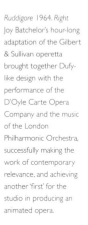

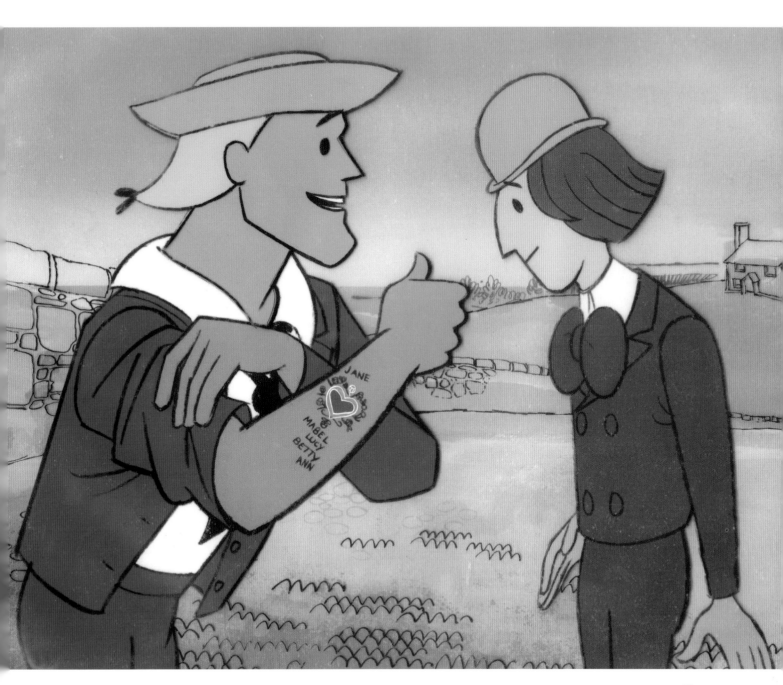

Sullivan's comic opera *Ruddigore* (1964), sponsored by the Westinghouse Broadcasting Corporation of New York, and made with the assistance of the voices of the D'Oyle Carte Opera Company with the music played by the London Philharmonic Orchestra. This was only made possible by the impending release of the operas from copyright, which permitted much freer and more experimental forms of production than had hitherto been the case. The animation, and in particular the choreography of the chorus, was highly stylised.

Concept Films 1961-69. Harold Macmillan, Prime Minister from 1957 to 1963, discussing the educational series for schools.

The other principal productions of the 1960s were educational – indeed, education was by now John Halas' primary interest. Longmans, the publishers, sponsored two series of language-teaching films – *The Carters of Greenwood* (English) and *Martian in Moscow* (Russian), each series consisting of 12 four-minute films. Macmillan in turn sponsored 12 twelve-minute films for teaching French, *Les Aventures de la Famille Carré*, while McGraw-Hill promoted eight twelve-minute films on the *Evolution of Life* (1964); the latter, like those made by the unit for BP, have a schematic stylisation in graphic design which combines clarity of exposition with beauty of composition and use of colour. Other informational films developing John Halas' special talent for graphic exposition were *Wonder of Wool* (1961) made for the International Wool Secretariat, with finely designed animation showing the growth and chemical nature of the wool fibre, and the scientific film, *Linear Programming, Matrices and Topology* (1966) (on the science of shapes), designed and directed by Harold Whitaker, who was also responsible for a spoof educational film, *Flow Diagram* (1966), on what is in effect a time and motion study of the processes involved in bathing a dog. Also, at the close of the 1960s, a series of films on mathematics, including *Functions and Relations* (1968), were produced in cooperation with the distinguished mathematician, Patrick Murphy; these were animated by Harold Whitaker to storyboards drawn up by Stan Hayward, who also directed a two-reel film, *What is a Computer?* (1967), showing the evolution of calculation from the abacus to the data-storing computer, and scripted Tony Guy's equally lucid film about the history of weights and measures, *Measure of Man* (1969). To this period, too, belong two of Joy Batchelor's best informational films, *The Commonwealth* (1967) and *The Colombo Plan* (1967), both made for the Central Office of Information.

Wonder of Wool 1960. Scripted by Halas and Batchelor's eventual historian, and a frequent writing collaborator of Halas, Roger Manvell, this film demonstrated the uses and properties of wool. It was sponsored by the International Wool Secretariat.

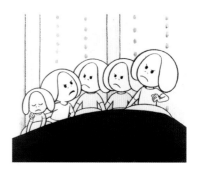

The Five 1970. Joy Batchelor's film about foot care and sensible shoe purchase for children, sponsored by the British Medical Association.

During the early 1960s, a new organisation, the Educational Film Centre (EFC), was established in association with Halas and Batchelor at the

Evolution of Life 1964. McGraw-Hill sponsored eight 12-minute films, including *Origins of Rocks and Mountains*, *Life in the Early Seas*, *The Coming of Man* and *The Age of Dinosaurs*, principally made by Stuart Wynn Jones, Brian Borthwick and Bob Privett, who once again showed their expertise in creating graphically stylised and diagrammatic animation to facilitate complex ideas in a simple and direct fashion. Halas believed that the animated form was especially helpful in the presentation of this material.

What is a Computer ? 1967. Seriously neglected for its participation in the early debates and developments in, and about, computers and computer animation, the Halas and Batchelor studio made this history of computers and computing in 1967, featuring computer animation by Tony Pritchett. It was scripted and directed by Stan Hayward, one of Halas' major collaborators in this area of interest.

Linear Programming, Topology and Flow Diagram 1966. Designed, directed and animated by Harold Whitaker, with scripts by Stan Hayward, and mathematicians, Patrick Murphy and Trevor Fletcher, these films looked at shapes and aspects of geometry. The latter, was a parody of an educational film about bathing a dog in strict time and motion.

suggestion of the educationalist, Maurice Goldsmith; the initial directors also included Lord Snow (C.P. Snow) and Roger Manvell, who was at that time working on research and scriptwriting for the unit. The Centre's primary interest at this stage was the so-called 'Concept film', brief 8mm silent film loops contained in cassettes and designed to illustrate in colour specific points in scientific and technological textbooks which were written with teachers in mind, providing immediate classroom animated illustration as and when required. With the backing of Technicolor, which was interested not only in marketing the films but in selling the very inexpensive miniature projectors needed for demonstration, some 200-loop films on biology, mathematics and general science were produced between 1961 and 1969, under the direction of Brian Borthwick and the sponsorship of the publishers, Macmillan and Longmans. The idea of the concept film was excellent for its period, but its function in the classroom has now been superseded by other media. The EFC also sponsored in 1967 two one-reel films on elementary sex education for schoolgirls, *Girls Growing Up* (1967) and *Mothers and Fathers* (1967), scripted and designed by Dorothy Dallas.

Meanwhile, Harold Whitaker, veteran animator of Halas and Batchelor films, animated C. Northcote Parkinson's well-known *Parkinson's Law - How Not to Succeed in Business* (1975) with caricature graphics and minimal background suggestions by Mel Calman. Joy Batchelor directed

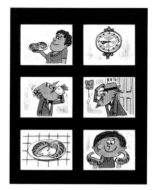

Les Aventures de La Famille Carré 1964. The Macmillan Company sponsored twelve 12-minute films, featuring the Carré family, for the purposes of French language teaching in secondary schools. Animated by Derek Lamb, later a renowned figure in the field, the narratives, scripted by Gerald Fleming, were based on small scale situations and concentrated on developing vocabulary.

The Question 1967. Storyboarded by witty scriptwriter, Stan Hayward, *The Question* is based on the core philosophical question of what can bring meaning and purpose to existence, suggesting that while religion, politics, art, science, money, self-knowledge and power may offer the solution, it is only love which gives true fulfilment. This is graphically achieved through two question marks owned by a man and a women coming together as a heart. It was scored by Jack King, who also worked on sound and effects in the studio.

Lone Ranger 1966-67. Thirty seven episodes were made for CBS about the classic western figure. Designed by Jules Engel and Tom Bailley.

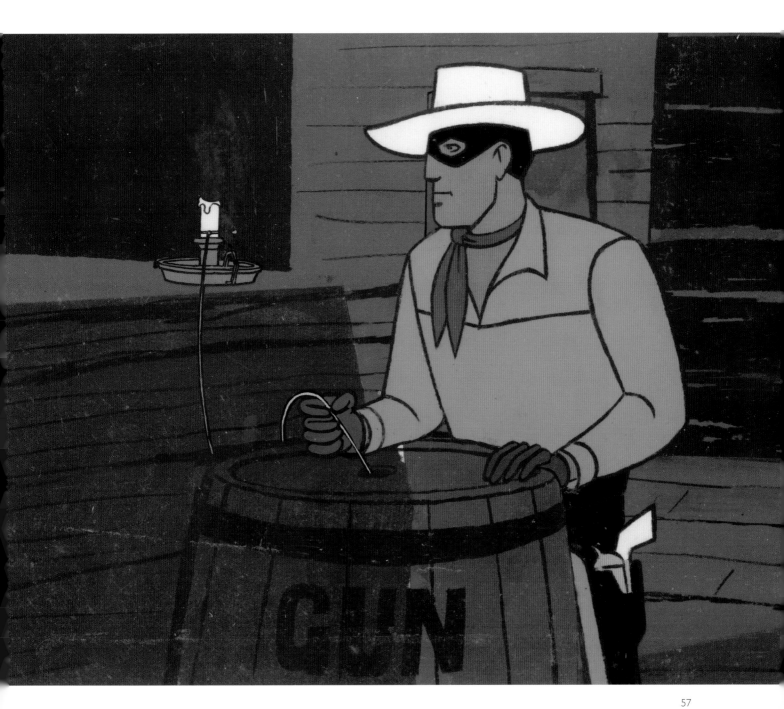

Wot Dot (1970), an educational film on visual perception for children and her film for the British Medical Association on care of the feet and buying shoes for young girls, *The Five* (1970), as well as John Halas' film based on children's art, *Children and Cars* (1971), showing their ideas of what cars may look like in the future - a corollary to *Automania 2000*.

Towards the close of the 1960s, John Halas and Joy Batchelor decided that they wanted to concentrate virtually entirely on educational and informational work, and as a result sold the company that bore their names to the British regional TV company, Tyne Tees. The work of the next few

The Jackson Five 1972. During the period when the Halas & Batchelor studio had been temporarily sold to Tyne Tees Television there were commissions from the US. *Tomfoolery* was sponsored by Rankin & Bass, and *The Addams Family*, *The Jackson Five* and *The Osmonds* were funded by Hanna Barbera.

How Not to Succeed in Business 1975. An animation by Harold Whitaker of Mel Calman's illustrations for C. Northcote Parkinson's *Parkinson's Law*, a popular and amusing publication in the mid 1970s, cautioning against bureaucratisation and over administration in business.

Children and Cars 1971. Sponsored by British Petroleum, and based on the winning drawings submitted by children for a competition, the film explored imaginative - and often ecologically friendly - notions of the car of the future.

Max and Moritz 1976-78. *Left and below*
A full length work, of seven stories, based on Wilhelm Busch's classic narrative. Produced by John Halas and Hans Adolph Seeberg, directed by John Halas and designed by Paul Shardlow. Animation, Harold Whitaker, Brian Larkin, Graham Ralph, Terry Harrison and Phil Robinson.

Wilhelm Busch Album 1978. Having completed the Max and Moritz mini-feature, the studio produced 13 three-minute films based on Busch stories, directed by Brian Larkin, Graham Ralph and Bob Godfrey. Like the longer narrative, they were designed by Paul Shardlow, and produced by the EFC and Polymedia.

Butterfly Ball 1974. Directed by Lee Mishkin, and based on the scripts and designs of Alan Aldridge, who shot to fame as the illustrator of The Beatles' lyrics during the 'swinging sixties'. Aldridge's original book, *The Butterfly Ball*, had been inspired by reading that John Tenniel had told Lewis Carroll, when illustrating *Alice in Wonderland*, that it was 'impossible to draw a wasp in a wig'. The film was animated by Harold Whitaker and Nick Spargo - later the creator of *Willo the Wisp* - and remains a cult classic.

Max and Moritz

Wilhelm Busch Album

Max and Moritz

Wilhelm Busch Album

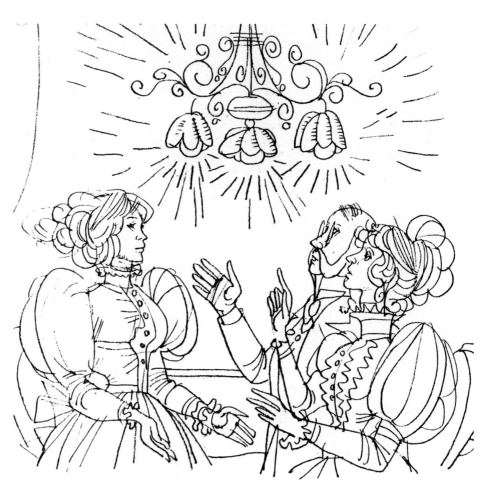

Contact 1973. Designed by Janos Kass with music composed by Andras Ranki. The film received several major prizes in Europe and the USA.

Flurina 1970. Based on the Alois Carigiets' designs with a script by Selina Chonz, Halas and Batchelor, together with Condar Films, produced this film about a girl and her pet for the Swiss Tourist Board.

Together for Children 1979. One of the many films that Halas and Batchelor made for UNESCO.

years bearing the Halas and Batchelor hallmark concentrated on the production of TV entertainment sponsored largely by American companies such as Hanna & Barbera, Rankin & Bass, CBC and NBC – this accounts for the company's association during the 1970s with the TV series, *Tom Foolery* (1970), *The Addams Family* (1972), *The Jackson Five* (1972) and *The Osmonds* (1973). John Halas and Joy Batchelor, moving to other premises, took over EFC as their main charge and concentrated on educational and the more prestigious type of public relations films. One of them was the film *Contact* (1973), sponsored by Compagnie Générale d'Electricité in France for its 75th Anniversary. The film traced back the history of electricity up to the latest developments of transistors and computers. The style of the production was reminiscent of the BP documentary cartoons, but stylistically more advanced. Janos Kass, the outstanding Hungarian artist, co-operated in designing the characters and the backgrounds. *Contact* was scripted by Pierre Braillard and Joy Batchelor, with John Halas and Joy Batchelor directing. The film won a number of important international awards and was released both in the cinemas and on TV. In the mid-1970s, however, John Halas and Joy Batchelor decided, in agreement with Tyne Tees (which had by then merged with Yorkshire TV), to re-purchase their old company and moved back again into their original London studio in Kean Street, Drury Lane, which had housed the unit since 1966 when they had moved there from Soho Square.

Tom Foolery 1974. One of several sponsored TV series for the USA, 17 half-hour episodes of *Tom Foolery* were designed by Paul Shardlow and Geoff Dunbar.

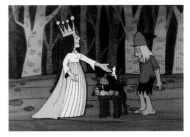

European Folk Tales 1974. As part of an international collaboration of 20 nations, the studio made two traditional tales, *Christmas Feast* and *The Ass and the Stick*, as a contribution to the 39 that were produced.

The Ass and the Stick

Christmas Feast

By the 1970s, John Halas was already devoting considerable time to international commitments; he served on many international film festival juries, and attended conferences and festivals specialising in animation. In 1970 he had become President of the International Council of Graphic Design Associations (ICOGRADA) - for which he had made the film Icograda Congress in 1966 – and eventually in 1975, became President of the International Animated Film Association (ASIFA). The unit's subsidiary studio at Stroud in Gloucestershire became not only a centre for production under Harold Whitaker, but a centre for apprenticeship and training in animation. The unit, prior to John Halas' return to Kean Street, made *Butterfly Ball* (1974); this short film, produced by Jack King, directed by Lee Mishkin and designed by Alan Aldridge, used pop music in the idiom of The Beatles to match the animation of fantasy insects and animals executed in primary colours. A snail and a butterfly dance together, a frog sings, and in the grand finale at night, insects gather to dance in a green glade. The British Federation of Film Societies chose this as the best short of 1974. Meanwhile, John Halas assisted on certain longer projects, notably seven films in the *Max and Moritz* series (1976), produced jointly with Polymedia, Germany, and other international feature length products, *The Twelve Tasks of Asterix* (1973) (a co-production with France), *The Glorious Musketeers* (1973) (Italy), a series of 13 films derived from Wilhelm Busch's classic tales (in co-production with West Germany), and *Ten for Survival*, a one-hour film made for UNICEF (Italy)

in support of the International Year of the Child. Other co-productions were the *European Folk Tales* series (1974) (also with Italy) – 12-minute films derived from traditional stories from different national sources, such as *Christmas Feast* (a Scottish fairy tale) and *The Ass and the Stick* (an English tale), both scripted and directed by John Halas and Joy Batchelor. A co-production with the British animator Bob Godfrey and Zagreb Film was the delightful *Dream Doll* (1979), a caricature of the sexual frustrations of a so-called man in the street, haunted wherever he goes by the creation of his dreams, a life-size inflatable nude doll.

Players 1983. *Right*
Two tennis finalists confront each other in this eight-minute surreal satire on aggression. Directed and produced by John Halas, the script and design were by Peter Sís with animation by Chris Fenna and Roger Mainwood. Jiří Stívín composed the music and the film won the special Jury prize at the Montreal World Animation Festival in 1982.

Dilemma 1981. *Left*
The last of Halas' more philosophically driven films, posing the question of whether humankind will use science and technology for the good of the planet or to its more destructive and negative ends. Arguably, the first fully digitally produced film, created in collaboration with Jim Lindner at Computer Creations in Indiana, and featuring animation by Eric Brown, Shaun Reynolds and Kathy Levy. Storyboard and design, Janos Kass.

Dream Doll 1979. *Right*
A collaboration between Bob Godfrey and Zlatko Grgic, *Dream Doll* is a surreal fantasy about a man's infatuation for a blow-up sex toy, which has tragi-comic overtones. Produced by Halas and Batchelor in a co-production with Godfrey and Zagreb film.

The Great Masters 1984
A series embracing
three great artists,
bringing their work to
contemporary audiences
through animation. *Above*
Leonardo da Vinci, drawn
and designed by Janos
Kass.

Other graphic experiments for fun included *Skyrider* (1976), with Thurber-like line drawings for a fantasy of space travel in a dream, and *Autobahn* (1979), with semi-abstract animation by Roger Mainwood - space imagery again, introducing gliding faces and figures, isolated mouths and a bald, nude spaceman, all flowing with a hypnotic, rhythmic progression. During Spring 1979, the unit formed a special department to create a series of comics with the characters of Sport Billy and Sport Susy and established a partnership with Sport Billy's promotional company to develop characters worldwide. Following a series of *Bible Stories* in 1980, Halas worked on *Dilemma* (1981), which he described as 'the most important film of my life', and which was completely digitally produced. Another personal film, *Players* (1983), followed, before Halas committed to three series which exemplify the studio's commitment to art - *The Great Masters* (1984-86); animation - *The Masters of Animation* (1987); and *Europe - Know Your Europeans* (1995) made after Joy Batchelor's death in 1991. Only Bob Godfrey's witty critique of the UK was made in the latter series before John Halas sadly died in 1995. These late projects - along with *A Memory of Moholy-Nagy* (1990) - acknowledge the influences upon the work of Halas and Batchelor, and signal, too, that even in its later years the studio maintained its integrity and belief in the form as a progressive, singularly 'modern' tool in the education and entertainment of a global audience.

References

1. See Barrier, M. *Hollywood Cartoons: American Animation in the Golden Age*, New York & Oxford: OUP, 1999; Cabarga, L. *The Fleischer Story*, New York: Da Capo, 1988; Canemaker, J. Felix: *The Twisted Tale of the World's Most Famous Cat*, New York: Da Capo, 1991; Crafton, D. *Before Mickey: The Animated Film 1898-1928*, Chicago: University of Chicago Press, 1993; Klein, N. *Seven Minutes: The Life and Death of the American Cartoon* (New York: Verso, 1993). Mark Langer has written widely on the Fleischer studio in a variety of journals and his definitive history is published shortly.

2. See Halas, J. & Manvell, R., *The Technique of Film Animation*, London: Focal Press (revised edition 1978), p. 249.

3. For the special problems and opportunities involved in filming entirely from artwork conceived as basically still see *ibid*., 1978, Chapter 4.

4. See the elaborate charting of the recorded score as a guide to the animated action, and Seiber's comments, *ibid*., 1978, pp. 250-1.

5. *Ibid*., 1978, p. 307.

6. Considerable research has been undertaken about this issue, principally by Karl Cohen and Dan Leab. See Appendix One for an article by Karl Cohen on *Animal Farm* and Appendix Two for an extract from Dan Leab's book *Orwell Subverted; the CIA and the filming of Animal Farm*, 2006.

7. The unit also produced two films derived from the BBC Toytown programmes – *The Showing Up of Larry the Lamb* and *The Tale of the Magician*, both directed by Harold Whitaker.

A Memory of Moholy-Nagy 1990. *Left* Halas' finaltribute to his great influence and mentor, including state-of-the-art motion graphics. The film combines drawn animation with models and photographs, using computers to reveal the many facets of László Moholy-Nagy, whose work epitomised the Bauhaus movement in Europe. Computer animation by Tamas Waliczky.

Know Your Europeans 1995. *Right* John Halas persuaded Bob Godfrey to make this satirical romp about the British as part of what was to have been a 12-part series in celebration of the European Union. Only Godfrey's film and the German contribution by Christoph Simon, a surreal virtuoso where Bach crashes his Volkswagen Beetle into the Berlin Wall, were ever completed before John died in January 1995 and the funding ran out. The other films were to have been made by Michel Ocelot, Petra Dolman and Bruno Bossetto amongst others.

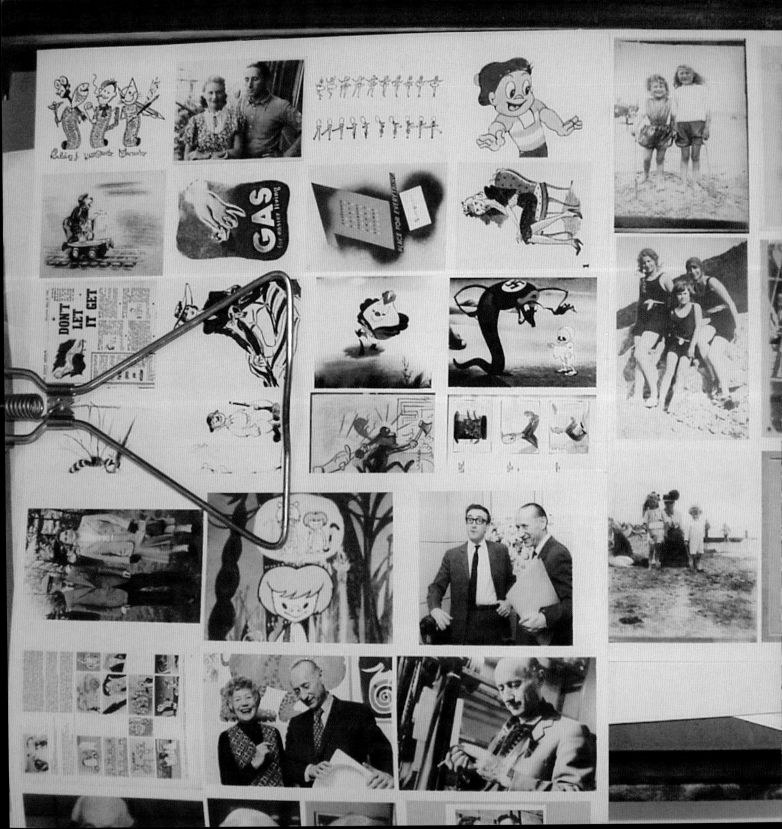

My family and other animators

A Personal Memoir by Vivien Halas

The memoir that follows is based on my own recollections, the personal papers of my mother and father, the materials of the Halas and Batchelor Collection, and research I have undertaken in a spirit of getting to know my parents better, and to understand how their lives became dedicated to their art. My parents' differing backgrounds provide a genuine context for their individual perspectives, and offer reasons for why they were later able to share both a personal and artistic outlook.

John Halas 1912-1995

My father hardly ever spoke about his childhood. The rare times he told us stories, of how he had lived with the gypsies, became a soccer champion at two years old and that his best memories were of living with his eldest brother under the bridges in Paris sharing stale bread and red wine with tramps, my mother would tell us it was all pure fantasy. There was not much to go on; that is until after my mother died, when he started dictating his memoirs.[1] No doubt they are in large part unreliable, but they are his story and how he decided to tell things at that point in his life. Where possible, I have checked places, documents and letters so that his memories tally with historical and geographical fact. While clearing out the family house after his death I also found a folder of my mother's personal recollections. The two points of view are intertwined.

Janos Halász was born in Budapest in 1912, the seventh and youngest son of a Jewish mother and a Jesuit father. This was no paradox. Around the time that my grandfather, Gyözö Halász, was born in the mid 1800s, Hungary was part of the Austro-Hungarian Empire and Catholic. The Minister of Education had issued a decree, the *Wegtaufung* or 'Baptism away from the other side' that required children of other faiths to be baptised Catholic. The priest would subsequently send the birth certificate to the minister of the other denomination; in this case the Rabbi. So although Gyözö was Jewish, he was brought up as a Catholic with a Jesuit education and aspirations of becoming a writer.

The decree was short lived and in 1895 the Jewish religion was officially accepted. Consequently, a prosperous and cultured Jewish community developed in Budapest and by the time Joseph was a young man it was an important centre for journalism. The first Jewish Hungarian newspaper was the weekly *Magyar Izraelita*. Jews also assumed an important role in the founding and editing of leading newspapers in Hungary, for example the journal *Nyugat* (1908-1941).[2]

Above A document attesting that in May 1932 John lived in Beniczky utca 3, 1st floor, 8, Budapest, VIII. He was born in 1912 in Pesterzsébet (at the time a village but now the XXth district of the capital). Father, Gyözö Halász, mother Berta Singer. The paper states that he is an artist, not married and of the Jewish religion.

Left Budapest, view from Buda over the Danube.

Far right Gyözö Halász As a young man Gyözö changed his name from the German, Fischer, to Halasz to be more easily accepted in Hungary.

Right Gyözö Halász in middle age.

This gave Gyözö a good start and he was able to become a writer and journalist in a period of relative stability and expansion when the Jewish contribution to industrialisation, art and literature was seen as positive.

He met John's mother, Berta Singer, in Vienna where, according to my father, she was a 'prima ballerina' of great beauty. However, John's eldest brother, Ladislaus (Ladis), who was 14 by the time John was born, told me that in fact she had been a chorus girl in a Variety show. Both agreed that their mother came from a much 'better' family than the Halász' and that Berta and her elder sister Louise had been society girls in Vienna during the 1890s, the Vienna of the Succession of Sigmund Freud and Gustave Klimt. Berta married Joseph, exchanging her career in Vienna for motherhood in a small town near the Black Sea where Gyözö taught the Hungarian language, literature and economics. According to my uncle Ladis, Berta felt isolated and missed the buzz of city life with its coffee house culture, so they moved to Budapest.

Berta (Singer) and Gyözö Halász around 1935.

Early twentieth-century Budapest was a cosmopolitan, cultural centre that was considered more beautiful than Vienna and more chic than Paris. Gyözö found a more prestigious job as a journalist on the morning newspaper, *Pesti Hirlap*, that enabled them to move into a first floor flat in a

middle class part of town. By now they had six sons and Berta longed for a daughter to help her at home and for some female company. When yet another boy, my father, arrived she dressed him in girls' gowns and proudly showed him off to her girlfriends in the coffee houses while his father won bets as to which sex John was. My mother had a theory that all the attention, along with his being the youngest child, was responsible for his sense of self-importance. Johns' star status was short lived, however, lasting only until he was two years old, in 1914.

Ladis was a keen sportsman. He belonged to a rowing club in Budapest on the Danube, and later in Paris on the Seine.

From middle class to lower class

The outbreak of the First World War changed everything. The Austro-Hungarian Empire collapsed. The situation in Hungary became unstable and in 1920 with the Treaty of Trianon, it lost two-thirds of its territory. Everyone suffered as a result. In 1918 and 1919 two revolutions and a Rumanian invasion brought severe social and political turmoil, rekindling anti-Semitic policies. From a tolerant society that fostered the arts, there was a general clamp-down that led to particular hardships and deprivations for Jews, however secular. In November 1919 Admiral Horthy entered Budapest to clear out communist revolutionaries who had led the 'Red Terror'. He purged the country and restored order in what became known as the 'White Terror'. As a result, Jewish officials in the army and government were dismissed; Jews were forbidden to trade in wine or tobacco, certain universities and scientific institutions were closed to them and many were forced to leave the city. [3]

The Halász family was no exception and faced with this prejudice they had to move out of the centre of town. Gyözö lost his job and was considered lucky to find a less well-paid one editing the small ads on the evening paper, *As Ez*. Ladis, the eldest son, who was regarded in the family as the most resourceful, found work as a mechanic in an aircraft factory in Pest Erzat, a poor suburb on the outskirts of town near the airport. The job offered more money than his father could earn as well as an engineering apprenticeship, so they all moved to a small house next to the factory. It was common to house several families in small single-storey houses, made from the traditional materials of wattle and daub, so there would have been nothing unusual about the cramped conditions that my father remembered and wished to escape from.

Away with the gypsies

John's earliest memory is of hunger, fear and running away into the woods opposite the house. 'It was a very small house with three rooms between two large families. There was one entrance so everyone had to walk through our part. My mattress was under a big table, the most precious family possession. Only my parents had a real bed whilst the other brothers had to fit in round the rest of the furniture... One evening I crept away into the woods to explore. My father told me that they sent a search party out for me but I had disappeared like smoke... I was missing for two weeks. I was found by a travelling group of gypsies who took me in... How warm and comfortable it was, so much better than home... My father put an advertisement in his newspaper offering a reward for finding me so I was eventually returned. My sentimental relationship with gypsies has never changed. I feel a special kind of brotherhood with them and their aspirations for free movement. My appetite for foreign travel must have been motivated at that tender age.'

This idea was reinforced when, aged three, his mother, took him with her to Vienna to visit his grandmother, the family matriarch and 'wise woman'. A family council had been called because Berta's sister, Theresa, who had married a Swiss, had no children whilst Berta had too many to feed. My great grandmother decided that Berta should give one of her

Decorated ginger biscuit from Transdanubia. Folk art penetrated middle class taste and was integrated into Hungarian mainstream design in the early 1900s.

A typical Hungarian bread oven. Traditional dress like this could still be seen in the countryside when I first visited Hungary in 1947 and saw the women carrying geese to market in big baskets balanced on their heads along the shores of Lake Balaton.

sons to her sister to be brought up in Switzerland where there would be plenty of food. John's brother Joseph was chosen.

Although the Singer family was considered well off, food was also scarce in Vienna and by the time Berta and John were ready to go back to Budapest, to collect Joseph, they were starving. 'After a month in Vienna I was homesick, I was getting even thinner and didn't like my Austrian cousins. The only uplifting memory was meeting my uncle who was a footballer and to me a great hero. He told me that you must never give up in a fight and be quicker than anyone else. I adopted his formula and have found it very useful to this day.' Berta took John, still too small to be left alone, with Joseph to Zurich; Joseph for a new life and John to be fattened up by their aunt and uncle.

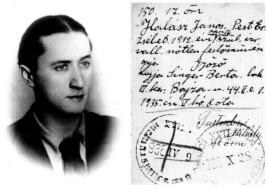

Front and back of John's passport photo in 1935.

John does not mention the return to Budapest or the war years but said, 'After the war things became progressively worse, my Viennese grandmother came to visit and was horrified to see children so thin. She made arrangements for me and my brother Antal to be taken by the Red Cross to Switzerland for safety and to get proper nourishment with our aunt and uncle. The train journey seemed endless; we had nothing to eat for over 24 hours until at last after many delays we reached the Swiss border and a group of Red Cross nurses boarded the train feeding us mugs of hot chocolate. I have never forgotten its sensational taste. For the remaining two hours of the journey we thought we were in heaven, being continuously fed by angels. The gastronomic experience continued throughout our stay. Local Swiss people came to visit my aunt and uncle to see the little Hungarian boys, bringing them gifts, boxes of chocolate and sweets. I was greedy and got into the habit of grabbing the whole box so, unlike my more polite brothers, I suffered with dreadful stomach pains.'

This idyll went on for seven months, enough time for John to pick up Swiss German and nearly forget his Hungarian. While in Switzerland, Antal became an expert chess player and was invited to stay longer for a championship match so John was sent home alone under Red Cross care.

Max and Moritz. As a child John would have been familiar with this troublesome pair created by the German cartoonist and satirist Wilhelm Busch.

He would have been about six or seven and remembered the traumatic journey as once again the train was held up. 'Fighting flared up between the Austro-Hungarians and the anti-Hapsburg Communists. As we travelled through Austria we were in the centre of a battle. For days the train was decked with Red Cross flags and signs and we were told to hide under our seats since some of the passengers were military Communists. At some points of the journey we could hear gunfire, terrible things were happening around us but to me as a small child it looked more like a chaotic circus act. I am ashamed to say that I was more upset that in the four days it took to get home I lost all our Swiss gifts. Worse still, my mother was not at the station, or that's what I thought until I noticed a group of railway officials clustering around a weeping woman at the far end of the platform. It was my mother, she had not recognised me as I got off the train and panicked. I tugged at her skirts but it took some time for her to see that it was me because I was no longer the skinny little boy she had dispatched seven months earlier. Once she realised she cried even more.' From this experience my father realised once again that away was better and to beware of too much emotion. He had to learn Hungarian again and found school difficult. He does not record the rest of his childhood other than to tell how he and a friend spent their time like the two truant rascals in *Max and Moritz* selling balloons and matches, dodging the skirmishes, by hiding in churches and under cinema seats, not just for safety but as a way to see films for free.

First job at Hunnia Film

John started working as soon as he could. A firm believer in searching the small ads, he found a job at a film studio where he had to paint 1,000 small wooden rats for a German promotional film, *The Red Rats*. He then found a job copying film posters on to hoardings outside cinemas. He found that he had a natural talent for drawing but his debut as an artist ended quickly as the police stopped him for obstructing traffic.

John first learnt the craft of film with George Pal at the Hunnia film studio. 'I learnt the mechanics of making an object move'. Hunnia Films made subtitles for silent films; to make them more attractive Pal illustrated them with cartoons, which he then animated. John was Pal's assistant, helping with the animation that they both learnt as they worked. They could see American cartoons like *Felix the Cat* and *Oswald the Rabbit*, and Pal had met George Field, another Hungarian who had worked in

Hollywood as a film editor. He told Pal how animation was done. There were no books on the subject at the time so they had to invent their own registration and pins. Soon Pal found work in Germany where he developed the idea of moving real cigarettes for an ad that in turn led to Pal developing his famous Puppetoons.[4]

With George gone, John also left Hunnia; the pay was poor with no prospects, so when he saw another ad in his father's newspaper for an assistant to an artist / animator in Paris he felt his moment had come at last, added to which by now Ladis was living in Paris working as an engineer. Unfortunately the new employer turned out to be a gay salami salesman who wanted John as a companion and window dresser. Ladis was away in Algeria on an engineering project so John found himself alone, unable to speak French and with no money. But he had made it to Paris and ever resourceful he decided to look up every Hungarian restaurant until he found one that gave him sign-writing work in exchange for food. 'There I met a regular customer; a young designer who offered me work in his sign-writing studio. It was little more than a sweatshop but it enabled me to stay in Paris for nine months.' Poor but enthusiastic, John was soaking in the atmosphere of the city and meeting other designers and artists of the time.

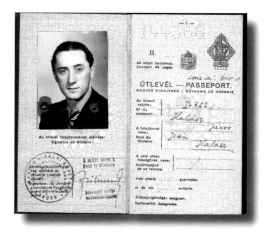

1937. Hungarian passport photograph of Halász János for his first visit to England.

While I have been able to verify John's story to this point, I can find no evidence for the claim, suggested in his obituaries, that he studied at the Beaux Arts. It seems to me that my father often played out a kind of wish fulfilment in the way he sometimes talked about his life. John not only inherited the Jewish tradition, or perhaps his father's attitude, of scepticism and resistance to authority, but also a certain capacity for rising above reality. He was constantly reconstructing a persona and a place for himself in a chaotic world that was trying to destroy him and his kind. Along with many middle Europeans who escaped from fascism he had an innate optimism that defied failure. Certainly whenever I asked him about the past he told me that his only interest was in the future.

John's worried parents sent him a train ticket back to Budapest but he could settle to nothing and rushed back to Paris within a few months. His former employer promised him a better job but by the time he arrived back in Paris it was too late, the studio was boarded up and he was told his boss had left the country. Undaunted, John recalled 'This time, with greater confidence and a little French, I knew I would survive, and I did. I

met a talented Rumanian poster designer, Popescu, who offered me work in his studio as his assistant on his posters and brochures for the big department store, 'Printemps'. He pinpointed my shortcomings in graphic design and I realised how much I must learn if I wanted to become a graphic artist. While he was away, for two weeks, I also managed to meet and assist Alexander Alexeieff, who made *Night on Bald Mountain* (1934). He disliked my film work but took me in and I learnt the value of tone from him while Popescu taught me technical skills in handling paints and paper. It was a pity that Popescu decided to return to Bucharest, but the time spent with these two artists made my time in Paris extremely valuable. Soon after, I too returned with regret to Budapest for the second time that year.'

The Hungarian Bauhaus

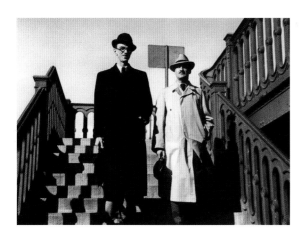

Two associates of the Colortron team, Janos Macskássy, Gyula's elder brother who was a well known poster artist and Isteván Bedö, a copywriter.

Back in Budapest, fired with enthusiasm for design, but unable to afford tuition, John managed to talk his way into the newly formed private art school set up by the eminent poster artist Sandor Bortnyik. He became a lab assistant in return for lessons. Bortnyik had recently left Germany where he taught at the Bauhaus and set up the Muhely atelier in Budapest along the same lines. It became known as the Hungarian Bauhaus. It was John's film and technical experience that convinced Bortnyik to offer him work. Not only did John learn from tutors such as Victor Vasarely and Gyorgy Nemes, but he was able to help with their kinetic experiments. He assisted Moholy-Nagy by sewing together articulated figures for a series of animated experimental films he was working on and so soaked in the Bauhaus ethos. 'I learnt from them construction and how to look behind the surface to solve a problem.'

Halász, Macskássy and Kassowitz 1932-1936

John became friends with two 'real' students at the Muhely, Gyula Macskássy and Felix Kassowitz, and together they set up a small animation studio. 'The partnership of Halász, Macskássy and Kassowitz 1932-1936, while short-lived, made its mark. We became known as the Colortron studio and our unit produced 42 short films both commercial and experimental in four years; among them the first colour animated film in Hungary with the Agfa Bipack system. We worked well together as a team. Gyula Macskássy was a strong animator whilst I was stronger in

halász j. *kassowitz* *Macskássy*

technique; we were equals as graphic artists. Neither of us felt able to write scripts. For this we asked Felix Kassowitz, a well-known cartoonist, to join us. During that time we made a film test based on Liszt's Hungarian Rhapsodies. Macskássy with his usual generosity encouraged me to make this two-minute colour test on my own while he got on with more commercial projects. Although the test lacked polish, with the strength of Liszt's music it appeared to succeed because it attracted the attention of a group of backers in London.'

The group, British Colour Cartoons Limited,[5] offered John a contact to make four advertising films and two entertainment films a year. The first film was to be based on the life of Hans Christian Andersen. So he moved to London to set up a studio and the first thing he did was advertise for animators. This was how he met my mother.

'I advertised in the *Daily Telegraph* and out of all the applications there was one that caught my eye. It was from a Joy Batchelor who claimed to have experience as an animator. A test revealed that she was excellent, better than anyone I had met before.' Joy said, 'We met in a crowded room but it was crowded with animation tables littered with drawings, for this was no social event but an interview. To this day I don't know what, if anything, John Halas felt or thought at that first encounter, but I was hired, and fired some months later when the animation was finished.

Left 1932-35. *Nikotex* The logo is used here on the front credits to a two-minute ad for Nikotex cigarettes. Much of the studio's work echoed popular Hungarian folk art such as this heart found traditional decorated spice cakes. The ad tells the story of two children dressed in folkl costume who are entrusted by two scientists with a very special cigarette like no other, to take to the king.

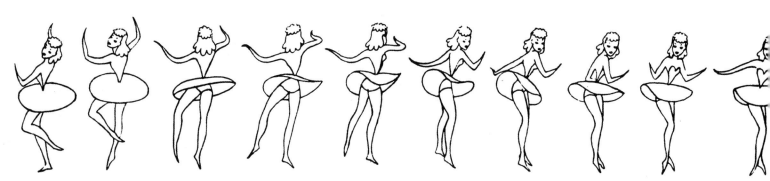

During those months we learnt to work together and we learnt from each other. It wasn't just that John was a single-minded character. He loved animation.'

Music Man 1938. The style is very similar to that of the Nikotex ad, showing no real signs of my mother's visual influence. The script was written by a fellow Hungarian, Imre Hajdu, who later became well known as an animator in France as 'Jean Image'. It was thanks to this rather weak story that my mother decided that she could do much better and became a script writer as well as designing and animating.

For the next proposed production, John hired Joy again, 'It was agreed that we produce the film in Budapest as I was already set up there. Joy came with me. The film, which I had seen as an artistic expression of the Hungarian rhapsodies, finished up as *Music Man* (1938), a ten-minute film that ran £280 over budget and was the first completed Technicolor cartoon made in England. The only trace of the original concept was in Liszt's music. It opened at a Newsreel and Cartoon cinema at Charing Cross, London and soon faded out of existence. A well-deserved fate.' In what was to be an important turning point in their working relationship, Joy said, 'Working on the film as animator did not prevent me from observing the film as a whole and commenting on it.' Soon Joy was John's voice; she took over writing the scripts, planning, production, design and selling their services. He had the vision and the Hungarian belief in his own excellence while Joy rewrote and translated what he did, not only in to English, but, crucially, taking into account the British way of life. This is what gave them a unique edge to their work; the émigré energy combined with a sense of 'Britishness'.

Part of the test that Joy did for *The Brave Tin Soldier*. John employed her on the spot.

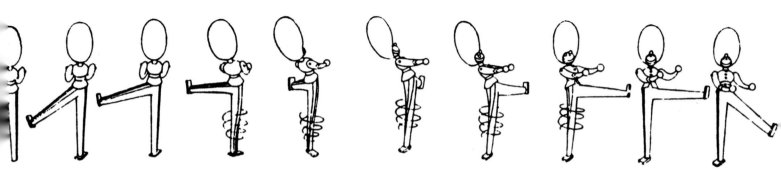

Joy Batchelor 1914-1991

Joy was born in May 1914 barely nine months after my grandparents were married. It was an Edwardian love affair. My grandmother, Ethel Amy Herbert, always told us that she gave up a prestigious job as manager of Northwood Golf Course to marry Edward Joseph Batchelor because she fell in love with his good looks. He was a master lithographer[6] and a craftsman but a disappointment to my grandmother because he was modest, indecisive and without ambition. Joe, as he was known, was the youngest of nine children, 'a true cockney born within the sound of

My mother Joy Batchelor in 1916. As a toddler her mother would punish her for picking flowers in the garden.

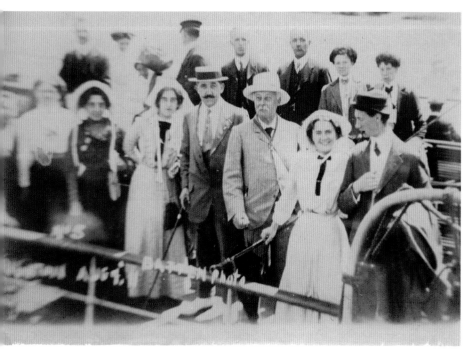

Bow bells'. He had been constantly ill as a child through malnutrition. His mother died at the age of 35 through fatigue and poverty. Unfit for war, he carried on as a lithographer but was enlisted into the home guard as a policeman. My grandmother always said of my grandfather 'creaking gates last longest' and she was right as not only did Joe survive two world wars but outlived Ethel, living well into his nineties. This meant that unlike many children at the time, my mother had a father at home; a father who encouraged her drawing skills by bringing her home long paper off-cuts to draw on. My grandmother was thwarted in her own

Left It was an Edwardian love affair. My grandparents, Ethel Amy Herbert and Edward Joseph Batchelor *front right* on a boat trip prior to their marriage, Ethel having given up her career to get married.

Joy *right* with her brother John who died of diphtheria in 1921.

ambitions and frustrated by her husband's refusal to become a manager. He preferred to remain a craftsman and lithographer, commuting from Watford to John Bale & Danielson Ltd in Clerkenwell. Ethel ran a spotless home in their tiny terraced house next to the sewage works. She was renowned for her wicked tongue and her ability impersonate anyone. She should have continued to work as a manager herself but living in an era when this was not an option, she channelled her ambitions into my mother instead. She insisted that both Joy and her younger sister Barbara worked hard at school to win scholarships or else, she threatened, they would land up in the workhouse.

Joy suffered because she arrived too early in the marriage and her parents had really wanted a boy. Three years later when her brother John was born she felt neglected and jealous; she even wished he would die. He died of diphtheria aged four, just after the birth of Joy's sister Barbara in 1921. Ethel had a nervous breakdown and was hospitalised. Her hair fell out temporarily and she lost the nail of her right thumb, infected while holding open John's mouth to help him breathe as he died. This was a permanent affliction, and fascinated me as she would show it to me and tell me the sad story over and over again. Joy felt guilty and unloved. When her mother came back from hospital she said to a friend in front of Joy, 'If it wasn't for the baby I would have killed myself.'

Joy developed a temporary speech impediment so that all her words came out backwards. Ethel punished Joy for minor crimes such as picking flowers in the garden by locking her in the cupboard under the stairs. Joy pretended that she loved this little cubbyhole and its comforting smells. She told herself stories, developing her sense of fantasy and narrative. It also fuelled her with the wish to escape, shine and be different. Joy won the scholarships that her mother insisted on, coming top in the entire county

1928. Joy *left* with her sister Barbara and her mother Ethel on holiday.

My grandfather was an amateur photographer. He used to show me his old camera and the glass plates he used. His dark room was in the garden shed.

Right Family holidays were taken in Ilfracombe. My mother would show me this photo along with others to tell me about her many admirers.

but what she really wanted was to be an artist. Coming from a family of artisans, her parents encouraged her and consequently Joy went to art school in Watford, again on a scholarship.

An ambitious star pupil

Joy left art school a star pupil. She was offered a place at the Slade School of Art but there was not enough money for her to go, even with a scholarship. She was now trained and expected to work to support the family. Joy wrote, 'My first job was as part of an assembly line turning out ghastly hand-painted calendars and knick-knacks. It was sweated labour and I said so. For this impertinence I was laid off at Christmas! The only other job on offer was in a newly opened animation studio (with an Australian called Dennis Connelly). My first work consisted of in-betweening but within a week I was promoted to animation since I had noticed, and said,

that the characters weren't moving properly. Of course I didn't know how to move them but I found out. It was three years before the firm's money ran out and by that time I was teaching other people and earning more money than my father. On the strength of my vast salary of five guineas a week my mother managed to move to the house she wanted – and now I was out of work. Luckily, I found work in a silkscreen printers as a poster designer. My qualifications were nil but I soon learnt. Six months later, sick of the smell of paint and the attentions of my boss and the foreman, I answered an ad for another new animation studio and here I met John Halász.'

1933. A poster to save the almshouses near the art school in Watford. My grandmother used to warn my mother and aunt that if they didn't get top marks at school they would land up in the 'workhouse'.

1932. Letters and awards from the time show that Joy was a star pupil both at school and at art school in Watford. This gouache and pencil drawing already demonstrates Joy's strong design sense that appears in her later work.

Time in Budapest

My mother remembered their time in Budapest in a romantic daze. She was fêted as the beautiful talented blonde English girl by John's partners who loved her and teased John. They had no money but still managed to enjoy pre-war Budapest which was known for its wonderful restaurants with their obligatory gypsy music, cafés, shops, theatres, galleries and above all its spa pools that were (and still are) the centre of social life. Imagine a place where everyone is famous, everyone doing momentous projects. At last Joy had found an exciting life where she was appreciated for her skills and swept off her feet. Nothing could have been further away from Watford and the regulated lower middle class world that she had sworn to escape from. She was free and bohemian. So when there was suddenly no more money and they couldn't pay anyone it came as a shock. They borrowed the £6 they needed for a third class train ticket from one of John's brothers, Pishta, and managed the four-day journey back on wooden benches with just a few sandwiches also donated by kind friends. The Second World War was looming and fascism was on the rise in Europe.

Back in London they had no work. Joy took their portfolios around the advertising agencies. At first she was the one who kept them going. She got commissions from *Harper's* and *Queen* magazines as well as doing illustrations for the *Daily Mail* and many books. John's old teacher from the Muheley, Lazlo Moholy-Nagy, was in London, also escaping from anti-Semitic fervour in Europe, and was the art director for Simpson's, the department store on Piccadilly. He commissioned John to design several posters and from there other commissions came in from British Gas and Shell.

John wrote *Music Man* which ended in disaster. Back in London, Joy and I had no work so we turned from film to graphic design. I did posters for advertising agencies and clients such as Simpson's and the Gas Board, whilst Joy did fashion illustrations for magazines such as *Harper's* and *Vogue*. Joy took the work around as she could speak English and

John Halas and Joy Batchelor in Budapest in 1938.

Above and right 1938-39. Joy was a regular freelance contributor of fashion illustrations for *Vogue* and *Harper's* magazines as well as the *Daily Mirror* and other newspapers. Many of Joy's illustrations were fillers for articles, comment and advice columns.

Far right 1939. Joy's front cover for *Harper's*.

Far right 1939. Airbrush posters for Gas and Simpson's department store by John Halas. On their return to London in the summer of 1938 John and Joy had no work at all. Joy, being blonde and speaking English, took a portfolio of their work around all the agencies.

Far far right 1939/40. Two speculative posters by John Halas, demonstrating his airbrush technique with female portraits.

was blonde and pretty. It was a difficult time as the war was approaching so companies' budgets were drying up. Then out of nowhere George Pal appeared from Holland where he worked for Philips the electrical giant, making long promotional films for their products. He took us to the advertising agency J. Walter Thompson and there we were introduced to one of the art directors, Alexander Mackendrick. Mackendrick remembered seeing *Music Man* and within a few days we found ourselves part of the team making animated cartoons for their clients.'

That was in 1940. There was now plenty of work but in order to be paid the agency insisted that they form a company and so Halas and Batchelor Cartoon Films was born. That year John was threatened with internment on the Isle of Wight as an enemy alien. He appealed to the Prime Minister on the grounds that his work was important to the war effort, and so it was, as the Ministry of Information took over the studio, taking it away from advertising brands to information and propaganda work.

Joy decided that rather than lose John she would save him and they got married. She was taken aback when to her dismay she was labelled as 'a friendly enemy alien', and both had to adhere to a strict curfew. To cope with the workload, the black-out and the limitations of the curfew, my parents worked at home in their Chelsea flat at night. The neighbours watched this suspicious couple, the dark foreigner and the blonde, blue-eyed girl come back early and heard strange whirrings of a compressor during the night. Sure that this couple were a couple of forgers they called the police, who raided the flat only to find my father airbrushing backgrounds for war effort films. Shortly after, Janos Halász received his official papers to become a British citizen, John Halas.

Wartime propaganda films for the MOI and COI

As war broke out J. Walter Thompson was taken over by the BBC and the Ministry of Information. My mother wrote, 'As bombs showered over London during the early years of the war, the British Ministry of Information turned to two young animators to assist with essential information about how to survive the war. Films were made about growing your own vegetables, saving paper, metal and bones for the war effort and how to protect yourself from enemy spies. We produced 70 propaganda films between 1940 and 1944 with a very small unit working day and night to the point of total exhaustion, under most difficult circumstances: shortage of paper, pencils, film stock and cel materials. Among the most interesting productions were three showing Abu, a small Arab boy with his donkey, constantly being enticed and misguided by Hitler and Mussolini; and a film written by Roger McDougal (*The Mouse that Roared* 1959) entitled *Jungle Warfare* (1943).'

Having settled into their new-found roles and moved to a flat in Cheyne Place, Chelsea, it was subsequently bombed. My mother was buried up to the shoulders in rubble, while my father, being luckier, was standing in a doorway and was protected. They were dug out and treated for shock. Joy was in hospital for some time as her spine was injured and from that time she suffered with back pain, and became gradually more depressive. However, it didn't stop them; they moved out of London near my mother's parents in Watford and opened a studio in Bushey to resume work. By the end of the war they had made over 70 animated films, two of which were feature length.

Just after the Second World War there was a surge of hope. Their work for the government had enabled my parents to establish close links to the decision-makers of the time, such as Stafford Cripps, the austere Prime Minister who urged Britons to tighten their belts and rebuild the country; Beveridge with his Marshall Plan to lower trade tariffs in Europe and rebuild industry; and filmmakers: John Grierson, the grandfather of documentary, Alexander Mackendrick, who made the Ealing comedies, *The Maggie* (1953) and *The Ladykillers* (1955), Sir Arthur Elton, Edgar Anstey, and Dennis Forman, who set up the BFI, to name just a few, encouraged them to feel that their contribution was making a real difference. With the 'Charley' series, featuring Charley Robinson, the little every-

Dustbin Parade 1941. *Above* A ten-minute film shown in all British cinemas, this was one of the first Halas and Batchelor films made for the Ministry of Information. Now Joy and John were working as equal partners with a small team of key animators including Wally Crook, Vera Linnecar and Kathleen (Spud) Houston.

Jungle Warfare 1943. *Below* An eight-minute film to warn of the dangers of Jungle Warfare. The music was by Matyas Seiber, the script was by Roger McDougal, the well-known playwright (*The Mouse that Roared, Gog and Maygog*) who was the cousin of Alexander Mackendrick (*Whisky Galore*) who scripted *Train Trouble*. The design was by both Joy and John for the MOI.

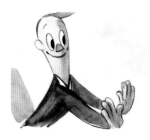

Charley 1947. The main character of the *Robinson Charley* series, designed by Joy, was a recalcitrant everyman devised to explain the new Social Security system. He looks a little like my grandfather who was also very cautious and slow to embrace new ideas.

Joy with a model and drawings of *Charley* in 1948. My mother would let me make patterns in the plasticine townscapes that she made as rough ideas.

man figure, who they created to introduce the principles of the Social Security system, they achieved this. In fact, one of my earliest memories is of watching my mother make a townscape with little people out of plasticine on a low wooden table. She let me poke patterns into the scene with a chunky yellow plastic knitting needle. I was about two and a half and thought it was a game exclusively for me. I realise now that she must have been working on 'Charley'. Although the films were made in traditional cel animation my mother worked out the characters and the topography of his small world with models first.

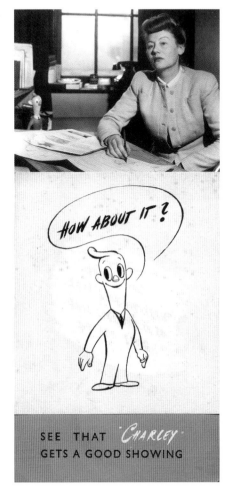

In Dennis Gifford's book on British Animation[7] he listed five Halas and Batchelor films made in 1945, the year I was born, and ten in 1946. My mother worked on most of them at a time when it was considered a woman's duty to stay at home to look after the baby. Bob Godfrey, who had just started work at the only other big studio, W.E. Larkins, told me 'There were loads of women in animation; because of the war all the men had disappeared so the women had to take over. In fact, I thought animation was a woman's job!'

Joy was unusual because she was more than an animator; she was an equal partner with John. As his passport to the English language and British life, he relied on her not only artistically but also as a front woman to sell their work. Joy was a producer and director, writing most of the scripts as well as working on the design and key animation.

To accommodate this, I was packed off to a weekly boarding nursery, only coming home at weekends. Even so, Joy found it very hard to adjust. She

wrote later 'Peace in Europe and our daughter arrived within a few days of each other, as did the Atom bomb; a major upheaval all round. The Halas and Batchelor relationship was no longer fifty-fifty. I was, as one witty friend put it, left literally holding the baby, but by the time our son was born I had learnt to organise a household, fit in visits to the studio to work on scripts and storyboards at 6 o'clock, to pick up where I had left off at any time; to go without enough sleep and to be eternally grateful to my mother.' My grandmother gave up her wartime job at the admiralty, so that she could look after me at least some of the time. This lasted until my brother Paul was born in 1949 and we moved to Hampstead to be closer to the studio in Soho. By then my parents could afford help and we were looked after by a series of au pair girls. My father remained a shadow until I was about five years old and he wanted some children's drawings for some film titles. He asked me to do them; a film now long forgotten. I felt very proud and important; he needed me at last and opened a savings account for me with an amazing £50 fee.

Joy with Paul in 1949. A photo by the émigré photographer W. Suschitzky. By the time Paul was born Joy was managing to look after us, run the house and still design, write and direct the animation.

The studio in the 1950s

When possible, my brother, Paul, and I were taken along with our parents so we often spent our Saturdays at the studio in Soho Square. In those days it only took 15 minutes to drive there from Hampstead. It was possible to park in the square just outside the front door of number 10A. We went up a flight of dark stairs to the studio where we were given paper and crayons and left to our own devices while Joy and John worked. We played in the editing suite, splicing film and whizzing editola machines backwards and forwards. We would splice old bits of film and play films backwards for the sound effect. Sometimes Jack King the sound editor would be there and bark at us through clouds of pipe smoke. Jack King was one of the core members of the studio. He brought the films to life with his sound effects and composed the music for the films when the budget did not stretch to a special score. Also there was the studio manager Bernard Gitter to discuss the workload. Often we would then be taken to see line tests and rushes around the corner in Dean Street at the Crown Cinema. We were not alone as John and Joy used to show the studio team the latest cartoons from America - not Disney - but UPA films such as *Gerald McBoing Boing* (1951), or one with *Mr Magoo*, or more experimental films by Len Lye or Norman McLaren. Afterwards, we were treated to lunch in the fish and chip shop in Berwick Street market or in the New Shanghai restaurant in Wardour Street where we learnt to

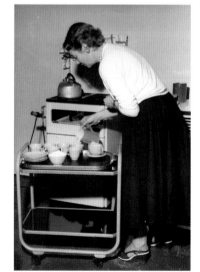

Joy 'making tea' at home for *Woman's Own*.

Overleaf 1952. Magazines such as *Woman's Own* were more interested in the domestic part of Joy's life than her work.

eat with chopsticks. Design, films and food became part of our daily life and our parents working at weekends seemed normal to us; the studio in Soho was as much a home as our real one.

We enjoyed these outings and did not feel neglected but our parents' intense involvement with their work meant that family life was lived in the shadow of the studio. My mother lost her health with severe bouts of sinusitis, chronic bronchitis and pneumonia, so becoming depressive and an alcoholic while attempting to bring the two worlds of home and work together. My brother Paul and I suffered the consequences, living in fear of her dying, as several times she was put on oxygen at home during her bouts of illness. As for my father, most of the time he managed to take no notice of our mother's distress because he was simply too absorbed in his passion for animation.

The early 1950s was a time of post-war reconstruction and a new hope. The notion of men sharing the 'parenting' or even the idea that children needed special attention and nurturing came later when the ideals of social change and the impact of the welfare state gave the British a better standard of living. Paradoxically, my parents were unable to give us their full attention because they were too busy trying to fix the world through animation. Their close links with and work for the government made them feel part of the process of post-war reconstruction, and they fully believed in the socialist dream of a classless society and that 'all animals are equal'. *Animal Farm* (1954) came at the right time for them. During the war John had lost a brother, a sister-in-law and several nephews and nieces in the holocaust. Two other brothers, Ladis and Pishta, had been in the concentration camp of Mathausen. Remarkably, both survived. Another brother, Antal, the chess player, had walked back to Hungary from Russia, having jumped out of a train and lost his toes through frost-bite. So it was no wonder that my father wanted to make a film that 'mattered'. He wrote 'Our theme was "power corrupts". We sharpened the story to show the exploitation of the weak and the consequences of that exploitation. We used Hitler and Mussolini as the basis for the villains.' I once asked my mother what class we belonged to and she told me that we didn't belong to any social class because we were artists!

Above The studio in the 1950s. Jack King *centre* showing early rushes of *Animal Farm*.

Right Pencil sketch of me by Joy in 1947.

Below 1955. Pen and ink drawing by Joy Batchelor from the illustrated edition of *Animal Farm* to mark the first screening of the film in London.

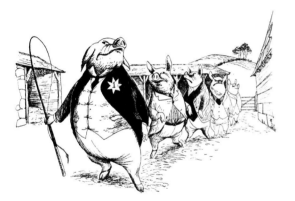

HOME AT

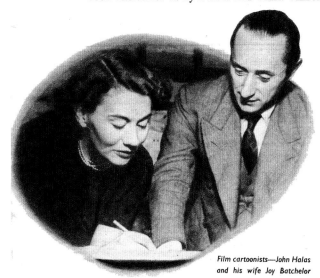

Film cartoonists—John Halas
and his wife Joy Batchelor

The Owl and the Pussy-cat

IN 1951 Mrs. John Halas, who is Joy Batchelor of the Halas and Batchelor Cartoon Film Company, used to take her small children for weekend walks from their Hampstead flat, among the picturesque Georgian houses and the cliff-like Edwardian blocks of flats, up to the Heath for fresh air. Like a lot of people, she was looking for a dream-house with a garden, like them she had stopped being very hopeful. But she used to linger every time at one spot at the top of the hill just before you get to Whitestone Pond, where children have sailed their boats since time immemorial.

Here, on a quarter of an acre of ground ringed round by trees, workmen were busy building a small bungalow, detached rectangular, neat—one of the first houses to go up on Hampstead Heath

since the war. It was a perfect house from Mrs. Halas's point of view. But of course it was somebody else's house. She just went on watching it get bigger . . . for a long time she couldn't get her husband to come and look at it at all. However, he came at last—liked it—met the architects—confirmed it wasn't for sale—regretted and forgot it. And then, by one of those fantastic coincidences, it was suddenly on the market. The Halases made an offer—to their joy it was accepted.

They've been living in it for two years now—the new little house with its screen of ancient trees is settled and completed. The surrounding garden sprouts, at appropriate moments, roses, delphiniums, wallflowers, geraniums.

As in most modern buildings the emphasis is on the inside rather than out—but Mrs. Halas's indefatigable part-time gardening has produced a garnishing of creepers. However, it is inside that one realizes how cleverly it has been designed to suit a housewife who has two children and a full-time creative job.

Roughly, the house is like an L with a very short bottom bit. The front door and, oddly enough, the back door are set in the angle of the L, side by side, so that vegetable supplies don't have to clutter through the hall—but anyone in the front of the house can answer tradesmen when they ring. All the rooms open off a hall—small cloakroom, bathroom, kitchen, four small bedrooms, and the spacious living-dining-room.

Throughout the house every attempt has been made to catch available light—Mrs. Halas has used lots of white, yellow and blue.

Pigs at play in The Animal Farm

Drawing engines is Paul's speciality—this one is "Tomus"

HALAS and Batchelor Cartoon Films is a British company started by two enterprising young people—both artists with a flair for the unusual and a passionate interest in their work. Since 1940, when the unit was formed and John Halas and Joy Batchelor got married, they have produced over a hundred and twenty-six film cartoons of all kinds, instructional films for the Admiralty, advertising cartoons and that enchanting coloured 3D cartoon of Edward Lear's immortal *The Owl and the Pussy-cat.* Their latest triumph is a coloured cartoon of George Orwell's famous modern fairy story *The Animal Farm,* a clever satire with wry humour. The film has had a great success in New York and comes to London early this year. The Halases are now preparing Bunyan's *Pilgrim's Progress* in which there will be acting by live actors as well as cartoon animation.

HAMPSTEAD

Ringed with fine old trees, not far from the Heath, a house as modern as tomorrow

Glimpsed through the gate, the Halas house on a carpet of lawn and flagstone, a design of clean-cut beauty, simple and easy to run

For Vivien and Paul, a bedtime story by the fire read by Mummy is bound to be a time for shared laughter

Paul, who's nearly six, has a vast cupboard in his room which has three walls papered in an ABC pattern, red on white, and the fourth in blue with a star pattern. Yellow linoleum gives warmth and light but Mrs. Halas would like to replace it some day with parquet, like that on the hall and living-room floors.

PAUL'S sister, Vivien, who is nine and a half, has a roomy built-in cupboard in her room too and, as she's a tidy little girl with quiet tastes, they can risk a mushroom-coloured fitted carpet in her room. She has a blue bedspread and chintz curtains with a large cream pattern. The first thing which catches the eye is an enormous painting she did herself and which even her critical and artistic parents admit is good enough to frame.

Chief high light of the house is the big, L-shaped living-room. The most striking thing in the room is the fireplace, about knee-level, raised and set into a brick wall and fronted with a long low platform. On the wall above is a black and red trellised paper; the remaining walls are papered with a beige and gold linen weave. The modern furniture, light and comfortable, is most attractive in this setting. Gold and yellow floor-length curtains hang at two french windows which open on to stone-paved terraces that catch both morning and afternoon sun. The third window is uncurtained except for a Venetian blind. The pictures vary from an original Picasso nude to two delightful Swiss paintings in brilliant colours.

Everywhere Mr. and Mrs. Halas have created an effect of sunny warmth and cosiness without clutter, a home easy to run and so pleasant to live in—two minutes away is lovely Hampstead Heath —a short walk down the hill is the tube to London. Lucky people!

Striking features of a lovely room—the fireplace set in warm brick and a fireseat with deep storage lockers

Differing wall papers—grey striped, red starred with white marguerites

All the charm of contemporary design—strong contrasting colours in carpets and walls, simple lines in furniture

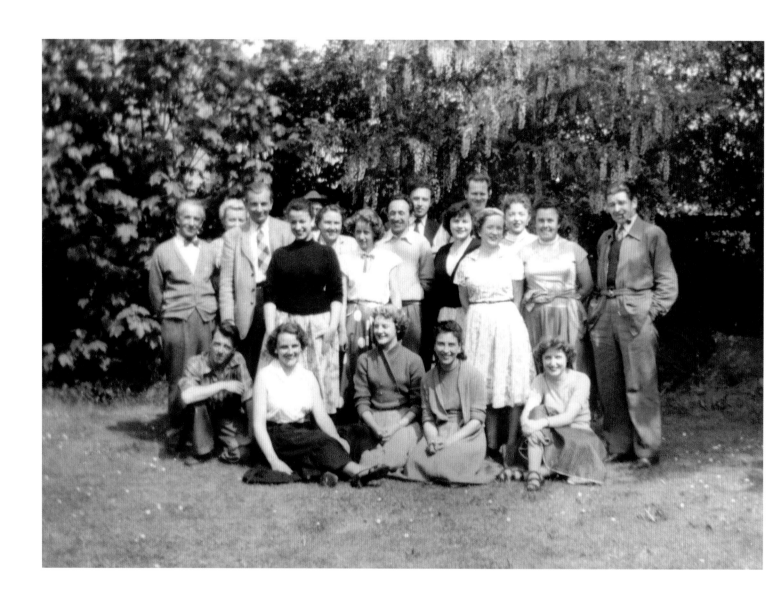

Left 1950. To cope
with the production of
Animal Farm Halas and
Batchelor took on extra
staff from David Hand at
GB Animation and the
Anson Dyer Studio in
Stroud that was about
to close. Here is the
team as Harold Whitaker
remembers them.

*From left to right, at the
back* Ken Kirley, Winnie
Stewart, Harold Whitaker,
Unknown, S. G. Griffiths
(Griff), Pat Shiers, Don
Baker, Colin Whitaker,
Kay Gardiner, Tony Guy,
Mary Bennett, Anne
Buffham, Joyce Smith,
George Chatterton,
sitting down Ron Taylor,
Unknown, Madeleine
Potts, Unknown, Pam
Knowles.

Below 1954. A posed
shot for *Woman's Own*
showing Joy reading to
Paul and myself with
Rosie the doll that was
too good to play with
and Ivy the Polar bear
that Sonia Orwell bought
for me.

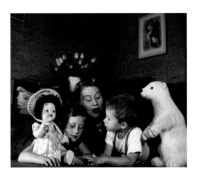

With the transition from war to peace came commissions from companies like Shell and BP. Bob Godfrey told me how there was suddenly a new seam of money to spend on animation. 'After the war the big companies were faced with something called the Excess Profit Tax so a way out was to spend it on 20-minute animation films.' One of the people that worked on those films was an early partner in the studio, Commander Allan Crick, who lived with us for months. He was a technical genius who adapted the studio's first Bell and Howland on an old gun mount to make a rostrum camera, which was robust and did not shake. He directed all the films for the Home Office and the Admiralty, *Handling Ships* (1944), *Water for Fire Fighting* (1948), *Submarine Control* (1949), *Linear Accelerator* (1952), *Power to Fly* (1953), and was a great asset, not only to Halas and Batchelor but also to us children, as he showed us how to make sailors' knots, slung a rope to the big chestnut tree in the garden to make us a swing and told the most fantastic adventure stories. Here was a very different kind of man to our father. Joy told us stories but John never really talked to us before we were old enough to talk about design! Allan Crick had a wife and children and a houseboat on the Thames at Richmond where we watched the boat race. We were never told why he was staying with us or why he left suddenly. No one spoke about him again. I believe he didn't like the American influence and the way the studio was expanding when *Animal Farm* came along.

Watching Animal Farm

The pre-production for *Animal Farm* started in 1951. I was nearly six and Paul only two and a half. The first thing we noticed was that exciting new people came to the house bringing us presents. One of those people was Sonia Blair (Orwell). She was pretty and blonde, not unlike my mother to look at, but more glamorous and gregarious. Her charm spilled over to include both Paul and myself. She took us to Hamleys, the most amazing toyshop we had ever seen, and told us to choose whatever we wanted. Overwhelmed, I chose a large plush white bear named Ivy with her cub Brumus, named after the first baby polar bear just born in London Zoo. Paul chose a pale grey velvet rhinoceros. We were spoiled and we loved it.

Then we found that our parents were going away more and more. During the four-year period it took to make *Animal Farm* our parents were often away in New York. It was one of their most productive periods,

when they were working together, not only on *Animal Farm* but ideas for future projects that never happened, for example, *Pilgrim's Progress* and *A Midsummer's Nightmare*, and ones which did, such as redesigning Louis de Rochemont's offices with hand-painted glass screens, while another of the designers from Halas and Batchelor, Digby Turpin, illustrated a series of title sequences for Louis' production for widescreen cinema, *Cinerama Holiday* (1953). De Rochemont was the renowned producer of the *March of Time* series, and was later to produce *Animal Farm*.

My grandmother moved in with us sometimes for what seemed like months at a time. She was strict but fair, making us do our share of the housework, and structuring our lives. She had time to help us and was always there when we got home from school, giving us a sense of security in a way our parents could not. Every time our parents returned they brought us gifts, to the point where we expected them. Paul got a Davy Crocket hat and denim-striped, American engine driver's outfit. I got a bright pink circular felt skirt with a train that whizzed around it. Then there were the records, Burl Ives, Paul Robeson, Sophie Tucker, Eartha Kit and Big Bill Broonzy, that like the gifts and the house visitors introduced us to American culture.

1954. With the making of *Animal Farm* my parents often worked in New York. Sonia Orwell is with them here at New York International Airport (later JFK). Not only was she closely involved with the production but she also took me shopping at Hamleys toyshop in Regent Street, London.

Philip Stapp, an American artist, writer and animator, was one of the first to stay with us. The friendship started before *Animal Farm* following the *Charley* series made to promote Social Security in 1946-48, when Halas and Batchelor were commissioned to make a film for the Marshall Plan in 1949. It was called *The Shoemaker and the Hatter* (1949) and was a plea for lowering customs barriers in Europe to regenerate the economy. At the time Stapp worked in the information division of the Marshall Plan Organisation and wrote the script with Joy. He was instrumental in introducing my parents to Louis de Rochemont and indirectly for the studio being chosen to make *Animal Farm*.

January 1955. The celebration launch of *Animal Farm* held at the Dorchester hotel. *Left to right*, John Halas, Joy Batchelor, Borden Mace and Sonia Orwell.

How it came about was, as far as I can tell, thanks to another American guest, Lothar Wolf, a Central European Jew like my father who helped de Rochemont set up the production and possibly find the funding. He had worked on the *March of Time* series at the end of the 1930s with Louis de Rochemont and after the war became an associate producer on many of de Rochemont's films. De Rochemont, the eminent maverick American producer, considered the father of 'docudrama', had bought the rights to *Animal Farm* (1945) from Orwell's widow in 1951. Writer Finis Farr and former film producer Carlton Alsop brokered the sale of the rights. These two were part of a government Cold War think tank called the Psychological Warfare Workshop set up with generous funding and managed by the relatively new CIA. De Rochemont and Stapp were both in the US Navy film unit during the war so when de Rochemont was looking for the right studio to produce *Animal Farm*, Stapp suggested Halas and Batchelor. Just exactly how it happened is open to conjecture.[8]

December 1954. The opening night of *Animal Farm* in New York. *Left to right*, Borden Mace, Joy Batchelor and John Halas.

My parents told the story in different ways at different points in their lives. They knew that some of the money came from the US Government but the project was something they wanted to do anyway. My parents welcomed the opportunity to make a meaningful film. Joy wrote 'It was a formidable challenge, but we were ready for it after our years of training, learning, practice and discipline. While I had learnt by trial and error to write, plan and storyboard films, John had learnt more about how to organise, train and generate enthusiasm in people. We were both dedicated to the book and joined forces in turning this fable, a satire with deep lyrical qualities, into an animated film.' John said, 'We were determined to avoid politics and did our best to make a film based on human values'. He also noted that, 'There was a non-stop invasion from the States to look at us; to evaluate our skill, to judge our moral character, to observe our reliability as to whether from a political point of view we were suitable to deal with the subject matter.'

My parents enjoyed entertaining their guests as they were both good cooks and gave dinner parties as well as cocktail parties that were highly fashionable in the 1950s. I was allowed to help with the preparation but was then sent to bed. Paul and I had to watch the dancing and often riotous times that followed through a chink in the door. My favourite guest was the elegant and charming Borden Mace, a young lawyer of 24, fresh out of the US Navy film division where he had also worked with Louis de Rochemont. He set up the company RDDR for Louis to finance *Animal Farm*. I liked him because he was full of fun and talked to children

with the same courtesy as adults. He once bought me a toy squirrel at the airport as we were seeing him off. Joy was furious with me and let me know that it was rude and spoilt to expect presents, but the damage was done and I kept the squirrel. Borden smoothed things over with her, just as he did with the production problems and many script changes on *Animal Farm*.

Once the first treatment of the film had been accepted, work started on the research and character sketches. This meant that we spent a number of weekends visiting farms so that my parents could absorb the atmosphere and draw the animals from nature. One of these trips was with another family that had become close friends, Eileen and Lesley Oliver and their children. Lesley was the director of Technicolor London, and their large house and generous cuisine were my idea of what life should be about. Influenced by American abundance, Lesley cooked corn on the cob dripping with butter followed by honey roast pork or a side of beef, while Eileen prepared wonderful desserts. They had an endless garden with a river and woods at the bottom where we were free to roam to climb trees and go trekking. These visits were combined with screenings at Technicolor where once again we were shown all the latest American cartoons and colour tests of films in progress. At the time everything American seemed modern and exciting.

Stroud

The work on *Animal Farm* also meant that the whole family spent weekends in Stroud, Gloustershire. The studio at 'The Old Vicarage' was chosen because it had a direct railway link from Paddington and work could be sent back and forth to London within a couple of hours. It had previously housed the Anson Dyer Company and GB Animation, created by Rank, under the leadership of ex-Disney veteran, David Hand. The

Above La Croisette, Cannes around 1957.

Left Harold Whitaker at the studio in Stroud. He animated Farmer Jones and remained one of the mainstays of Halas and Batchelor. Joy said of Harold that he was one of the best animators that she had ever met.

studio in Stroud was set up to cope with the production of *Animal Farm* and a large part of the camera work was done there. Once again while Joy and John went over the work with the animators and camera team, Paul and I had free reign of the studio and what seemed then to be a very large walled kitchen garden. In season we would sit up in the Victoria plum trees, unseen, eating the fruit and spitting the stones on to unsuspecting passers by. We would camp out on the floor of The Old Vicarage, taking it over, eating the tomatoes so lovingly planted in the greenhouse by one of Halas and Batchelor's finest animators, Harold Whitaker, and wondering at the tiny ramps he had built for the ants. Joy said of Harold, 'He goes on and on, he's wonderful. And I don't know of any English animator who is better'.

Festivals

Another important thing that shaped our lives were film festivals. Usually we were left behind but in 1956 we travelled to Cannes with my grandmother to look after us. My father rented a small bungalow in Antibes. It must have been one of his meaner moments because as we arrived the owners were throwing the mattresses out of the window, 'à cause des petits', afraid that small children might wet the beds! In a fury John found a much nicer place that was covered in wisteria and had real beds with bed linen. He and my mother then disappeared while my grandmother taught me to read (at last) and stopped Paul from kicking me. We discovered Orangina and petit pain au chocolat and brilliant yogurts in earthenware pots. One thing we did do together was go to the beach and as my grandmother announced that this would be her last ever swim, John announced that there should be a separate festival for animation. 'More than just a festival there should be an association that would bring animators together as a universal family.'

Four years later ASIFA, the association created to support and represent animators worldwide, was born.

Annecy took the place of Cannes for animation festivals, and from time to time we were taken to Annecy, Rimini and Mamaia, where we met many great animators and were marked by certain films that we could never have seen otherwise. Films like *Les Dents Du Singe* (1960) by René Laloux; *Breath* (1967) by Jimmy Murikami, and the *Theatre of Mme Kabal* (1971) by Walerian Borowczyk, struck me in particular because they

Top Annecy circa 1968. A picnic on the slopes of Mont Blanc. Joy Batchelor with Lesley Oliver, director of Technicolour London.

Eileen Oliver with Harold Whitaker at the same event. While I took these photos all the food disappeared at top speed due to the mountain air. The journey back to Annecy by train was a blur to most of the guests as quantities of slivovitz were generously supplied by the Polish animators. Such were the early festivals.

John Halas and Joy Batchelor at a festival in the1950s.

1954. Paul Halas having tea with Philip Stapp in the garden at Hampstead.

1953. Lilla Seiber, Joy Batchelor and Matyas Seiber on location during the shooting of *Cinerama Holiday* in St Moritz.

made a strong statement and were graphically arresting. Meeting and talking with this new wave of animators made me more critical of my parents and their work just as they were going into what was arguably a creative decline.

At the first International Animation Festival in Rimini in 1961 we spent some glorious and hilarious times with Norman McLaren and his partner Guy Glover. Joy loved men with a more feminine side and tended to form friendships with people she not only admired as artists but with whom she could laugh and exchange ideas. John was more interested in people for their potential talent and how they might further the cause of animation as he saw it. So while Joy kept up friendships out of empathy, John found an ever-wider source of connections and artists.

Life after Animal Farm

1961. An informal meeting on the beach in Rimini. *Left to right* Guy Glover, Norman McLaren, György Matolcsi, Gyula Macskássy. Snapped on the beach with my Brownie 127.

Norman McLaren, at the National Film Board of Canada, working on his masterpiece *Pas de Deux* 1967.

Paul and I had lived along with all the productions; during school holidays we stayed in friends' houses in the South of France, wandered freely in the French countryside up leafy lanes, along muddy river banks, nearly treading on water snakes, and marvelling at the toads as big as cats. Paul learnt to fish for trout using wasps for bait and all the while Joy was writing scripts while John, often back at the studio, was promoting the cause of animation. She wanted to retire. He didn't. Paul and I were caught in the crossfire. Joy often felt abandoned; in fact she possibly chose my father because he, like her mother, was unable to reassure her emotionally, and it must have felt familiar. Looking at their childhoods, they shared a feeling of being unwanted and so each filled the void in the best way they could. That way was to make films. While they were young they were largely successful but towards the 1970s they had begun to run out of energy, or at least my mother had.

After *Animal Farm* and for the next decade the studio had flourished. They were able to make personal films such as *The History of the Cinema* (1957) and *Automania 2000* (1963), both satirical reflections of the propaganda / sponsored films they had made previously, as well as making TV commercials and specially made-for-TV entertainment series, such as *Foo Foo* and *Habatales* (both 1960). They collaborated with the best artists and musicians of their day and enjoyed their notoriety, but after 40 years of filmmaking Joy would have liked to concentrate on a more personal life. John needed to carry on and was always positive, possibly at his best, when faced with disaster.

One useful thing he taught me was to have as many speculative projects as possible on the go because if one out of ten came to fruition it could be counted as a success. Joy was increasingly negative and subversive and the more vainglorious and pompous John was, or anyone else for that matter, the sharper were her wicked and usually witty remarks. It was very hard for me to think of following in their wake. Any piece of design work I showed my father he would disclaim in his thick Hungarian accent that he never lost, 'You can do better dan theese'. If it was meant as encouragement it didn't work. On the other hand, any success I had was

seen as showing off by my mother and I soon learnt that she was more sympathetic to me if I was having a bad time. This pattern took years to untangle. However, while we were children Paul and I agreed that we were enjoying ourselves and we just hoped that we would be able to afford the same lifestyle when we grew up.

The Monster of Highgate Ponds

When I was 15 years old, the Children's Film Foundation asked Joy to write a story for their Saturday matinées for children. It was a live-action film and I lived along with the story as Joy wrote the script. The story was about a strange egg brought back from Africa as a present for a young boy, David, by his uncle. The egg hatched into a small monster that thought David was his mum. The Monster grew so big that David and his friends let him out on Hampstead Heath. The adventure unfolded as a pair of wicked showmen planned to capture him.

By this time my brother Paul had been sent to Dartington Hall, a progressive boarding school in Devon. There had been talk of my going too, but I hid under my bed holding on to the springs until my parents promised I could stay at home, so I became an only child during term time.

Paul and I stopped quarrelling and became close friends, writing to each other often and formed a bond of protection against 'the parents'. By now, we both had friends of our own outside of the family and started to spend weekends and holidays with other people. While Paul was off somewhere I spent three weeks on Hampstead Heath as a film crew groupie.

I was fascinated by the director Alberto Cavalcanti, who was by then at the end of his career and spent much of his time clutching his head in despair, exclaiming 'Gods gif me patience'. He regarded the film as a come-down from his former glory, making films for the GPO during the war and later for the Ealing Film Studios. I desperately wanted to help but was soon told that it was against union rules so I spent the time talking to the actors and developing a crush on the stunt man who played the Monster. The Monster, designed by Joy, was made out of plasticine as a baby but as he grew he became an awkward rubber model that lumbered around. The stunt man, Roy, spent his time half-immersed in the ponds working the various limbs and rotating its rather large seductive eyes.

1961. The Monster was a lumbering creature made of rubber and operated by the stunt man from the inside using a series of pulleys.

The other exciting thing was that I got to drink Babycham in the pub with all the crew and felt free and sophisticated. That summer we borrowed Cavalcanti's house in Ana Capri. We visited the Guggenheim Museum; Paul caught lizards with Ricardo, the caretaker's son, who took us on rocky walks to swim in the Blue Grotto, through vines and prickly pear, and fed us on goat's cheese and fresh figs. It was not a bad life.

Health farm and legacy

A thing you might not know about my father is that he did exercises and press-ups every morning, ate muesli for breakfast but was greedy for butter. Towards the end of the war, he became ill and was diagnosed as suffering from malnutrition. Joy was recovering from a miscarriage so both parents were sent to Champneys Health Farm. They were put on a healthy diet of carrot juice, rose hip syrup and muesli. This regime bonded them with another couple, Dorothy and George Baines. George was a young architect from Preston who later started Building Design Partnership, one of the first practices to give British architecture a good image and still, as I write, the largest architectural practice in Britain. Later, when I was at art school, I went to work for him in his Preston office for studio practice. I was allowed to use the photographic darkroom by the in-house photographer. He was extremely patient and generous to me. One weekend I managed to flood the darkroom and design studio while developing films and letting the film get stuck in the wash, but his only remark on Monday morning after I had mopped up the disaster was, 'By heck, but this looks grand'. Recently I was at an animation screening at the NFT where I was introduced to Nick Park. 'At last,' he said, 'I have been wanting to meet you because you knew my father.' Nick's father was the photographer who taught me, and later was Nick's model for the character of Wallace in *Wallace and Gromit*.

While George and John stuck to the diet at the health farm, and played ping-pong and tennis, my mother and Dorothy escaped to the local teashop for buns and tea. They became close friends and when Dorothy gave birth to her first daughter, Susan, Joy was even more determined to start a family. Finally pregnant, she was upstaged by John as he was delivered of his appendix just as I was born, so missing the event. From the outset an absent father, John's need to leave a legacy actually stopped him from ensuring the longevity of Halas and Batchelor. Whereas his friend George (Sir George Grenvell Baines) managed to let go and allow a new

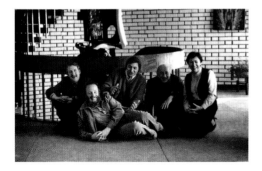

Top 1981. Photographed at the Technology Today Symposium, Moscow. *From left to right* Andrei Khrzhanovsky, Yuri Norstein, his camera operator Alexander Zhukovsky, John Halas and Sonya Berkovskaya; a friend and interpreter for my parents over the years.

Bottom Annecy 1978. An outing with animators including Bill Littlejohn with my parents *front row*. I am just behind him on the left.

generation to take over his partnership, John clung on. He sold Halas and Batchelor twice, once to Tyne Tees Television in the 70s, and then to a German company, Telemundi, in the 80s, which asset-stripped what was left. Each time, John bought the company back, clinging to the name and reputation that he so very much wanted to ensure his immortality.

The effect on Joy was that she developed arthritis in her wrists and could no longer write or draw. Under the regime of Telemundi she found herself ostracised and extraneous. One day she went into the studio to find her desk had been taken away; just like in a bad sitcom, she was redundant. No wonder she wanted to stop, but John, undaunted, turned to the Educational Film Centre and went on to make films like *Dilemma* (1981) and *Players* (1983). Joy became progressively iller. She knew that this was the last way to get sympathy from my father but the process was irreversible. The only work she still enjoyed was teaching animation at the London Film School, where she continued as a governor until shortly before her death in 1991.

1938. John Halas and Joy Batchelor in Budapest and *right* views from their studio windows.

In 1972 I left London as I had found a design job in Paris. It was as if a huge weight was lifted away from me. No one in the graphic design circles there knew my parents. I was 27, I had found a place and a life away from Halas and Batchelor and by leaving I somehow managed to feel closer to them. 'One image is worth a thousand words,' said Bill Bernbach, the advertising pioneer, who founded Doyle Dale Bernbach where I worked for some time. With animation there were thousands of images and they moved, and Joy's words made the image even more persuasive. My parents started off wanting to be great artists and to make a difference for the better. I believe they did.

References

1. Appendix 3, Canemaker, J. *Funnyworld Interview with John Halas and Joy Batchelor* (1980). Printed with permission from the author. This piece gives a slightly different version of their personal histories. VH

2. Molnár, M. *A Concise History of Hungary* Cambridge University Press (2001) pp. 201–250.

3. Molnár, J. *Gendarmes, Policemen, Functionaries and the Jews - New Findings on the Behavior of Hungarian Authorities During the Holocaust.* University of Szeged (2005) <www.jewishvirtuallibrary.org/jsource/Holocaust/hungholo.html>.

4. Hickman, G.M. *The Films of George Pal, South Brunswick & Father.* New York: A.S. Barnes & Co (1977), pp. 17–20.

5. Appendix 4, Contract termination, *British Colour Cartoons.* (1936).

6. Appendix 5, Frontispiece by E. J. Batchelor.

7. Gifford, D. *British Animated Films 1895-1985*, Jefferson, North Carolina: McFarland & Co. Inc. (1987), pp. 128–134.

8. Appendix 2 Leab. D. *Orwell Subverted: The CIA and the filming of Animal Farm* - extract. (January 2006). Penn State University. Press publication date scheduled for December 2006.

Animated commercials

Left Airbrush, wash and guache illustration by John Halas circa 1939.

Below Nikotex, 1935. This cinema commercial is the first known example of John Halas' work made in collaboration with Gyula Macskássy and Felix Kassowitz.

Advertising represents a unique form of visual communication, one which combines different modes and forms of visual language. In the context of commercial television, advertising offers an insight into the complex inter-relationship between image/text and graphic communication in the development of an advertising cultural discourse. It is notable that many of the pioneers of British animation from the 1950s and 1960s have commented on the unique experience of constructing a new visual language for animated commercials. John Halas noted that, due to the diversity of products and the flexibility of animation, there was the potential for creative innovation for television commercials.

The launch of ITV in 1955 presented an opportunity to develop a new and potentially unique communicative language and grammar. The vocabulary needed for this new language evolved from animators' experiences in the 1930s and 1940s when many were involved in public information films. The radicalism and experimental vision of Norman McLaren and Len Lye, who had both created films under the auspices of John Grierson at the GPO Film Unit, formed part of the catalyst for the radical revision and experimentations of the potential of animation in the United Kingdom. A further agent was the combination of the post-war generation and those who worked and fought in the war. The classic formal style of the pre-war period was broken down by the anarchic vision of animators such as Bob Godfrey.

In relation to the shifting parameters of animation in commercials, the Halas and Batchelor Studio represents a cornerstone in the transition in the visual language of animated commercials in Britain. Given the backgrounds of John Halas and Joy Batchelor it is not surprising that their

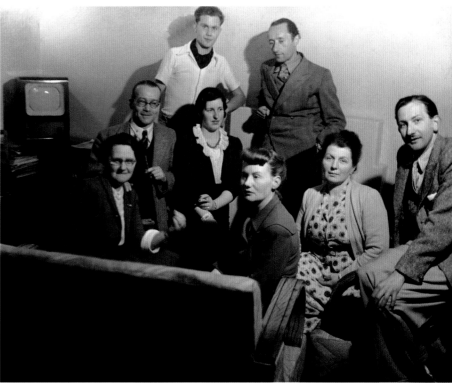

Left Fashion drawing for *Harper's* magazine, Joy Batchelor 1939.

Nikotex 1934.
Top Right The film follows a well structured plot found in most folk tales. Two scientists send a little boy and girl to take their latest invention, hidden in a series of wooden boxes, as a present to the king. They journey through a fantasy landscape full of symbols of Hungarian folk culture to successfully deliver the gift.

Music Man 1938.
Above right In this first collaboration there is no indication of Joy Batchelor's design influence, rather it follows the style of the advertising films produced during the Halász, Macskássy, Kassowitz partnership.

Train Trouble 1940.
Right The first advertising film made by Halas and Batchelor for Kellogg's Cornflakes.

Dustbin Parade 1941.
Right With the outbreak of war the COI took over the advertising agency using the skills of the studio for propaganda films.

Far right The studio team at Halas and Batchelor around 1949-50.

Magic Canvas 1948.
Right A personal experimental film made after the war.

need to make a living led them to build on their talent and experience in producing commercial illustration, graphic design and advertising. There is, however, a notable difference in style, aesthetic and vision in their work denoting cultural differences. Joy Batchelor's illustrations show a strong creative vision, which embeds and interweaves word and image. Her illustrations show an understanding of the explicit use of illustration as a communicative medium, which enhances and extends the discourse of the written word. Joy's work for *Harper's*, *Vogue* and other magazines shows an ability to innovate in response to the avant-garde.

It was in part Joy's skill and cultural knowledge that enabled the couple to survive in the pre-war period and gain clients. In contrast to John's illustrative work Joy's shows a clear use of bold lines and a sense of freedom. There is a subtle presence of humour; one that could be said to reflect a

refined English sense of fun. Joy's insight into British culture and in part its class system enabled them to produce work that directly engaged with the different social and cultural worlds of contemporary British society. This did not mean that their work failed to reflect and respond to the European avant-garde. There are clear indications in their non-animated work of elements of a formal visual language developed and in part influenced by the avant-garde. These elements were naturally transposed to their animation, which is notable in the difference between *Music Man* (1938), the cinema commercial *Train Trouble* (1940), the public information film *Dustbin Parade* (1941) and the experimental film *Magic Canvas* (1948).

Right Invitation card for the László Moholy-Nagy exhibition 1936, designed by John Halas. Moholy-Nagy worked as art director for the department store Simpson's in London in 1935. In 1937 he moved to Chicago where he founded the 'new Bauhaus'.

Left Airbrush poster by John Halas 1938, commissioned by Moholy-Nagy for Simpson's.

Right Collage and airbrush poster by John Halas, for *Illustrated News* in the same era.

In contrast to Joy's work John's visual aesthetic reflects the diverse forms of media and creative practices he experienced. His direct or perhaps indirect exposure to one of the key founders of the avant-garde, Moholy-Nagy, can be seen in some examples of his work. Most notable is the invitation card he produced for the László Moholy-Nagy exhibition, which was opened by Walter Gropius at the London Gallery in December 1936. His animated homage to Moholy-Nagy, *A Memory of Moholy-Nagy* (1989), shows John's continued interest in avant-garde design, which he explored in his publications for *Graphis* and later *Novum* magazine. John's desire to work in animation and his awareness of commercial advertising can be seen in his early work as a graphic artist and animator, in particular the commercial for Nikotex cigarettes. John produced the cinema commercial during his partnership with Kassowitz and Macskássy.[1]

The combination of both Joy and John's creative skills proved an effective and well-timed partnership, with the formal establishment of Halas & Batchelor Cartoon Films Ltd in 1940 based at Bush House, Aldwych.

It is notable that the building was also the headquarters of the advertising agency J. Walter Thompson. This would seem to offer a clear indication of Halas and Batchelor strategically straddling the two worlds of advertising and animation, which were creatively and conceptually intertwined. The

LEISURE. P.T. FRESH AIR.

These sets of character designs show a direct relationship between Joy's illustrations for cookery books and the visual style adopted for some of the studio's animation work. The precise title and details of this film production are unclear but some archive material links it to the film *Animal Vegetable Mineral* (1955). However, a closer look at the designs and character description would seem to indicate that the designs were for a film about health.

The Truth about Stork, a book for adolescents on sexual reproduction illustrated by Joy Batchelor to lighten the subject.

THE TRUTH ABOUT THE STORK 65

figure 26

T.A.S.—5

main objective for both Joy and John was to produce animated films. Animated commercials naturally formed part of the studio's business that continued until 1995. Although technically the studio was part of J. Walter Thompson and most animated work produced by Joy and John prior to 1940 had limited production credits; their first formally credited commercial was the Kellogg's Cornflakes advertisment *Train Trouble* (1940). In this short cinema commercial there is an emphasis on a narrative discourse that evolves from traditional animated shorts. However, the stronger narrative trope of the film lies in its appropriation of formal Hollywood narrative devices and scenes that echo Buster Keaton's *The General* (1926). This same narrative plot can be also seen in Nick Park's *The Wrong Trousers* (1993) and Virgil Widrich's *Fast Film* (2003).

During the 1940s clear signs of a definable style and visual aesthetic began to develop, most notably in two cinema commercials, *Train Trouble* (1940) and *Dolly Put the Kettle On* (1947). These reflected the influence of the Disney model of realistic backgrounds; the stretched stylised figures and facial models of 1930s animation can be seen in these commercials. This density of visual layers was later reduced to clear line

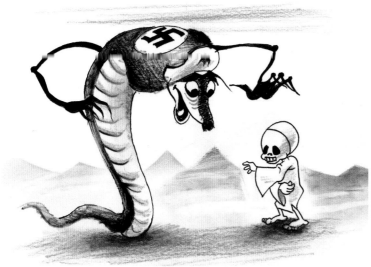

Left Snake Charmer. From a film for the Shell Film Unit made in the fifties. Design Saul Bass, narration, Peter Sellers.

Right Joy Batchelor illustrated a series of recipe books for Josephine Terry and other writers during and after the Second World War.

Below left 1943-45. *Abu and the Poisoned Well.* Elements of the drawing style and character design can be seen in the studio's commercials, propaganda films and public information films such as the post-war *Charley* series.

Right 1947. A still from Joy Batchelor's film for Brook Bond Tea, *Dolly put the Kettle On.* Animation Wally Crook, Kathleen (Spud) Houston and Vera Linnecar. Music György Ránki.

drawings with neutral backgrounds as found in commercials for Danish bacon (1956) and Mobil Oil (1950s). This form of reduction in aesthetic density was developed due to the financial need to lower the production costs of animated commercials and television series. This was not a radical development but reflected the studio's experience of producing public information, educational and instructional and corporate films. A model of animated production found in UPA's *Gerald McBoing-Boing* (1951) and *Unicorn in the Garden* (1953).

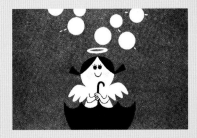

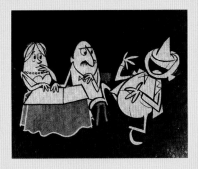

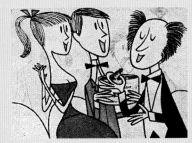

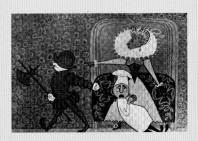

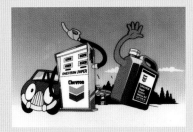

Flu-in Squad 1951. The scripts, scheme and master drawings were produced by S. Presbury & Co. Ltd who had held the Aspro account for many years. *Advertisers' Weekly* (8 November 1951) described the commercial, 'as ringing the bell as vigorously as a fire-engine. No punches are pulled out of coyness or for reasons of presumed public dislike for having the name of branded goods dinned into the ears. The public will take plenty of this kind of filmic medicine and come back for more.'

Millions of Cubes 1954. Produced for Oxo. The commercial shows a further example of the use of anthropomorphic characters to promote the product.

Pandora Pear Drops 1960. The storyboard was designed by Saul Bass. The press coverage relating to the commercial noted the significance of Saul Bass's involvement *Television Today* noted: 'This is the first occasion on which such a well-known Hollywood creative artist has pooled with a London production unit for television commercials. W. M. de Majo MBE, FSIA, who is consultant designer to John Miller & Sons Ltd., of Edinburgh, makers of Pandrop Perfect Peppermints, is acting also as liaison between Saul Bass and their Scottish client. Halas and Batchelor have been commissioned to do the animation for this commercial'.

The Brides of March 1960. The commercial was produced and broadcast in one week to promote John Chapman's play *The Brides of March* at the St. Martin's Theatre, London. The film was produced by drawing directly onto cels to reduce production times and costs. An article in *Television Mail* noted that the commercial was produced due to poor box office returns and that animation was created using the studio's recently acquired Oxberry camera.

White Heather, Chocolates and Toffee 1959. Advertising agent Mather & Crowther Ltd for James Pascall Ltd. The studio produced two 45-second commercials which ran until Christmas 1959.

Britain's Bread Makes History 1955 Commercial for Procea bread. The advertising agent was Dorland Advertising Ltd.

Yorkshire Bank, Chevron Petrol, Michelin X and BP. The studio produced a number of UK and overseas commercials for leading advertising agencies through the 1960s, 1970s and 1980s using very different styles.

Joy Batchelor made the most noticeable contribution to the studio's early development of a recognisable character and visual aesthetic. The character sketches for the Marshall Plan film *The Shoemaker and the Hatter* (1949) show the refined style and creative visual imagination found in Joy's illustrations. Most notable are Joy's cooking illustrations for Josephine Terry's *Front-line Food* with clear strong character designs. There are noticeable similarities here between these illustrations and those Joy designed for the Bovril commercial *What's Cooking?* (1949). The key to these visual designs was Joy's ability to construct characters whose visual narrative is expressed as a

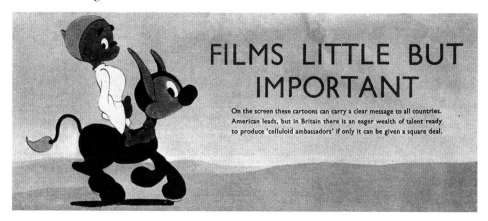

cohesive whole of their narrative matrix. Joy's characterisations present a humanistic sensibility to the character that is engaging and empathetic.

This empathy is best illustrated in the propaganda film *Dustbin Parade* (1941) and the character Abu, in the *Abu* series of propaganda films designed for the Middle East. In *Dustbin Parade* (1941), the anthropomorphic bone becomes the main protagonist of the story, leading the way and ultimately the bombshell towards its target. In a similar vein of self-sacrifice the vegetables, in the Bovril commercial *What's Cooking?* (1949), cavort and enjoy themselves knowingly towards death, in this case a bath of Bovril enriched sauce. The anthropomorphic element of these commercials, while following the classic style of anthropomorphism associated with Disney and Fleischer, presents a world of 'animated consumerism'. *What's Cooking?* (1949), a humoristic approach to consumption, presents an association between food, health, energy and enjoyment. The visual choreography of parades, dancing and swimming evokes references to the British theatre tradition and Hollywood musicals. For Joy and John there was a direct correlation between the construction of a narrative world for the commercial and the need to inform, educate and entertain. These three points were commented on in the *TV Mirror* newspaper's 'Ad Spot News' (22 October 1955) for the studio's commercial *Flying Horsepower* for Mobilgas (see *Halas and Manvell* (1959/1973), pp. 109–15). It is notable that early television commercials included a significant number of animated characters rather than full live action. John Halas

Above Illustration from an article in *Everybody's* magazine on the Abu series 1941.

Below Illustration from *The Shoemaker and the Hatter* 1949. The importance of strong character design can be seen in this film which retains the creative vision of Joy Batchelor. The film was commissioned as part of the Marshall Plan to reconstruct post-war Europe.

Murraymints 1954.
Advertising agent S H
Benson Ltd.
The continued popularity
of the commercials for
this product derives from
its humorous setting and
jingle. The most often
remembered example
of the series is of the
soldiers. Other stories
included the bridegroom
phoning his bride on the
day of the wedding to
find that she is lying on
the bed sucking the mints.
Another is homage to
the Keystone Cops and
Ealing Comedies about
a group of incompetent
bank robbers.

Spangles 1955. The studio
produced a series of
humorous commercials
for the product set in
'amusing situations, such
as Boy Scouts caught in
the rain'.

noted that there were significant financial and commercial rewards in producing animated commercials (see *Halas and Manvell* (1959/1973), pp. 109-15). The dualism between animated product and consumption can be seen in the Murraymint's commercials (1955), in which the protagonist refuses to enact their expected stereotypical actions until they have finished enjoying their Murraymint, followed by the jingle:

Murraymints, Murraymints, too good to hurrymints.
Why make haste,
When you can taste,
The hint of mint in Murraymints.

In the Spangles commercial (1955) the collective enjoyment of consuming sweets is notable and explicit within the narrative of the film, reinforced by the jingle:

Easy to open, easy to eat,
Spangles are the favourite sweet.
Offer your friends whenever you meet,
Spangles – MMM – that's really a sweet.

Both commercials engage, excite and animate the consumer through the combination of character design, animation and jingle (tagline). This combination of consumerism and advertising is interwoven as part of the matrix of consumer culture.

Graphically designed narrative agents evoke stronger consumer empathy and commercial spin-offs than celebrities. In this way the animated graphic character is created to bring to life the product and animate the consumer's desire. In turn, a symbiotic relationship develops and brings the product to life via a graphic illustrated character, which in turn is animated in commercials. In the commercial *Oxo Parade* (1954) the animated character is the product, Oxo cubes. In *What's Cooking?* the Bovril jar is brought to life; in the Gillette commercial *Skating Blues* (1955), the razor blades are brought to life skating and slicing through tree trunks and apples. Contrasting examples can be found in *The Flu-ing Squad* (1951) commercial for Aspro, which includes 'three humanised buildings suffering from a 'splitting' headache, a sore throat and a stomach ache, [which] find[s] instantaneous relief in the Aspro palliative.' (*Advertisers' Weekly*, 8 November 1951). A further example of anthropomorphic

These TV commercials are remembered!

1. MURRAYMINTS "GUARDSMAN"
 Agency: S. H. Benson, Ltd.

2. IDRIS FRUIT SQUASH
 Agency: Greenly's Ltd.

3. WOODBINE CIGARETTES
 Agency: S. H. Benson, Ltd.

4. TALLON BALL PENS
 Agency: Ford Farrow & Partners, Bristol.

5. FOX'S GLACIER MINTS
 Agency: Frank Gayton, Ltd., Leicester

6. BACON
 Agency: Erwin Wasey & Co. Ltd.

7. KLEENEX TISSUES
 Agency: Foote, Cone & Belding, Ltd.

8. OMO
 Agency: S. H. Benson, Ltd.

9. CHARRINGTON'S TOBY ALE
 Agency: Greenly's Ltd.

10. WOODBINE CIGARETTES
 Agency: S. H. Benson, Ltd.

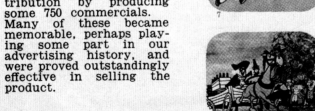

Since the start of commercial television in Britain, Halas & Batchelor have made a considerable contribution by producing some 750 commercials. Many of these became memorable, perhaps playing some part in our advertising history, and were proved outstandingly effective in selling the product.

These new TV commercials are selling hard now

1. MICHELIN X TYRES
 Agency: Modern Advertising Service, Ltd.

2. NESPRAY "ARTISTS"
 Agency: Raw Products, Ltd.

3. PRINCES SALMON
 Agency: Forbes Keir, Ltd., Liverpool.

4. SIGELLA
 Agency: Werbe-Gramm, Dusseldorf.

Why H. & B.?

Because H. & B. have the most skilled animators, an expert music and sound department, and the finest equipment in the country. Every film is made under the most careful creative and technical supervision. In every production we undertake our aim is to make a commercial which has originality of approach. We regard this as our creative contribution to the modern technique of selling that every agency requires.

products and humour can be seen in the series of animated commercials for Guinness in 1954, which brought to life well-established characters with strong narratives and taglines.

The pleasure and enjoyment derived from conspicuous consumption can be found in these early food commercials. However, further articulation of submitting to one's desire to feed and animate one's life was also represented in commercials for oil, petrol, shoes, tyres, banking and cars. The relationship between consumer desire and products responded to the sense of self-improvement and a belief in the future; promoted via the Festival of Britain in 1951 despite the continued enforcement of rationing until 1954. Commercial television was therefore able to communicate to a wider social demographic and respond to the aspirational development of a post-war market society.

Nestlé 1970 for Lintas Hamburg.

By 1954 the studio was in advance of the launch of commercial television in the United Kingdom and the studio's experience in producing material for the American market helped them to sign contracts for commercials earlier than some other studios. Joy and John's work for the American television industry developed as a result of their working relationship with Louis de Rochement in 1951, when Halas and Batchelor started production on *Animal Farm.* In 1955 the studio signed a two-year contract with TV Advertising Ltd worth £75,000 for television commercials. (*To-Day's Cinema,* 15 July 1955)

Tutti-Frutti for Lintas, Hamburg. The studio produced a number of commercials for international markets.

In the 1950s the studio rapidly developed and expanded their production of animated commercials. In 1957 John Halas noted that the studio had:

'... produced more than 250 cartoon commercials covering 120 products, including the 'Too-good-to-hurry-mints' whose guardsmen topped the popularity poll for seven months.' (*TV Times,* 27 September 1957)

A further sign of the studio's success was noted in an interview in *The News of the World* in which John noted that:

'Last year, we made 100 cartoon jingles, which is more than anyone in the world... we do not copy America. We teach. Already, we are exporting colour television jingles to the States. We will be ready when coloured TV comes here.' (*The News of the World,* 31 March 1957)

Smarties, circa 1975.

Wall's Ice cream circa 1975.

Michelin Tyres, 1975. The studio produced a number of commercials for the French company in Paris.

Nivea Cream, 1976. produced for DDB, Dusseldorf.

The international dimension of television commercials was extremely important for the studio. A sign of their success was in the selection of the Murraymints commercials for a special screening by Alistair Cooke on NBC television in 1956. CBS also showed *There Was an Old Woman Who Lived in a Shoe* (1955), a commercial for Freeman, Hardy and Willis, which was produced by Television Advertising Ltd in collaboration with the advertising agency Pictorial Publicity. Both commercials were selected as examples of the best in British commercials. It was later noted in *Advertisers' Weekly* (1955) that Gillette had requested copies of the films, indicating the potential for British studios to gain more international contracts. Significantly, Halas and Batchelor had already produced a Gillette commercial for the British market in 1955 titled *Skating Blues*.

International relationships also included creative partnerships between advertising agencies, designers and producers. In 1960 the studio produced the commercial *Pandora Peppermint Drops* based on designs by Saul Bass. The international reputation of Bass's work enabled the advertising agency to promote the artistic achievements of the commercial. The commercial retains key design elements and visual forms associated with Saul Bass. In the same year Halas and Batchelor's commercial for John Chapman's play *The Brides of March* was promoted in the *Television Mail* in July for having been developed, produced and screened in one week.

By the late 1960s, interest in animated commercials declined and many studios stopped producing commercials, or closed. Halas and Batchelor also wound down their role in commercials, perhaps reflecting the shift in ownership to Tyne Tees. In the late 1970s and 1980s the studio started producing commercials again for a more international market. They produced commercials for a range of products including: Michelin tyres, Nivea cream, British Gas, Desserta, Renault in Spain, Rabobank in Holland and Lintas' Tutti-Fruttis. These later commercials present a diversity of visual styles, characterisation and narrative, which reflect the changing relationship between advertising agencies and animation studios. The commercials highlight the significant social, political and economic changes of the period. The new generation of animators working at the studio brought new ideas and approaches, which enabled the studio to respond to changes in consumer culture and media entertainment. However, Joy Batchelor's slow disengagement in designing and work on the studio's films and commercials is noticeable when viewing these commercials.

The creative potential in producing animated commercials was realised by the studio and the long term effect on British animation can still be seen today. As John Halas stated, in 1950 there were 20 studios and by 1959 there were 200 producing animated commercials (see *Halas and Manvell* (1959/1973), pp.109–15). These statistics offer one perspective to the positive impact of commercial television; a regional view presented in an article in the *TV Times* in 1957 noted that:

'As many as 248 firms in London alone are engaged in making ITV commercials, with another 60 in the Provinces and 12 in Scotland.' (*TV Times*, 27 September 1957)

In one respect the 1950s represented a new frontier for animators, in which they were able to experiment and push the boundaries of animation. As a result, the creativity and imaginative use of experimental processes and narrative structures led to the development of a distinctly British visual and aesthetic language for animated commercials. As such, the significance and importance of ITV and animated commercials to the development of the British animation industry cannot be underestimated.

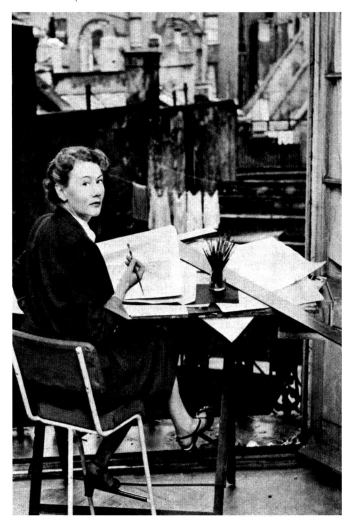

Joy Batchelor in the studio
at Paddington, circa 1951

Front-line Food
A war effort publication
illustrated by Joy Batchelor.

References

Evans, B. The Art of the cartoon 'spot', *TV Times*, 27 September 1957.

Halas, J. and Manvell, R. (1959rp1973) *The Technique of Film Animation* (London: Focal Press).

Nugat, P, 'Review of Advertising Films', *Advertisers' Weekly*, 25 November 1954.

Wernick, R. *Time Inc.* 29 September 1955

Uncredited :

Advertisers' Weekly, 8 November 1951.

Advertisers' Weekly, 28 October 1955.

Advertisers' Weekly, 20 January 1956.

Grocers' Gazette, 31 December 1955.

Television Mail, 22 July 1960.

The News of the World, 31 March 1957.

To-Day's Cinema, 15 July 1955.

World Press News, 4 November 1954.

World Press News, 3 December 1954.

World Press News, 15 April 1955.

World Press News, 22 July 1955.

World Press News, 4 November 1955.

Footnote

1. *Boldog Király Kincse (Nikotex cigaretta)* [Halász J. – Kassowitz – Macskássy, Operatör: Kaulich L., Zene: László S., Hang Pulvári, Kéült a Magyar Film Iroda Mütermében]

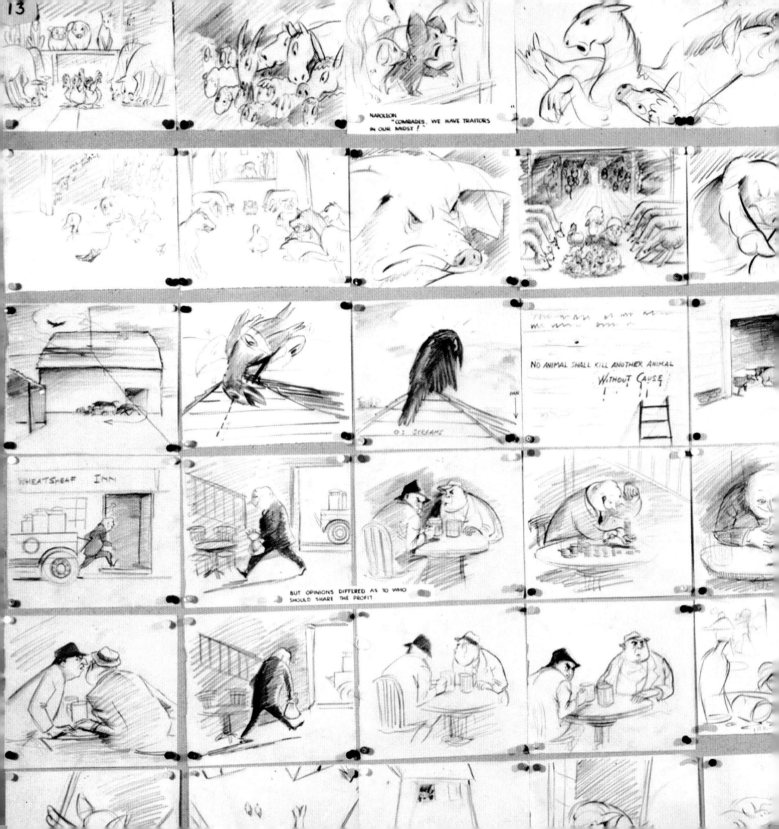

Animation techniques

In this section, Richard Holliss considers some of the techniques employed by Halas and Batchelor, concentrating on some of their pioneering work, most particularly in relation to *Animal Farm*, but also as part of a broader discussion of approaches to animation, in general. The section also includes recollections from Halas and Batchelor alumni about specific projects.

Experiments in techniques

Having consciously steered away from the graphic style of Disney and other Hollywood animators, John Halas had welcomed the challenge that short films, made either for the purpose of government propaganda or advertising, had offered his studio. These 'experiments in technique' were an excellent learning tool, an opportunity for his artists to explore different styles of animation and methods of storytelling.

They also proved useful in preparing the studio for more ambitious projects, such as a feature length version of George Orwell's political satire *Animal Farm*. Unlike many of the short films in which Halas and Batchelor had established their enviable reputation, *Animal Farm* (a story of how a group of farm animals rise up against their human oppressors) was afforded a budget more suited to traditional hand-drawn animation. The problem with the traditional method, however, in which thousands of individual drawings are copied onto sheets of celluloid (called cels) and photographed one frame at a time, is that it is very time-consuming. *Animal Farm* would eventually take 70 people over three years and 300,000 man-hours to complete.

PRODUCER WRITER DIRECTOR COMPOSER DESIGNER ANIMATOR TRACER PAINTER CHECKER CAMERAMAN EDITOR PRODUCER SPONSOR

Planning

 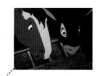

Main Story

| Jones goes to bed. | Animals awake and go into barn. | Old Major makes speech revolution to come. | Animals enthusiastic. Sing Revolutionary hymn so loud that.... | ...they wake Jones who fires his gun. | Animals disappear into stables. | Next morning. Farmyard deserted. | Animals unfed. Animals get hungrier. | Jones sleeps drunkenly. Animals get restive. | Hungry animals raid food store. | Jones wakes. | Animals turn and chase Jones away from farm. |

Tension (rising and falling line graph)

| Mood | Expectant | – | Excited | – | Enthusiastic | Climax | | Progressive repression and | Discontent | Revolt | Suppression | Open-revol |

| Music | Subdued | | Inspiring | | Song works to climax | Silence | Subdued | Mood music | building up to | | Crash effect | Fight between animals & Jones (staccato) |

| Colour | Moonlight | | Exterior colours | | | Dark | | Bright daylight getting harsher | | | | Hard clear colours |

| Time of day | Night between 10 p.m. and Midnight | | | | | | Sunday dawn | Through day | | Through day | |

| Time of year | Midsummer | | | | | | | | | Midsummer | |

NOTE:
To denote Sunday
we will always
have
distant church
bells.

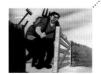

The Tension Chart was used to plot out the dramatic action and mood of the film. It was then discussed and modified until the story worked in dramatic terms. A first treatment or script was prepared along with a thorough breakdown of all the characters.

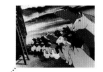

	Snowball despatches the animals.	Fight.	Jones and men make for the gateway.	Jessy is dead	Animals destroy relics of slavery and run up flag.	Revolutionary Song.	Enter farm building.	They inspect the house.	Napoleon steals the puppies.	Animals leave house. Pledge not to enter again.	Snowball paints out Manor Farm and paints in Animal Farm.
on		Anger and excitement		Sorrow	Jubilation		Distrust and Suspicion	Distrust	Aggression	Determination	Jubilation
. . . . build		Dynamic		Quiet	Inspiring	Song	Subdued	Subdued	Sinister note	Determined	Jubilation
		effects		Cold	Normal	Bright		Dark interior		Clear	Optimistic
					Through day			Day			
					Midsummer						July

127

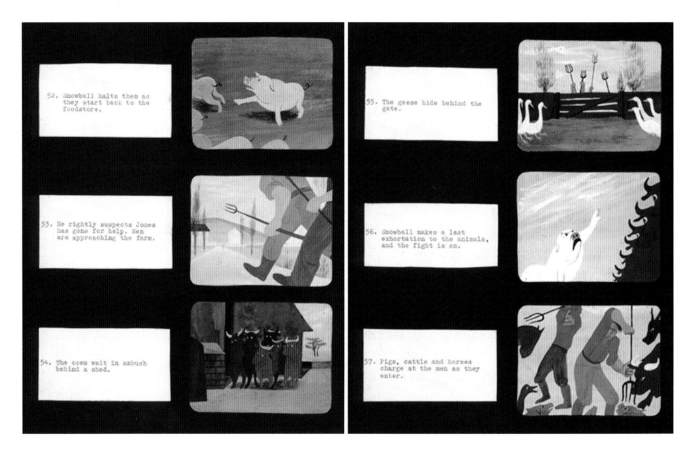

Before embarking on any project of this size, an in-depth understanding of the original source material is essential. Animation is not only time-consuming, it is also very expensive and therefore requires meticulous planning. So before a single drawing was undertaken, Orwell's story was broken down into a number of key elements, including plot, characterisation and dramatic highlights. A Breakdown Chart was then drawn up detailing the various relationships between the central characters. Eliminating some of the less important roles (both human and animal) was vitally important if the novel was to be successfully condensed into a 75-minute film.

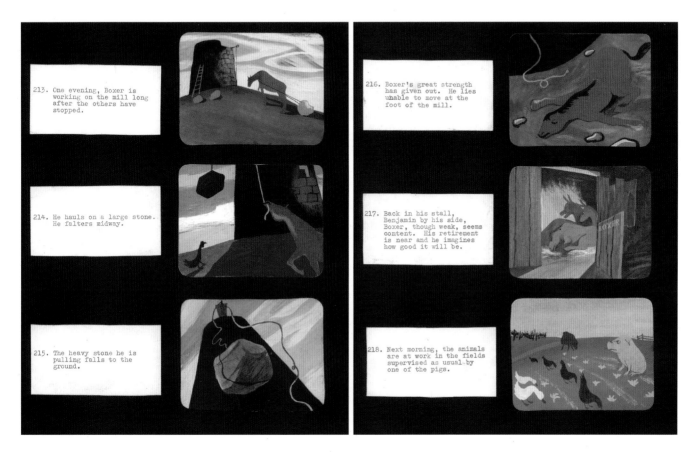

213. One evening, Boxer is working on the mill long after the others have stopped.

214. He hauls on a large stone. He falters midway.

215. The heavy stone he is pulling falls to the ground.

216. Boxer's great strength has given out. He lies unable to move at the foot of the mill.

217. Back in his stall, Benjamin by his side, Boxer, though weak, seems content. His retirement is near and he imagines how good it will be.

218. Next morning, the animals are at work in the fields supervised as usual by one of the pigs.

Philip Stapp who had previously worked with de Rochemont in the US Navy films unit during WW2 joined Joy Batchelor in writing and producing a colour storyboard. It was the first visual impression of the story.

In tandem with the Breakdown Chart, a Tension Chart acts as a guide to how the story's principal characters and key situations fit into the overall story. For *Animal Farm* the chart resembled a graph with parallel lines, each of which represented the sound effects, visuals and type of music required. The film was eventually broken down into 18 separate sections and a first draft script prepared, followed by a visual interpretation. Halas and Batchelor commissioned studio artist Philip Stapp to draw an extensive picture book based on the original treatment. Comprised of over 350 thumbnail sketches, the picture book gave an overall view of the finished film, underlining important plot points, characters and events. Before long, other artists were brought onboard. Their job was to assemble a storyboard - the next and most creative phase of pre-production.

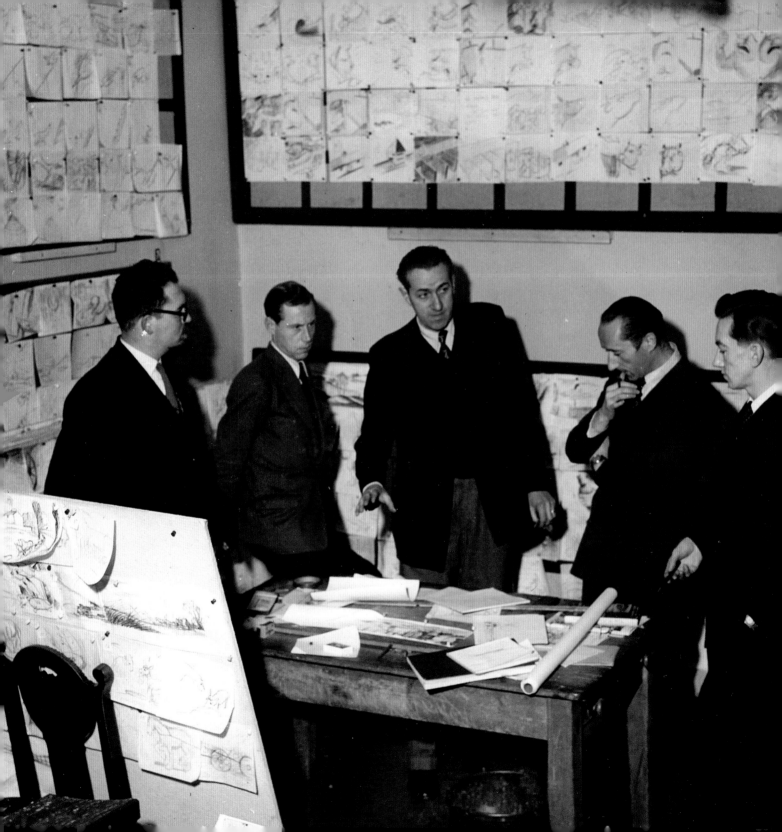

Storyboard

Left The design team with John Reed, animation director, John Halas and Geoffrey Martin, background artist, discuss the storyboard that filled two large rooms of the studio in Paddington.

Right Matyas Seiber, John Halas, Joy Batchelor and John Reed. Seiber, a student of Bartok and of Koday who was already well known for his post Bauhaus compositions, was brought in from the outset. He composed the music before the anumation and it was the the first time that a special orchestral piece was composed for an animated film.

When planning an animated film, the storyboard plays a vital role. Unlike live-action films, in which separate sequences are edited together once the principal photography is completed, the storyboard allows the editing stage of an animated film to take place prior to shooting a single frame. Camera angles, close-ups, long-shots, action scenes, pans, wipes, special effects – in fact every idea that the director can dream up is captured in a series of 6×8in sketches (up to 2,000 for *Animal Farm*) and pinned to large boards.

At storyboard meetings, attended by everyone involved in the project, whole sequences can be mapped out in advance. By adding or removing any number of drawings, individual scenes can either be extended or eliminated completely. The storyboard also helps the filmmaker to choose which method of animation would be best suited to a particular story or sequence. For the *Poet and Painter* series of films, made by Halas and Batchelor for the Festival of Britain in 1950, the storyboard actually resembled the final product. Static pictures were painted or drawn for each of the eight films while a roving animation camera provided the illusion of movement. With careful editing, it was possible to provide a continuity of screen movement to the point where the audience were not conscious of the lack of animation in the still painting or drawing. In this way, a story as complex as a fully animated cartoon film could be conveyed by paintings and drawings prepared at a fraction of the cost incurred by the orthodox method.

One major advantage that the storyboard has over a written script is the information it gives the animation team as to the pacing of an individual scene. In other words, it enables the calculation of how many sketches are needed to interpret certain onscreen events. For example, in *Animal Farm*, the battle between Farmer Jones and his rebellious animals required several hundred sketches to convey the dramatic impact, as well as outlining the necessary camera angles to capture the action. On the other hand, an exchange of dialogue between two characters, such as the confrontation between the two pigs Napoleon and Snowball, only requires one-fifth the number of drawings.

Music

Filming the storyboard (as a series of static drawings) can also be a useful guide to the structure of the entire film and the opportunity for the director to decide what works and what doesn't. In *Animal Farm*, the storyboard also acted as a useful guide to the film's composer, Matyas Seiber, on how to score the film for the best dramatic effect.

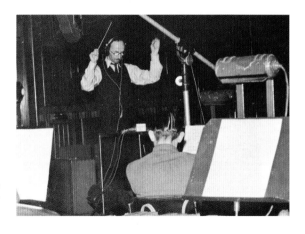

It is worth a small digression here to consider the extraordinary contribution of Seiber, and his fellow composer, Francis Chagrin, to the work of the studio. Both, in creating fully developed scores for much of the studio's output, enabled the films to operate within the broad architectures of 'classical' music and, therefore, be understood as serious compositions [even at their most 'witty', for example in the *Tales of Hoffnung* (1964)], within a more consciously artistic approach to animated film. While the hugely inventive and sometimes complex scores of Carl Stalling and Scott Bradley for Disney, Warner Brothers and MGM cartoons have been highly instrumental in creating a distinctiveness in American cartoon art, the specific relationship between sound and image – known as 'Mickey Mousing' in the way it essentially 'narrativised' chase sequences and comic events – was inappropriate for the approach Halas and Batchelor wished to take. Seiber and Chagrin offered a much more specifically 'musical' relationship of contrast and counterpoint to the imagery as well as illustrative motifs and themes. Chagrin valued the idea that the creation of music to evoke and suggest a mood or atmosphere was a fundamental part of Halas and Batchelor's aesthetic intentions, and was intrinsically related to other art forms, most notably ballet. He notes 'Ballet - as well as cartoon film - uses music as a basis for movement. Whereas in ballet the movement is performed by one or several dancers whose movement is governed by their skill and the law of gravity (amongst other limitations) the movement in cartoon film is completely free from such considerations. A change in cartoon films can be instantaneous... only music has the ability to change so quickly and so completely in a split second. And this is one of the foremost functions of music in cartoon films: to be the perfect mould on which the action will be cast.'[1] This 'perfect mould' relied on a particular attention to synchronisation, but more significantly, on the relationship between music, dialogue and sound effects; the music operating in a sensitive and strict harmony with the words rather than being merely a background track to the prominence of the verbal exchanges. Such sensitivity draws attention to the power of

The storyboard technique here - used to enabling effect by Seiber - is so flexible that the process has been successfully adapted by some of the leading exponents of live-action cinema, and is now a recognised process of 'pre-visualisation' in most contemporary cinema.

the music in relation to the words rather than working as a meaningless backdrop for them. There is a genuine synchronicity and narrative continuity in Chagrin's work because it offers the intensity and emotion of the music in pertinent moments, but never undermines or challenges the formal imperatives of the words or the power of the visual image when it is intended that these aspects take prominence. Chagrin properly integrates all elements of the soundtrack in these respects, making sure that every effect has narrative or emotional resonance; the music has a strong impact at a storytelling and emotive level; and that dialogue or voiceover is supported and enhanced rather than undermined.

Seiber, too, enjoyed the opportunity to either pre-compose and record the soundtrack, or to fit one to already completed animation. He notes of *The Magic Canvas* (1948), 'this was an abstract project; consequently, I considered that a similarly 'abstract' chamber music piece would be the most appropriate equivalent…it was one of the rare cases when within the framework of the story, it was possible to create an autonomous musical composition, a 'Phantasy' consisting of a slow introduction, an allegro, a pastorale, a scherzo and, finally, a recapitulation of the slow introduction.'[2] Seiber's talent in analysing sequences for their technical requirements and emotive suggestion, and composing accordingly, was appropriate for both approaches. His innate sense of timing hugely contributes to the ways in which movement in the animation finds pertinent 'symbolic' support and counterpoint in the sound – this is perhaps at its most explicit in his compositional strategy in *Animal Farm* when needing to make 'music' from animal 'sound'. He recalls 'I first had to find actors who could successfully imitate animals and at the same time sing the notes in a recognisable musical pitch. When I knew more or less what I could expect from my singers, I planned out the exact score, specifying when the pigs would lead the singing, when the chickens and so on. Under these single leading voices, however, I needed a solid background of sound, carrying the hymn right through, so I recorded the whole tune with a mixed chorus on one sound-band, an orchestral accompaniment on another, a special version for trombone and tuba on a third - so that at the final mixing any of these separate bands could be brought up or turned down.'[3] Seiber's acumen in finding the right 'tone' in supporting a serious narrative approach was crucial in the sense that any descent into 'the comic' was not appropriate to the story. He, like Chagrin, had a profound rapport with the artistic aspirations of the Halas and Batchelor studio, and was a significant element of their consistent achievement.

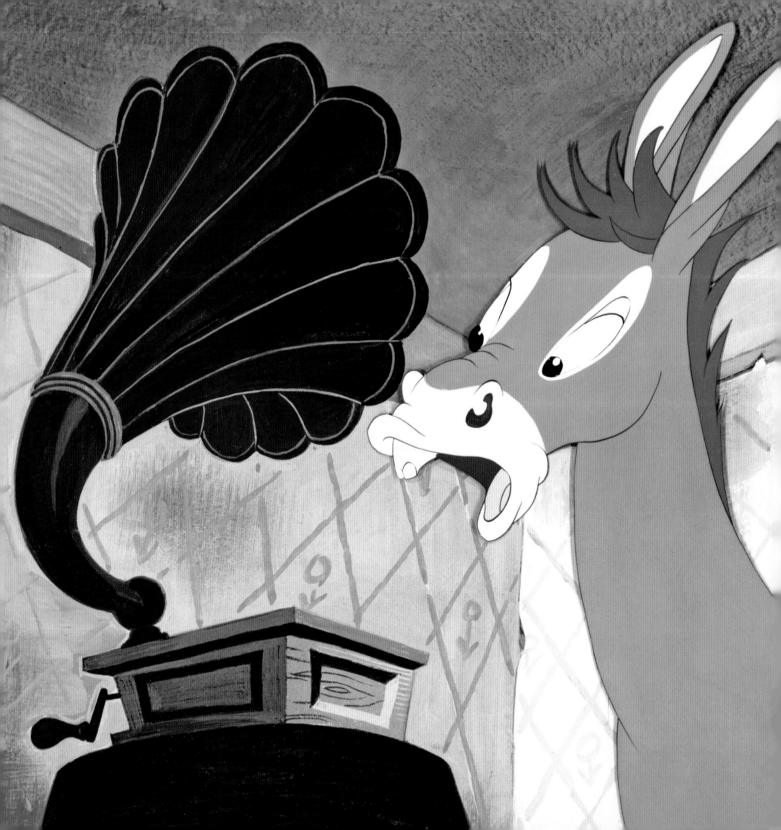

Characters

While the preliminary work is under way on preparing the first half of the script (in the case of *Animal Farm* a mixture of narration and voices), John Halas and Joy Batchelor began the work of fleshing out the individual characters. The temptation to be more experimental in the creative design of the animals, as depicted in earlier films like *Magic Canvas* (in which humans and birds were interpreted as abstract shapes), wasn't a viable proposition for *Animal Farm*. To give Orwell's story credibility the animals needed to be as realistic as possible, while retaining the physical appearance of beasts. As the film's main protagonists, each pig was given its own distinctive appearance to help the audience identify which character was which.

BOXER
CHARACTER : HARDWORKING TYPE, BRAVE & LOYAL WORKER.

In the original novel, Orwell had drawn inspiration for the characters from members of the Soviet politburo. The evil dictator Napoleon was likened to the Soviet leader Josef Stalin, while Old Major was based on one of the founding fathers of communism, Karl Marx. Without changing the obvious connection to their Iron Curtain counterparts, Halas and Batchelor chose to model the faces of their pigs on more recognisable role models. Old Major, for example, was drawn to resemble the Conservative leader Winston Churchill, while the creature's mannerisms where based on those of actor Maurice Denham (who also voiced the character). Animator Eddie Radage was then able to give the wise old pig Churchill's characteristic deep-set baggy eyes and huge jowls.

Combining the caricature of a leading politician with the physical attributes of a pig and making the character believable, is a delicate balance to strike for any animator

worth his salt. There is no such problem if the cartoon star is already a fantasy creation like Mickey Mouse or Bugs Bunny, but in *Animal Farm*, Halas and Batchelor were eager to elicit audience sympathy for the farm animals, while avoiding the temptation to over-anthropomorphise the characters. So, even though some of their four-legged actors had to adopt human traits, only the pigs were allowed to imitate humans by staggering about on two legs, wearing clothes and using their trotters as hands.

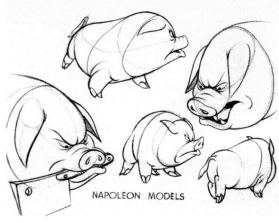

NAPOLEON MODELS

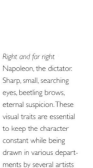

Right and far right Napoleon, the dictator. Sharp, small, searching eyes, beetling brows, eternal suspicion. These visual traits are essential to keep the character constant while being drawn in various departments by several artists over a long period.

Below right Squealer, Napoleon's 'yes man'. This character tries to do whatever Napoleon does, only more so.

NAPOLEON

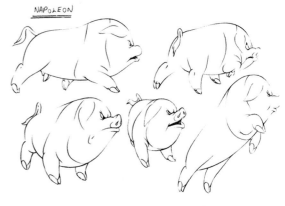

HEAD LOW
SHOULDER UP

SHIRT
TURNED UP
UNTIDILY

SHIRT
SLOPPY

HEAVY
HANDS

Left and above Farmer Jones, the cruel owner of Manor Farm. Dissolute, greedy and cowardly, he represents the embodiment of the old regime.

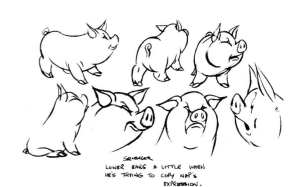

SQUEALER
LOWER EARS A LITTLE WHEN
HE'S TRYING TO COPY NAP'S
EXPRESSION.

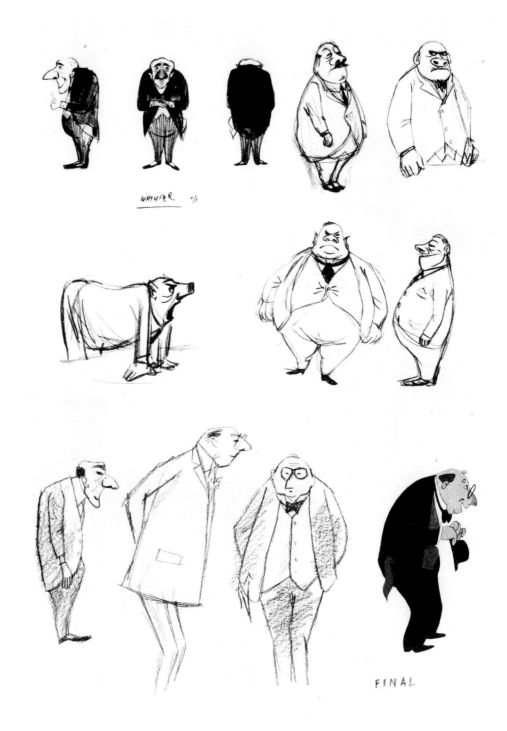

Right Wymper, the facilitator. Sketches showing the evolution of Wymper's character ending with the final model that typifies his temperament.

WYMPER #/1

FINAL

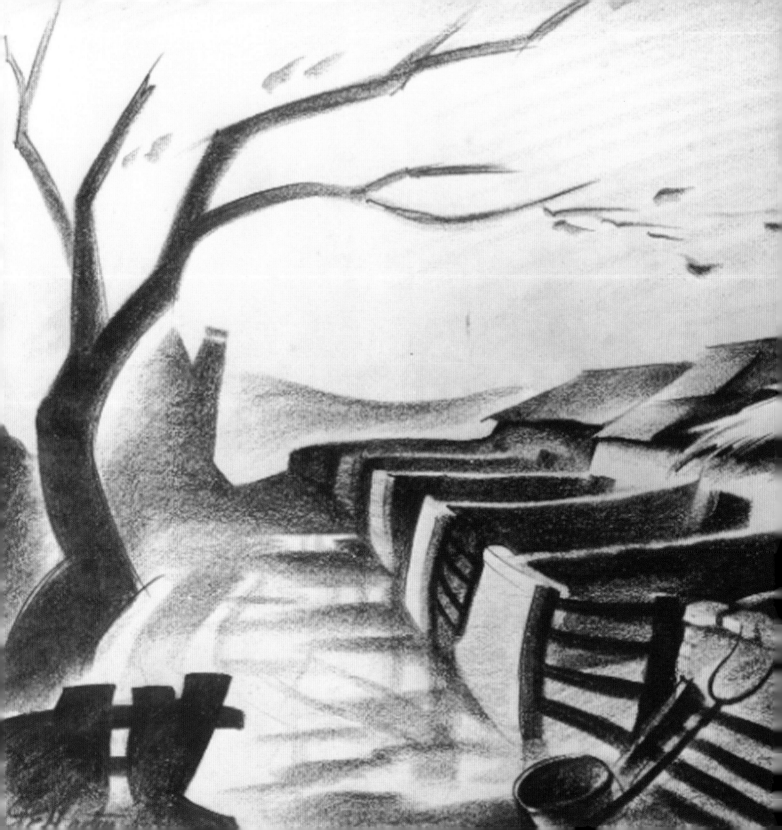

Backgrounds

Designing the environment in which the animated characters live out their fictional existence is just as important as the animation process itself. Films involving puppets or three-dimensional figures such as those in the Halas and Batchelor film *Figurehead* (1953) (a fantasy about Neptune's daughter who falls in love with a handsome, but unresponsive wooden carving) are, like their live-action counterparts, easier to plan. Three-dimensional sets are constructed and the characters filmed within them. Camera angles can be plotted in advance, as in a live-action film, to heighten tension or develop mood. A similar approach is also adopted for films using three-dimensional paper sculpture characters (with interchangeable heads) like *Snip and Snap* (1960), the animal stars of a Halas and Batchelor television series.

The sets in hand-drawn animated films are commonly referred to as backgrounds but, unlike those in puppet films, must be designed and painted from scratch. For *Animal Farm* meticulous background sketches were prepared in advance showing the interiors and exteriors of farm buildings, outhouses, barns and sheds. From these preliminary drawings, timbered roofs, farmyard machinery and even the surrounding countryside were painstakingly recreated on as many as 1,800 coloured backgrounds. Each had to be carefully planned so that they matched the proportions of the animated characters in any given scene.

The storyboard would be consulted throughout, so that all possible camera angles could be painted beforehand. For example, there is a scene in the film that shows the animals trudging one by one into the barn. The high-altitude 'camera view' of the building and its overhanging roof have to be painted first, so that the animation could be added afterwards using the same perspective as the background elements.

But backgrounds in a film like *Animal Farm* do more than just provide a world in which the various characters act out their lives. A static picture of the village pub, for instance, is all that is needed to set the scene for a later encounter with the farmhands. A view of the isolated farmhouse with a single light shining from an upper floor window can establish the mood of the scene without the need to spend a great deal of the budget on complex animation. In other words, backgrounds must also provide atmosphere without detracting from the story or the characters.

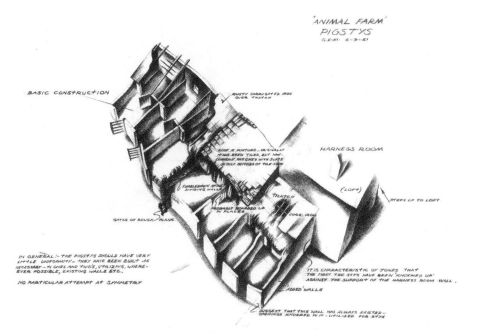

'ANIMAL FARM'
PIGSTYS
G.E.M. 6-9-51

BASIC CONSTRUCTION

RUSTY CORRUGATED IRON
OVER THATCH

HARNESS ROOM

ROOF IS MIXTURE - ORIGINALLY
IT HAS BEEN TILED, BUT NOW
SUNDRY, PATCHES WITH SLATE
SO ONLY PATCHES OF TILE SHOW

TUMBLEDOWN SPONE
DIVIDING WALLS

(LOFT)

THATCH

STEPS UP TO LOFT

ROUGHLY BOARDED UP
IN PLACES

CORR. IRON

GATES OF ROUGH PLANK

IN GENERAL :- THE PIGSTYS SHOULD HAVE VERY
LITTLE UNIFORMITY - THEY HAVE BEEN BUILT AS
NECESSARY - IN ONES AND TWO'S, UTILIZING, WHERE-
EVER POSSIBLE, EXISTING WALLS ETC.

NO PARTICULAR ATTEMPT AT SYMMETRY

IT IS CHARACTERISTIC OF JONES THAT
THE FIRST TWO STYS HAVE BEEN 'KNOCKED UP'
AGAINST THE SUPPORT OF THE HARNESS ROOM WALL.

ADDED WALLS

SUGGEST THAT THIS WALL HAS ALWAYS EXISTED -
OPENINGS KNOCKED IN IT - UTILISED FOR STYS

Sketches indicating constructional details of pigsty, food stores, manger and cowshed.

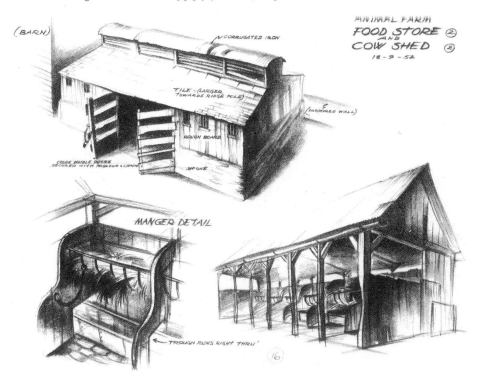

(BARN)

CORRUGATED IRON

ANIMAL FARM
FOOD STORE ②
AND
COW SHED ②
18-9-52

TILE - (LARGER
TOWARDS RIDGE POLE)

(FARMERS WALL)

ROUGH BOARD

CRUDE DOUBLE DOORS
SECURED WITH PADLOCK & CHAIN

STONE

MANGER DETAIL

← TROUGH RUNS RIGHT THRU'

(16)

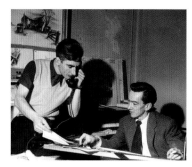

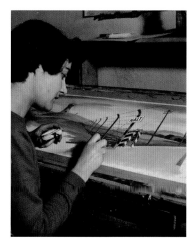

Top Geoffrey Martin
discusses the back-
grounds with a colleague.

Above An artist painting a
background for the farm.

Left Sketches indicating
the constructional details
of pigstys and food stores,
manger and cowsheds.

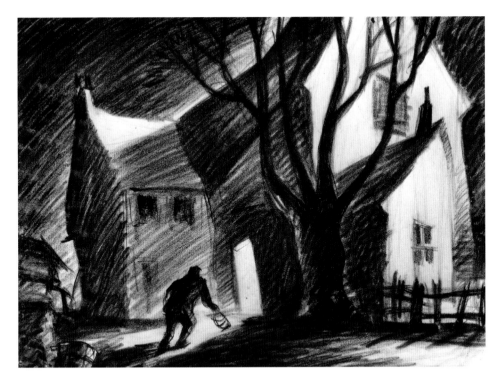

Above Colour mood sketch. As well as atmosphere drawings in pencil another colour storyboard of backgrounds was made to set the mood of the scenes.

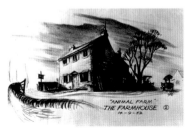

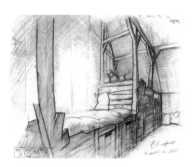

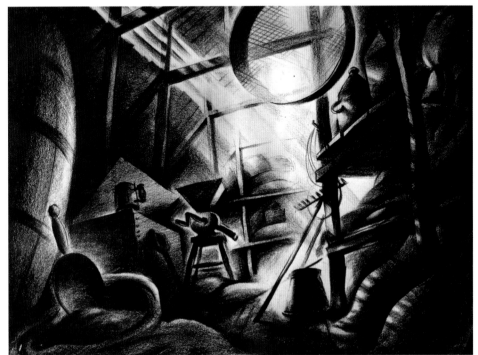

Animation

The animation process, the process by which the film's numerous characters are brought to life, is still the most complex and time-consuming of the entire production. Fortunately, the best and most economical way to animate a scene can be decided upon at the pre-production stage under the supervision of the film's director. Veteran animator Harold Whitaker remembers how different *Animal Farm* was to anything that the studio had been working on. 'It was different partly because the characters had to appear solid and believable and partly because of the arrival of a number of animators trained by Disney.'[4] One such animator was the film's director John Reed, who had served his apprenticeship as a special effects animator on Walt Disney's *Fantasia* (1941). 'Reed's influence on the animation in *Animal Farm* was tremendous.' Whitaker adds, 'He knew exactly the effect he wanted and how to get it.' Occasionally, throughout the film, a small duckling appears; its antics echoing the tortoise in

THE FIRST FIGHT

Harold Whitaker
acts out Farmer Jones'
expressions. The animator
is the unseen actor.

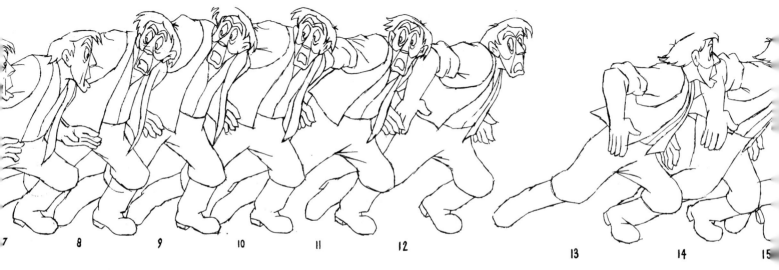

7 8 9 10 11 12 13 14 15

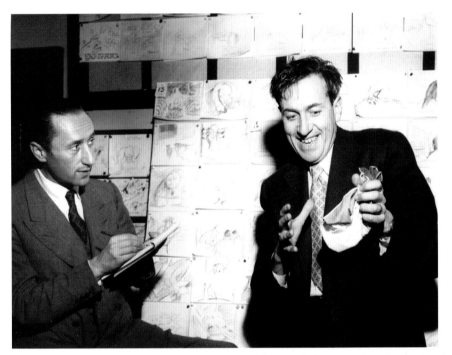

Disney's *Snow White and the Seven Dwarfs* (1937) who was always two steps behind everyone else. 'It's not known whether the cute duckling was Reed's idea,' Whitaker notes, 'but after working for Disney, he was concerned about the rather heavy atmosphere of the film. His approach was to get the mood right.'

Part of 'getting the mood right' was to create a workbook that analyses the action for the film shot by shot; taking into consideration camera movements, cutaways, dissolves and fade-outs. Again, all the principal forms of cinematography, that in a live-action film would be carried out during the production shoot. Often described as actors with pencils, animators have to create believable characters with a whole range of emotions from a series of simple line drawings. Using a light-box, a desk-mounted device that allows light to filter up through several

Above John Halas in discussion with animation director John Reed, who had formerly worked for Disney on Fantasia 1940.

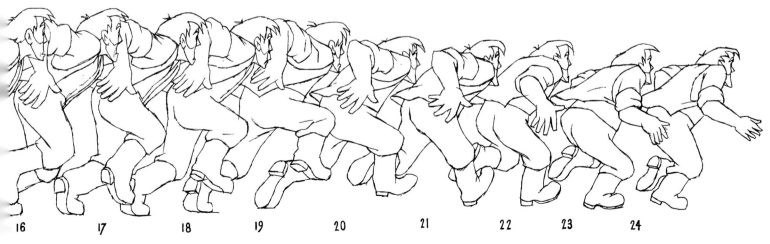

16 17 18 19 20 21 22 23 24

layers of drawings simultaneously, the animator can immediately see what changes are required to each successive drawing as he works through a scene. Posing or mugging in front of a mirror set up by their drawing desk also allows the animator to accurately reproduce the different facial expressions of their characters, whether human or animal. When Napoleon summons his pack of dogs to rid the farm of Jones and his followers, the animator exaggerates the pig's facial expressions to convey anger and thus heighten the dramatic impact of the scene. The fact that a pig's facial appearance doesn't change in real life is of no matter to the audience if done convincingly.

Animators also have to consider the weight, feeling and solidity of the characters they draw. Extremes of movement, in which animated figures defy the laws of gravity, or are twisted into impossible shapes, are used in all forms of animation from stop-motion puppet films to animated feature films and shorts. So extensive use is made of model sheets, drawings that are designed to show a character in various poses or from different angles. Occasionally animators will use maquettes (three-dimensional sculptures of the characters) to aid animation. When drawing human figures like Farmer Jones and his friends, animators would study live action film or still photographs of themselves miming certain actions. When Jones staggers through the farmyard at night, acting out the scene in advance can be a useful guide in helping the animator to define the character's mood.

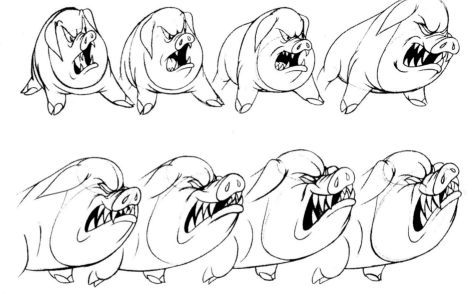

Drawing realistic-looking human movement is one of the hardest tasks an animator faces. Sometimes artists will resort to a system called rotoscoping. This involves filming a live actor, printing each frame of film as a photographic enlargement and then tracing the movements. Although this method was not employed by Halas and Batchelor on *Animal Farm*, a similar principle was applied to their 1953 short *Power to Fly*, for which live-action footage of a model aircraft was rotoscoped in

An analysis of one second of motion. The most important facial expressions and essential gestures are given emphasis and held for several frames.

order to accurately replicate the complex wing structure of a turn-of-the-century flying machine.

Timing a scene is very important and for this animators use a dopesheet. This is prepared by the film's director and tells them everything they need to know about a particular scene. The start and end of each shot (camera angle) is clearly marked. If a sequence lasts eight seconds, then the animator knows how many drawings are required to match certain dialogue before the cut to the next scene. It is also possible to achieve the same effect in an animated film using limited animation techniques. Static shots of Farmer Jones discussing the farmyard rebellion with his companions in the public house can establish the mood of the scene without the need for full animation. Or the character of Old Major, with his reputation for being fat and lazy, could also be accomplished with the minimum of drawings. When Snowball runs for his life from Napoleon's dogs, a series of drawings showing the character running is prepared and the cycle repeated as often as necessary. Thus 12 drawings in rotation can seem like hundreds. When Jones and his mob attack the farm, drawings of some of the human characters were re-used to save time and money. If the characters appeared together in the same shot, giving them different clothes or hairstyles could disguise their appearance.

If required, the animators' drawings can also be photographed in sequence. Called 'pencil' or 'line tests', or 'animatics', these silent film extracts allow the director to study the film for any imperfections or errors in continuity. Sweatbox notes, so-called after the cramped and non-air-conditioned screening rooms that were used by early animators to view pencil tests, are then sent back to the individual artist with instructions from the director to either re-animate or adjust the drawings or timings of a character's movements. As there are 24 frames to each second of film, 1,440 per minute, key animators usually draw only the extremes of an action - on average every fifth or sixth frame. So it falls to the job of the inbetweener or clean-up artist to smooth out the lines, fill in the gaps and make the drawings cleaner. Today, animators' drawings are scanned into a computer, which can enable more automatic processes to create the missing images, removing the need for an inbetween department.

Left Animator's pencil drawing of Napoleon ready for tracing.

Far left The essence of animation is the timing. It takes half a second for Napoleon to reach the climax of this expression.

Middle Prior to animation the artists studied the animals' movement from life.

Below Working drawings for lip-sync in full animation for Old Major's first speech.

"OUR CH —— I ——

— L —— DR —— EN —

Layout

Working in tandem with the director and animation team, the layout department prepares the overall look of the finished scenes. Under their guidance, the relation of the characters to the backgrounds can be worked out. With a number of animators assigned to work on the same character, or set of characters, it is vitally important that everyone works to the same specifications. Boxer, the silent but hard-working carthorse, who was animated by Arthur Humberstone, must always appear in the correct proportion to the smaller animals, such as his friend Benjamin the donkey, animated by Ralph Ayers. The layout department ensures that this is always the case and that continuity is maintained throughout.

Layout artist Alan Standen recalls: 'Via the street gossip or in the pub, I heard that Halas and Batchelor were looking for artists. I bought the book, *The Art of Walt Disney*, from a second-hand bookshop in Charing Cross Road. I read it in one sitting, probably on a park bench, and was fascinated. There in London was a film studio looking for talent. I called at this grand house in Sussex Gardens with my drawings of the Kent countryside, farm wagons, threshing machines, pubs and animals. They were just what John Halas and Joy Batchelor wanted. I met Bernard Gitter, the chief administrator, and my wages were decided on and the terms of my contract. I was to become a provisional member of the trade union and my work would be Layout Artist on *Animal Farm*. I and Jeffrey Martin, and Richard Dodds, worked with John Reed, under the supervision and inspiration of John Halas and Joy Batchelor.

'A cartoon film requires artists who are able to merge into the team and produce drawings that are similar in style. This discipline must be maintained throughout the film. Monday morning there would be a storyboard meeting with Halas, Batchelor and Reed. There was never a heated discussion or arguments. After the meeting Jeff Martin would go into to John Halas' office and collect sketches for the following scenes.

I usually drew the interiors, barns, pub and the house. It was vitally important that the artist knew every detail of the building inside and out so as to maintain continuity. Pots, pans, farm tools had to be in the same place and position in every layout. A good memory and an up-to-date notebook was essential for a layout artist. These drawings would then be passed on to the animators and background artists.

Blue pencil sketch of Boxer and Benjamin in the barn. This layout gives position and details of characters for the background artist.

'One person in particular, an artist of outstanding quality, was Matvin Wright, my former tutor from the Medway College of Art. In the two years I worked on *Animal Farm* I never ventured upstairs or to the other rooms. Our room was on the ground floor next to John Halas and Joy Batchelor. The tracing department was also on the ground floor. If a background artist should query a layout, or a cameraman question a pan or dissolve, then John Reed was called in and a quiet informal discussion would take place, and the decision placed before John Halas.'[5]

Trace and paint

Prior to the use of computers, the rough edges of the original animators' drawings began appearing in the final film due to the disbanding of the clean-up department and the introduction of the Xerox process which can photostat the animators' rough drawings directly onto the cels. Disney's special effects department, under the supervision of animator Ub Iwerks, invented the Xerox concept for use on the studio's 1961 movie *One Hundred and One Dalmatians*. With Xerox replication, the thousands of black spots on the puppy's fur could be animated with ease. The Xerox method also removed the need for an ink and paint department. Inking and painting was a time-consuming process that had to be budgeted for and planned as part of the film's post-production schedule. However, when *Animal Farm* was in production, the ink, trace and paint department were an invaluable aid to the overall process. Wearing cotton gloves to guard against unwanted grease marks, the department's staff meticulously copied every single drawing onto hundreds of 15in × 10in cels. After the laborious task of inking the characters' outlines, the cels are then turned over and coloured in. Painting on the reverse side of the cel ensures that a character's features are not compromised and that the smooth side of the cel always faces the camera.

Right Tracing on to cel required the artist to wear gloves as the acetate marked easily and quickly picked up grease and dust.

Bottom right The cels were painted in layers on the reverse side of the inked outline. It was done one colour at a time and each colour had to dry before another could be added.

Photography

Prior to photography, the checking department ensures that the cels match the backgrounds and that the characters movements match precisely any onscreen objects. For example, if Napoleon has to jump through an open window, the checking department will make sure that the various elements, the pig's body, window frame, background etc., are in register with each other. Drawings and their related backgrounds are then shipped to the camera department. Under the supervision of cameraman and trick photography specialist S.G. Griffiths, and his assistant John Gurr, Halas and Batchelor owned two principal Technicolor cameras. One of these was fixed to a table rostrum for cartoon work and the other mounted on a travelling pedestal which could tilt, pan and track for distances up to 22 feet. A third camera could point in any direction, including vertically downwards towards the animation rostrum. The animation camera must have both single-frame and continuous-exposure control, forward and reverse movement of film and a registration system which holds each frame of film in precisely the same position for each exposure.

Consisting of a glass platen under which the various cels are laid one by one, the animation rostrum is an intricately designed piece of equipment. The rostrum is designed in such a way as to enable the cameraman to move (again frame by frame) the background in any direction of the compass. In this way, the equivalent of a live-action pan can be undertaken with the cameraman following the guidelines set out for a particular scene by the layout department and noted down on the dopesheet. The cels are placed over their respective backgrounds and photographed one frame at a time. For the majority of the scenes in *Animal Farm*, four separate cels were photographed simultaneously as each would have been the work of a single animator working on an individual character or set of characters. Four cels stacked on top of each other, however, can seriously darken a background so some are painted in such a way as to compensate for this. The camera department is also responsible for creating a lot of the visual effects including trick-work or double exposure for smoke, fire and shadows.

For the Halas and Batchelor three-dimensional short *The Owl and the Pussycat* (1952), a multiplane camera was utilised to create a stereoscopic picture by photographing different levels of animation in order to achieve a feeling of depth. *The Owl and the Pussycat* had to be shot twice, from the

viewpoint of the left and right eye. *Animal Farm,* however, was shot using the consecutive frame method, a complex process by which each cel set-up is shot three times with either a red, green or blue filter to create a finished colour negative. Pioneering widescreen animation, including Cinerama (for animated inserts involving coloured murals in the 1954 live-action movie *Cinerama Holiday*) and Cinema Scope, meant that one of the studio's rostrum cameras had an anamorphic lens attachment which could optically squeeze the artwork into the confines of a regular frame of 35mm film. A reverse process in the cinema would optically restore the artwork to its original widescreen format. At the invitation of Louis de Rochement, the studio undertook the initial development of animation for the original Cinerama screen, which at that time was divided into three segments fed by three combined 35mm picture tracks, supported by seven separate magnetic sound tracks. The screens, with a combined ratio of 1:2.85, were deeply curved, and shaped like the greater part of a half-cylinder. The same technique of lighting effects developed originally for *The Figurehead*, was used.

John Halas wrote in 1954 after the completion of the work: 'We constructed a miniature Cinerama screen in our London studio and started experiments with new plastic materials. My object was to achieve depth with the aid of light and create designs in this form. Covering the huge 51 feet Cinerama screen with drawings and animation alone would have taken us longer than the time we were allowed. The idea of drawing and painting with light had been tried out by my colleague Allan Crick in our film *The Figurehead*... Our aim was to create a series of artists' impressions of the people and places shown in the Cinerama film, *Cinerama Holiday*, all executed in the style of a mural but lit like a stained glass window. First, we set up a sheet of transparent curved plastic about six feet wide and four feet high, framed in wood. In front of this plastic sheet the Cinerama camera was to be stationed; to the rear of the plastic sheet and on a level with its upper edge were extended wooden slats supporting tight wires on which could be clamped our coloured plastic cut-outs in any position we wanted. Cloud effects were achieved on a second panel placed behind the main panel... The photography was carried out with

the normal Cinerama live-action camera, but with a reduced exposure to ensure the faithful reproduction of colour values... The exploitation of a wide-curved screen of such dimensions with such cameras for actuality subjects is natural, but with drawings and paintings these effects had to be created by human hands. It was necessary to compose 16 separate painted scene-shots, and we learned to adjust our technique of design to the huge, concave, cylindrical screen. We had, in effect, to create distortions in the design to exploit to the full the immense advantages to the artist of having such a screen at his disposal.'[6]

Far left One of the rostrum cameras used at the Stroud studio.

Left Camera set-up for *John Gilpin Rides Again*, from the *Poet and Painter* series.

Sound

With the film's soundtrack already recorded prior to the animation stage, all that is left is the final assembly and dubbing together of the various tracks (narration, voices, sound-effects and music) onto a single track which is then married (or synchronised) to the visual images. Jack King was an important figure at the Halas and Batchelor studio in the sense that he was a master editor, and made editorial suggestions in relation to Seiber and Chagrin's compositions. The role of the editor is greatly undervalued in animation, in that it is assumed that the pre-production process, and the specificity of creating only the animation required, negates the editor's role. It remains the case, though, that the 'cutting' of sound to image, and image to image, requires a particular expertise which ensures that the required rhythm and timing are consistent and technically 'invisible'. King played a major role in making such technical and aesthetic considerations merely part of a production process but nevertheless enhanced all the work he was part of.

Computers

Thirty-five years on from *Animal Farm*, John Halas expressed the opinion that animation was no longer an arcane profession limited to animators. 'Painters, designers, graphic artists, students in applied arts, and scientists are now probing its aesthetic and technical potentials,' he said. In the use of computer animation, Halas was even more confident. Rather than fear this technological breakthrough, he welcomed the useful contribution it could make to the medium. For his 1979 animated short *Autobahn* (a visual interpretation of the music of Kraftwerk) Halas experimented with simple computer graphics in order to design some of the film's various images. 'Computer animation is able to perform the animating steps quicker, and far less expensively than any previous method of animation,' he commented at the time. 'The computer's greatest contribution will be the execution of animation's arduous and repetitive tasks at a very high speed. Computer animation will soon be in the hands of a generation that will use it as naturally as we write a letter.'

Stan Hayward, scriptwriter and collaborator on a number of Halas and Batchelor projects, notes: 'In spite of appearing to be old fashioned, H&B was the most modern studio of the time. It was the first to use photocopiers printing onto cel, had one of the first automated rostrum cameras, used sound synthesisers, and it developed advanced storyboarding techniques when all of these items were rarely seen in other studios. Whereas other studios would work on the basis of a high profit margin for a few films, H&B would barely cover costs on some films, and kept the studio busy all the time. My enthusiasm for computers at that time met with very hostile responses from just about everyone in the animation industry. Computers were seen as a threat rather than a technique and this was at a time when virtually no computer animation existed at all. Certainly no studios in the UK were using them, but John Halas immediately took to the idea of computers as a potential technique for animation as it was consistent with more efficient production, but he also saw the broader implications of computers as an art form, and this vision probably came from his earlier involvement in the Bauhaus projects where art was not simply decorative, or creative expression, but a way of seeing the underlying purpose of design.'[7]

Roger Mainwood was one of the first animators to work with John Halas on a computer animation: 'It was my fortune in the late 1970s to be

invited to an interview with John. I was still doing my MA in Film and TV at the Royal College of Art and had just started putting out feelers for future employment in animation. At the interview I showed John a few animation pieces from my college course, and also a live-action film I had made in Shetland. It was mostly shots of puffins and gannets cut to a lively jazz track but it seemed to impress John, maybe more than the animation pieces! Anyway, the next thing he said to me was that although they didn't have any puffins on offer, only pigeons, would I be interested in coming into the studio to help make a music film that he was wanting to do? He sent me home with a recording of *Autobahn*, the influential album from the German band Kraftwerk, and asked me to come up with some designs for a 12-minute animation.

'Within a few days I had decided to leave the Royal College, earlier than planned, and I started work on my first professional animated film. The film was to be put out on a new format called laser disc, a technology that never really took off, and John hoped that some sections could employ computer animation. To this end we visited the Imperial College with one of my designs, a rotating cluster of extraterrestrial baby heads, and asked them if they could help us out.

'In 1977 computer animation was very much an emerging art and the truth was that we pretty much failed to come up with anything that could be used in the film. The computer was a monster by today's standards, taking up half a room, but what let us down was the method it had for printing out drawings. This involved a long mechanical arm with a humble pen on the end moving in rather jerky movements over a piece of paper. So we came away with a pile of very jagged and shaky drawings that couldn't possibly be used. I ended up having to animate the scene by hand, but of course John's showmanship didn't let a thing like that get in the way of him promoting the film as having computer animated sequences in it - well I suppose we had given it a go! Looking back, I can't believe how lucky I was that John was around to give me that opportunity and I will always be grateful to him for taking what must have been a considerable risk. The film went on to win a number of prizes at international animation festivals, and was shown at the 1979 London Film Festival, and on a number of TV stations in Germany and the States.

'As to what it was all about... well, there was a lot of what was thought of as 'psychedelic pop' imagery around at the time which never had a great deal of conventional meaning at all and I guess I was tapping into that. It gave me a great chance to have some fun with animation and learn a lot about technique and somehow I managed to produce a film that has stayed in the memory of a lot of people who saw it. Twenty-six years on and I am still getting emails from people who remember seeing it when they were growing up. They tell me how influenced they were by it and describe the viewing experience in great detail. One person even mentioned what they were wearing at the time. So I guess I must have been doing something right!'[8]

Nick Yates, who also worked on *Autobahn*, remembers that: 'Technically, we were using a PDP-11 computer with a flat-bed plotter and I only

Above Animation with the aid of a computer radar scanning from the film *Contact.*.

Right Computer-animated figures from *Dilemma,* originally sculpted by Hungarian artist and designer Janos Kass.

remember using inadequate Rotring drawing pens in it. Maybe it wasn't the pen's fault because the plotter held it straight upright and whacked it down onto the cel/paper and then dragged it around from point A to point B while the operator prayed that the ink would continue to flow. It was fine for straight lines but when the inconsiderate animator insisted on curved shapes from the machine it had to negotiate so many course changes that it lost its way. A circle would then end up looking like a pretty good rendition of a cornflake!'[9]

For the Leonardo Da Vinci segment of his 1980 series *Great Masters*, Halas used one hundred per cent digital animation for the programme's opening section followed by a series of photographs, animated illustrations of his youth and finally, both old-fashioned cel animation and computer graphics. By the time John Halas had begun experimenting with computers, the traditional methods of making animated films (like *Animal Farm*) were becoming increasingly obsolete. Not that this worried the creative team behind Halas and Batchelor. To succeed in the animation business, John Halas once said that you need three major disciplines. 'Firstly, you have to be more brilliant than anyone else. Secondly, you have to have a lucrative market. Thirdly, you need the factory behind it. Animation is so rich a media. It's like a pool, you can never reach all the sides at once.'

References

1. Quoted in Halas, J. and Manvell, R. *The Technique of Film Animation* (London and New York: Focal Press, 1976), p. 238.
2. Ibid., p. 249.
3. Ibid., p. 252.
4. All quotations unless otherwise stated drawn from Halas, J. and Manvell, R. *The Animated Film* (London: Sylvan Press, 1954) and Halas, J. *The Contemporary Animator*, (London: Focal Press, 1990).
5. Interview with Authors, Jan 2005.
6. *Op. cit.*, 1976, pp. 307–8. Halas and Batchelor also provided four minutes of animated inserts for Carl Foreman's live-action widescreen feature, *The Guns of Navarone* (1960).
7. Interview with Authors, Jan 2005.
8. Interview with Authors, Jan 2005.
9. Interview with Authors, Jan 2005.

From the wildest fantasy to the coldest fact

Halas and Batchelor - animation, art and cultural history

There is continuing irony in the fact that the work of Halas and Batchelor is still, for many, 'an undiscovered country'. This is all the more extraordinary because the success and longevity of the studio marks out Halas and Batchelor as the very embodiment of 'British animation' itself. Halas and Batchelor's work was always highly responsive to cultural context and practice; continually showed a progressive quality in their films' aesthetics and consistently demonstrated critical, social and philosophical engagement. Consequently and simply, therefore, the art of Halas and Batchelor is an interrogation of the ideas and ideological principles that define the developmental imperatives of British animation and culture since 1940. As Edgar Anstey, documentary maker at British Transport Films and long-time John Grierson associate, was to acknowledge in 1961, Halas and Batchelor had found 'a solution of serving three masters - art, industry and the public - and turning the solution into a national asset.'[1]

John Halas, and his wife and creative partner, Joy Batchelor, right from the outset of the company in 1940 and even in their previous work on the first British Technicolor cartoon, *Music Man* (1938), recognised that animation, as a form, occupied a place somewhere between graphic design, filmmaking and modern art and while they acknowledged that Disney had essentially defined animation throughout the 1930s in the *Silly Symphonies* and in the pioneering achievement of *Snow White and the Seven Dwarfs* (1937), they also saw a more far-reaching potential in the form. This has seen their work aligned with the 'breakaway' Disney artists of UPA (United Productions of America), Steve Bosustow, John Hubley and Dave Hilberman, but in many senses the work of Halas and Batchelor has more in common with the limited animation and political tendencies of the Zagreb Studios. This is unsurprising, of course, given Halas' Eastern European background, but it is important to stress that UPA were essentially opposing Disney's aesthetic and the industrial model it emerged from, preferring instead more auteurist approaches and embracing the idioms of modern art. The Zagreb School, and similar animation studios across Eastern Europe, however, were reacting to the far bigger agenda of oppressive government and totalitarian regimes. While, arguably, UPA

opposed the limited ideological stance of Disney's populism – though this in itself is problematic if Disney is viewed more as a left-leaning radical than a reactionary conservative[2] – it bears little comparison to the work of filmmakers seeking to use art to oppose repression and defend human freedom.

This factor should not be underestimated in the creative and social imperative of John Halas (and indeed, his fellow émigré, Peter Sachs at the W.E. Larkins Studio) in using animation for genuine democratic purpose; a perspective that accorded with the Griersonian imperatives of the 1930s, which had encouraged the abstract work of Norman McLaren and Len Lye as the embodiment not of social record – the main focus of John Grierson's documentaries – but of 'freedom of expression' in itself. The work of the Halas and Batchelor Studio also gained from the beneficial coincidence of establishing itself at the very same time as a socialist agenda was to dominate immediate post-war British politics and culture. Though both Halas and Batchelor never made any claims to a specific political purpose, they clearly had a left-wing prerogative and their work was utopian in tendency. Halas and Batchelor were ultimately, of course, much more interested in the philosophical and metaphysical nature of animation as a tool of creative expression, though it is important to note that the studio was highly instrumental in creating work that demonstrated the suitability of animation as a vehicle for mass communications – Joy Batchelor mused ironically, much later, when she was fully involved in educational practice, that she was surprised that her work was termed 'communications design'.[3]

Both Joy Batchelor and John Halas were, though, highly self-conscious about their work throughout their careers, always articulating their approaches, perspectives and beliefs, but it was Halas who was to write constantly about the expressive uniqueness and social purpose of animation. His role as a theorist should be valued as highly as his achievement as a practitioner and advocate. Writing about animation in a number of books and articles throughout his career, he defined the form as an art and a craft, but, equally, as a creative method to explore issues of social responsibility and moral outlook.

In July 1947, Halas argued that animation could accommodate 'the wildest fantasy to the coldest fact', suggesting the work that had taken place

during the war had essentially consolidated the animation medium in Britain as a model of communication, geared to 'instructional', 'educational', 'propaganda' and 'advertising' films.[4] This analysis offers up one of the first configurations of 'genre' in the animated form outside those defined by technique – the cartoon, stop-motion puppet animation and so forth. More importantly, the article also defines Halas' creative position through its critique of American comic strips and cartoons. Halas notes, 'One seldom finds a trace of real graphic art or mental maturity in them.'[5] He warms to his theme more vociferously some years later, writing 'European cartoonists are, by and large, artists who think in terms of conveying an opinion about life and attempt to convey thought and emotion through their work. Our American colleagues are satisfied to generate only excitement and temporary light amusement. Often, if they attempt to make a comment, their films become embarrassingly preachy and high-faluting.'[6] These are significant observations, because again, not unsurprisingly given Halas' own background and experience, they privilege the view that the philosophical imperatives of European 'modernity' only found genuine purchase in European artworks and ultimately and most pertinently, in the output and ethos of the Halas and Batchelor studio. As filmmaker and artist Matyas Sarkozi has confirmed, 'John Halas maintained throughout his life that cartoon film was primarily there to provide artistic visual experience, and its laughter-making role was of secondary importance.'[7] It was such a vision that made Halas and Batchelor, in the first instance, the foremost proponents of non-fiction animation and, consequently, demonstrated 'that this country [Britain] leads the world in cartoon film production'.[8]

Even in the contemporary era, this marks out Halas and Batchelor as champions of more progressive uses of animation, when in the public imagination the form is still thought of predominantly as 'Disney', or as light comic entertainment. It is pertinent to remember, though, that Halas was not merely arguing for animation to be understood as 'art' or 'education', but as a functional tool for a range of markets and contexts outside the realms of 'entertainment'. It was this that led him to champion the form to the United Nations as a vehicle for universal expression, able to break down the distinctions of language and territory.[9] This necessitated that he define the distinctive aspects of animation to business and political communities and persuade sponsors of the particular appeal of animation to both the popular audience, already seduced by Disney's

cartoons, and the lay or industry audience, which might require animation to relay specific kinds of instruction or information in a national and international context.

Writing for *Management* in 1949, Halas notes 'While the live-action camera is used to show what an object or a process looks like, animated drawings are usually relied upon to explain their meaning.'[10] Halas then goes on to describe the language of the animated cartoon, citing the 'symbolisation of objects and human beings'; 'picturing the invisible'; 'penetration' (showing the inner workings of something); 'selection, exaggeration and transformation'; 'showing the past and predicting the future'; and 'controlling speed and time' as the key elements which not merely show how animation works as a vocabulary of expression but why the subsequent images gain an enduring resonance. To use symbol and metaphor, or to reveal something not readily or literally seen by the human eye, or to focus upon a hitherto unnoticed aspect of something, or to redefine time, was to create a whole new plethora of images unseen by audiences; images which represented 'modernity'.

While the cartoon in the United States was essentially the consequence of 'modernity' and did to some degree engage with the aesthetics of European art, this was effectively in the service of depicting the new machine culture and its social and political effects. It was not explicitly in the service of 'ideas' and their expression. American cartoons reflected the new age rather than informed it. Halas, while being a fierce admirer of Disney films and their technical excellence, nevertheless wanted to move beyond the populist ideological imperatives intrinsic to Disney's folk idioms, or indeed, the Fleischer Brothers' more daring, surreal and sensual notions of American urbanity, to create a synthesis of art and philosophy, which he saw to be the central core of modern culture. Crucially, Halas was reconnecting the formal principles of 'modernist' art with the conduct and understanding of 'modernity' itself, particularly in Britain where many British artists, during the 1920s and early 1930s, sought the comforts of formalism in art for its own sake, rather than dealing with the on-going consequences of change still resonant from the First World War. It is useful to recall, too, that British animation made during the early years of the form itself was hugely resistant to other aesthetic influences, preferring instead a modernist 'take' on its own indigenous traditions in theatre, literature and illustration.[11] In many senses, this sustained itself in the work of Ernest Anson Dyer, during the 1930s, whose *Old Sam* films,

based on the highly parochial and dialect-based monologues of Stanley Holloway, were locked firmly in a 'British' model. Work which embraced European art practices inevitably seemed more progressive in this light.

A vivid example of this is the animated films of Anthony Gross and Hector Hoppin made in the mid-1930s, which remain a bold exemplar of a brilliant aesthetic sensibility, prioritising an almost surreal pastoral lyricism. *Joie de Vivre* (1934) and *Foxhunt* (1936) are high watermarks of modernist animation in Britain as they sought to respond to, and differentiate from, Disney's *Silly Symphonies*. As David Peters Corbett argues, however, 'even at its supposed high point in 1914, modernism was always a compromised formulation in England. Its promise of a radical public language with which to evaluate and comprehend modernity depended on a shaky anchorage in the shifting sands of English culture'.[12] It was Halas and Batchelor who understood that the indigenous subject could be addressed through contemporary approaches to European art, and in doing so, created work that reconnected with the real preoccupations of the modern world. The combination of the 'insider' – Watford-born Joy Batchelor – and the 'outsider', émigré John Halas, would prove invaluable in this respect.

It is no coincidence that it has always taken such an 'outsider' within the field of British animation to offer a more progressive vision. Halas (Hungary) stands in a long line of animators from elsewhere - Len Lye (New Zealand); Lotte Reiniger (Germany); Peter Sachs (Germany); Bob Godfrey (Australia); Richard Williams (Canada); George Dunning (Canada); and Terry Gilliam (USA), to name but a few who flourished in Britain, not merely by embracing British culture in their work, but by offering a more objective, if personal, interpretation of it as well. By viewing 'Britain' from an alternative perspective, and using animation as a progressive tool, each essentially exposed what the artist visionary, William Blake, was to call the 'contraries' of the culture; the contradictions and oppositions at its heart which were the true barometer of national character and continuity. Halas and Batchelor clearly understood these issues, resulting in an approach to their work which fundamentally addressed the seemingly contradictory aspects of the British sensibility - most notably, the notion that the British were backward-looking while forward thinking and also that they preferred plain speaking and the sense of the mundane at the parochial level, while aspiring to the epic and visionary on the national and international stage.

At the same time as war and its aftermath took its toll, Halas and Batchelor had to embrace the preoccupation of 'national character', which was under particular scrutiny in the arts. As Margaret Garlake has pointed out, 'In a number of books published during the 1940s, critics sought to define the British historical tradition in the visual arts in relation to national character... post-war commentators settled on Gainsborough, Blake, Turner and Constable as evidence that British Art has always been predominantly romantic, with individual informality and spontaneity as its distinguishing characteristics.'[13] Inevitably, this evaluation provoked debate, not least because it implicitly denied the influence of 'foreignness' and showed a lack of recognition for more 'realist' idioms in British art, when it was clear that these two aspects had, in essence, defined much of its tradition. Ironically, Halas and Batchelor embodied these very aspects, and were in the vanguard of once more mobilising 'tradition' while impacting 'modernist' idioms, more in tune with European ideas, in the service of creating a progressive vision of nation and nationhood. They were ultimately concerned with providing a fresh understanding of a changing contemporary world and providing a valuable artistic resource in the dissemination of knowledge and innovative thought. Simply put, Joy Batchelor drew on her sense of 'Britain' and 'Britishness' and her knowledge of the British love of engaging narrative, while John Halas brought his knowledge of modern art and philosophy to their creative bond, ultimately reinventing the form in the British context. It is this kind of 'modernism' that is at the core of Halas and Batchelor's work, and it is animation which becomes, to coin Peter Corbett's phrase, the 'radical public language' of expression that depicts and explains the 'modern world' in Britain.

It is clear from Vivien Halas' recollections earlier in the book, that the background and experiences of her mother and father were hugely instrumental in defining their artistic and philosophical stance. Halas had worked with legendary stop-motion puppet animator George Pal on early cut-out animated commercials, before joining the Bauhaus-influenced Muhely applied arts studio, training under Alexander Bortnyk and making short films with Laszlo Moholy-Nagy, Victor Vasarely and Tibor Szanto. The studio also embraced the tutorage of Paul Klee. Halas acknowledged the profound impact of the principles of the Bauhaus, largely determined by German architect Walter Gropius, who suggested that there was no fundamental difference between the fine arts and craft work, stressing

'The world of the pattern-designer and applied artist, consisting only of drawing and painting, must at last and again become a world in which things are built.'[14] Halas recognised that his art could have this sense of purpose and outcome and, while he never claimed that his work spoke to the tenets of constructivism, it is clear that he embraced Moholy-Nagy's view that 'Constructivism is pure substance - not the property of one artist alone who drags along under the yoke of individualism. Constructivism is not confined to the picture frame or the pedestal. It expands into industrial design, into houses, objects, forms. It is the socialism of vision - the common property of all men.'[15] It was not merely a 'socialism of vision', but a 'vision of socialism' which Halas then embraced when he returned to England at the end of the 1930s, thwarted in his ambition to develop his own 'Pannonia' studio by the increasingly right-wing, anti-semitic tendencies of Hungarian politics. The ability to address and solve inherent problems, which was at the heart of constructivist thought, was highly instrumental in the outlook that both Halas and Batchelor would have, thereafter, informing all aspects of their working endeavours.

Batchelor had joined Halas in his European sojourns after they became a couple during the making of *Music Man* and, though they sometimes found it hard to communicate, they shared the deep common interest of creating images. Batchelor trained at a small art and design school in Watford, England, picked up the techniques of animation working with the Australian, Dennis Connolly, on his film *The Eternal Triangle* and later became an illustrator. The couple married on their return from Budapest, not merely for romantic reasons, but pragmatic ones, too. Halas' status as an 'illegal alien' may have prevented him working in Britain at all, had he not married a British citizen and, even following their marriage, the couple were to encounter further attention concerning the legality of their presence. There is some irony, then, to the fact that their work was to become so important to the British government during the war and thereafter, as the epitome of effective communication in a singularly 'British' style, though, as I have stressed, this in itself was the outcome of a confluence of influences and circumstances.

In their early advertising films for J. Walter Thompson, the work undertaken for the Ministry of Information during the war and the post-war public information films for the Central Office of Information, for example, Halas and Batchelor drew upon the 'personality' animation so valued at Disney and aligned it with a European graphic sensibility. What is less

recognised is that Halas and Batchelor were not only combining Disney-style aesthetics and the more abstract confections of modern art in the studio's work as it became established in the early 1940s, but recalling and revising important aspects of indigenous British art and graphic design. The material culture of wartime and post-war rations met with a particular kind of enduring rationalism in English art which was always predicated on observation and function. As early as William Hogarth's *Analysis of Beauty*, there was recognition that 'Fitness of the parts to the design for which every individual thing is formed, either by art or nature, is first to be considered, as it is of the greatest consequence to the beauty of the whole', while Francis Bacon had written in his *Essay of Building*, 'Let use be preferred before uniformity, except where both may be had. Leave the fabric of houses for beauty only to the enchanted palaces of the poets, who build them with small cost.'[16] Halas' understanding of contemporary art and the imperatives of British art history combined with Joy Batchelor's skill and knowledge in graphic design and storytelling. As Richard Holliss has stressed, 'By the time war was declared in 1939, graphic design had come to play an essential part in political life, particularly at election times... the images of leaders, reinforced by repetition on the front pages of newspapers and illustrated magazines, on posters and postage stamps, became icons.'[17] Batchelor understood, though, that long before the war, British graphic design had embraced European modernist innovation in the work of E.M. Kauffer for Shell; Theyre Lee Elliot at the National Employment Exchange Service; and Moholy-Nagy himself, for the London Underground, while Eric Gill had published the hugely influential *All Art is Propaganda* essay in 1935, stressing 'it is impossible to do anything, to make anything which is not expressive of value.'[18] Gill's dogmatism is noted here because, while making an important point about the value-laden notions of art, it fails to recognise the specificity of propaganda messages. In the case of Halas and Batchelor, this is crucial, because their work becomes highly particular in the ways in which it expressed ideas and points of view, while taking into account these aesthetic tendencies and innovations.

Train Trouble (1940), for example, was a Disneyesque fable in the guise of an extended commercial extolling the virtues of Kellogg's Cornflakes as 'the 30-second breakfast'. This quick preparation time enabled Sam Squirrel to man his signal box on time and more efficiently, preventing the 'train trouble' of engines nearly crashing when he neglects his duties as a consequence of his preparation and consumption of a fried breakfast. *Dustbin*

Parade (1941) was an effective piece of wartime propaganda, which presented anthropomorphised pieces of old scrap and domestic waste signing up for recycling into wartime munitions and resources. Live-action shorts dealing with the same subject were largely patronising scenarios in which the educated middle class taught the working class what should be done to help the war effort. Halas and Batchelor created a far more persuasive and entertaining film in which the idea of sacrificing oneself to the war effort was shown through the actions of playful cartoon characters willingly and literally giving themselves up to a greater cause. This sense of universality and commonality of purpose was crucial to a consensual view. If these two films work as examples of the early commercial and propaganda films at the studio, it is surely *The Magic Canvas: A Study in Movement, Form and Colour* (1948) which defines Halas and Batchelor's artistic outlook, prefiguring an abstract film featuring a metaphor about the resilience of the human spirit, with a statement that sought to define the nature of their art: 'Here is something different from the ordinary cartoon film. It is a ballet in which dancers symbolise two aspects of man - one part of him soars up bravely like a bird and brings riches and joy to the earth; the other stays imprisoned and waits to be set free. Here is something new and exciting; relax and let your eyes and ears enjoy it.' The aspirational, spiritual and aesthetic intentions of the piece are clear and seek to use animation as a new language of enquiry and enlightenment. The studio perhaps best exemplified its understanding of the relationship between art, technology and progress, though, in their *Poet and Painter* series made for the Festival of Britain in 1951. Though these were largely rostrum-camera 'animations' of the dynamics of movement expressed in static works created by, among others, Ronald Searle, Michael Ayrton and Henry Moore, they nevertheless exemplified a recognition of the place of Halas and Batchelor in the British arts community, and animation as a progressive language of expression and modern thinking.

Halas and Batchelor always remained aware of the ways in which contemporary art could facilitate their endeavours. It should be remembered, for example, that by the early 1940s, the impact of photography had modernised graphic design, per se, requiring that 'caricature' - the staple of First World War propaganda - find redefinition. Halas and Batchelor were, once again, well placed to embrace these changes, especially within the formal contexts which now necessarily engaged with changing art practices in order to properly facilitate 'communications design' in the political arena. For example, the Ministry of Information organised

design groups in poster production to lift morale and provide information in the new context of war and also established an Exhibitions unit, under the auspices of Frank Pick, the publicity manager of the London Underground (who had much earlier encouraged work which allied art and information), which toured artwork and public instruction materials in a range of unconventional places. These included the Underground itself and decimated areas which had been bombed. The MOI recognised, however, that the poster was becoming increasingly outmoded in the new era of developing mass communications and, besides, paper was soon to be rationed. Film stock was not yet in short supply and the MOI quickly shifted its attention to making accessible short films. The public, however, soon become disengaged with newsreel and live-action shorts and it was clear that the animated short was to become crucial in bridging the divide between traditional graphics and modern art; the needs of propaganda and public information film; and the reconstruction of society itself.[19] The talents of Halas and Batchelor had found a profoundly appropriate place in which to grow and develop.

Halas, in particular, enjoyed the research aspect of the studio's development. In 1947, for example, Halas visited a number of continental studios and cinemas to research how animated advertising films were being made. His findings are interesting in that he identifies the fact that the general public across Europe were far more aware of and engaged with art and design in advertising, suggesting that 'the continental is a far more receptive onlooker than his or her counterpart in this country... He is more receptive to pictorial ideas than the British cinemagoer, but much less critical of story content', adding 'A well constructed pictorial composition could stir his emotions, while the same composition might fall flat in our cinemas.'[20] Halas realised, however, that 'The bulk of cinema advertising consists of slides, as it did before the war in Europe. These tastefully arranged slides, mostly based on poster technique, satisfy the local advertiser's demand.'[21] He was quick to see, therefore, that the cinematic innovations the Halas and Batchelor studio had achieved during the war in creating fully animated narratives with a modernist aesthetic, often echoing flat, more abstract poster art, were highly progressive and matched the standards of the Le Gemeaux studio in France, Goop Geesink's three-dimensional stop-motion ads for Philips in Holland, Jiri Trnka's propaganda films for the Czechoslovakian Film Corporation, and Pinschewer's films in Switzerland, which Halas especially admired as they had a 'wide appeal, as they are based on purely pictorial conception, a

language which has no boundaries.'[22] Halas' most pertinent observation, though, and a clear endorsement of the COI's scepticism about the effectiveness of poster campaigns, came with his evaluation of Les Gemaeaux' work: 'Like so many French advertising cartoons, this one ends with the product's poster, thus linking up the films with the publicity campaign. In spite of the effort to link up the story content with the poster, in most cases it introduces anti-climax to an otherwise charming film.'[23] It is in this respect, once more, that Halas found great benefit in his partnership with Joy Batchelor. Batchelor, as well as being a fine graphic designer, was also attuned to the needs of 'story' and the particular appeal that such narratives had for British audiences less well versed in understanding the purely visual. I will explore more of Batchelor's role as a key 'problem-solver' later in this discussion.

Halas and Batchelor's films were not merely geared to the British audience, though, and Derek Morgan, writing in 1949, suggested British cartoons 'create goodwill and establish a receptive frame of mind. In a way that is at once quite simple and clear, they outline for foreign audiences the idiomatic character and native expression of the country of their origin and, because their humorous appeal is universal, they do this sympathetically', adding 'They must condition overseas audiences to the British idiom, the British way of life, the British way of speech.'[24] Halas was not fearful of the burden of meaning in the studio's films but recognised, too, that the rhetoric of social progress was sometimes the substance of party politics and that the work had to privilege ideas over ideology.

For example, with Clement Atlee's commitment to both the war effort and social reform with the advent of victory, came the need to find a clear relationship between the role of the creative community and the development of a new cultural identity. Halas and Batchelor were not merely at the right place at the right time in the application of their creative skills, but completely in accord with the philosophical and moral agenda of the William Beveridge Plan, based on his 'Pillars of Security' which were to create a 'New Britain... as free as is humanly possible, of the five giant evils, of Want, of Disease, of Ignorance, of Squalor and of Idleness.'[25] This may seem a trite observation in the light of the self-evident need in the post-war period to find consensus and look to the future, but in a period in which 'graphic designers' were already perceived as 'commercial artists', and the 'Hot War' was almost immediately becoming the 'Cold War', it is important to take into account that Halas and Batchelor maintained

an intellectual understanding of their role and activities which preserved a highly self-conscious approach in their work to the relationship between art, industry and post-war culture. As Margaret Garlake has noted, 'The political reality of social reform had established the conditions for an expanded art support system, while higher educational standards, full employment and increased leisure contributed to a more widespread interest in the arts.'[26] Consequently, Halas and Batchelor were to interpret and service the needs of all sectors of the community while not sacrificing their own commitment to art, philosophy and moral rigour.

Having established themselves through highly conducive artistic and cultural conditions during the war, creating engaging advertisements and propaganda shorts, the company made the seamless transition to public information films, which serviced modern Britain, yet which work as aesthetic statements in their own right. The studio succeeded in fulfilling the requirements of their sponsors while enhancing their own technical and artistic reputation. The *Abu* series (1943) (including *Abu's Dungeon* and *Abu's Poisoned Well*), which were anti-fascist films, made in Arabic and shown exclusively in the Middle East during the war, had provided the template by which a central character could command the sympathy of the audience, even when that character might behave inadvisably, or find himself under threat from the Axis powers presented in the guise of a snake (Hitler) and a frog (Mussolini). It is one thing, though, to communicate effectively with the public when preaching to the converted, but quite another to successfully reach audiences with perspectives which are matters of potential debate and deliberation. It was Joy Batchelor, though, who had the ability to look at such a problem, and find its resolution in modifications of previous work - looking back at the trials of Abu, for example, or through innovation in story design. Batchelor, in fact, was a serious thinker about the role of script in relation to animation, always adhering to the view that 'Situations must arise from the story and they must be visual at the idea stage. It is a stern discipline, but the economy of means is part of the strength of animation in putting ideas across.'[27] *Charley's March of Time* (1947), for example, '[I]n addition to giving information on payments and benefits... had an additional 'goodwill' job to perform. General knowledge on this subject can only be fragmentary... [It was necessary] to gather up these pieces of knowledge and make a patchwork quilt, pretty enough to catch the eye, and so designed as to make unity and sense of the whole pattern of social insurance.'[28] It is no accident that Batchelor should have alighted on such a craft-oriented

metaphor. She recognised that the studio would have to find a suitable conduit by which the essential problem – 'Making the general public feel pleased to pay up to 6/2d [quite a sum then] a week for insurance [in relation to] sickness, unemployment, widow's benefit, death grant... [which were all things with] morbid visual associations' – could be resolved, and the narrative somehow made entertaining.[29]

Charley, the central character was created, therefore, in Halas' term as a 'sourpuss', complaining about 'paying out good money now to insure against a host of unpleasant future possibilities' but with the caveat that 'in any former existence he would have been glad to get off so cheaply.'[30] Crucially, Batchelor had identified two core issues. Firstly, the capacity for animation to play with 'time', and secondly, the British tendency to always look back at the past nostalgically as a resistance to change in the present, without ever recalling the difficulties of previous experience. 'I'd rather go back to the days before we had any of your wonderful insurance' says Charley, which acts as the narrative provocateur for the film as it recasts Charley as primordial embryo, caveman, medieval serf and modern day exploited employee, seeking security in eras when humankind was abandoned to the vicissitudes of a more chaotic and fatalistic time. As Batchelor notes, 'With Charley arbitrarily placed by the medium of the cartoon in a position where he can experience his age-old struggles for security, both he and the audience can, in the process, learn to value comprehensive insurance instead of scorning it.'[31]

There was considerable risk in creating Charley because he is not an 'empathetic' character; but he is, however, 'sympathetic' at the level of embodying public resistance, while going through the learning experience which he must have and, by implication, the public must have, in embracing the new order. Some argued that this was the same old propaganda. *Film Sponsor* went as far as to say that Charley represented 'the government's point of view in the cinemas' while noting that 'symbolising the man on the street, he is never allowed to utter more than one mild protest on any subject before he is relentlessly pounced on, nailed down and fed with the current government propaganda... and left at the end a sadder and goofier scrap of animation.'[32] This view is to neglect the urgency and particularity of post-war reconstruction and the fact that the public were literally being educated in both the provisional and direct impact of post-war modernity. Importantly and, revealing clear evidence of their identity as social progressives, Halas and Batchelor created

Charley as an effective conduit not for a nostalgic vision of a lost Britain, but for the political restructuring which would create a new one.

Arguably, it was this political and philosophical acumen, as much as the artistic merit in Halas and Batchelor's approach, which enhanced their position in the field, and ultimately led to their continuing involvement with the government in creating *The Shoemaker and the Hatter* (1949) to disseminate ideas about the Marshall Plan and, later, the studio's master-piece, *Animal Farm* (1954). Halas and Batchelor had been hugely successful in consistently using animation for serious purpose, while valuing accessibility and wit in its undertaking. Part of this success resulted from resisting the Disney-style hierarchical studio ethos and embracing a more collaborative approach, working with highly talented creative personnel who shared their vision and willingly brought to bear their highly in-vested contribution. The American, Philip Stapp, for example, was a very able writer, artist and animator who, like Batchelor, could translate com-plex information into visual metaphor and appealing narrative.[33] Stapp was an associate of Louis de Rochement, later the producer of *Animal Farm*, during his wartime naval service and had a ready understanding of political and strategic agendas. Halas and Batchelor had been charged with making the Marshall Plan accessible to the public, when there was a residual tension about the United States having withdrawn its lend-lease funding so soon after the war, in essence abandoning Britain economi-cally at the very moment its assistance was most required. The sense of economic betrayal was, of course, as nothing to the more emotive issues about the loyalty of allies so, though the Marshall Plan was a 'hands across the ocean' reconciliation, it was more a fundamental encouragement to embrace a 'United States of Europe' by appealing to those nations to rec-oncile economic issues by removing legislative obstacles to cross-border trading. Interestingly, at the W. E. Larkins studio, Halas' fellow émigré, Peter Sachs, took the opportunity of making a more personal film, *With-out Fear*, which warned of the damaging tides of both National Socialism and Communism across Europe, which had undermined any such kind of a unified approach. Embracing an English pastoral idyll and the sense of openness and democracy he felt in Britain, Sachs speaks to the idea of the Marshall Plan in an aspirant, almost spiritual, tone, while Halas and Batchelor remember the more parochial limitations of British life, seek-ing to explain the implications of the Plan to a 'nation of shopkeepers'. The metaphor of selling hats and shoes in *The Shoemaker and the Hatter* affords an opportunity for Halas and Batchelor to depict the failings of

a European industrial infrastructure, due to the costs and restrictions on import and export of goods, but presenting it on whimsical terms and conditions which kept the issues at an accessible level. The film argues that without customs barriers 'supply and demand' could essentially work for the prosperity of all. In some senses too, the film works as a critique of bureaucracy and legal constraint, but it is once again the use of symbolic characters as ciphers for core principles, which is at the heart of the film's success. While Disney had recognised that his characters could operate around a key personality trait - Donald's irascibility, Goofy's incomprehension - Halas and Batchelor created characters who embodied an idea. It was no coincidence that they were identified as a studio that could make *Animal Farm*.

Though it has been argued that Halas and Batchelor had been chosen by Louis de Rochemont to make *Animal Farm* as a CIA funded project, promoting tacit Cold War propaganda - an economically viable proposition in the sense that British animators were cheaper than their colleagues in the USA and also politically sensitive, as American animators were perceived as left-leaning activists. It is also the case that Halas and Batchelor were ready to revolutionise animation by bringing their serious approach to the form in a feature-length production. Animals had been almost uniformly represented as comic creatures; at best, distinctive only in the ways that they operated as a vehicle by which to circumvent social, sexual and religious taboos. In embracing George Orwell's fable as the serious tract it was intended to be, Halas and Batchelor effectively reintroduce 'the animal' back into the popular animated form -'They are not sentimentalised to suit human prejudices' recalls Batchelor, 'nor are they cutely humanised like most animals in cartoon films.'[34] There are long sequences of animal movement for its own sake; use of animal sounds for voices; recognition of the actual plight of animals in depictions of the abattoir and the compelling inevitability of the butcher's block and, with the exception of an amusing little duck, an approach which was as un-Disney-like as possible. Personality here is not used in the service of 'the gag' but in supporting the substantive aspect in the symbolic depiction of character. This enables the film to function as an engaging dramatic piece and not feel burdened by its metaphoric weight in retelling the story of the Russian revolution. Old Major (Marx/Lenin), Napoleon (Stalin), Boxer (the proletariat) and Snowball (Trotsky) all work as effective conduits for Orwell's dialogue and emotive purpose while operating on a metaphoric level. It is foremost fairytale and not fact but,

171

nevertheless, Halas and Batchelor impress their own credentials as propagandists and philosophers on the story. They use authoritative voice-over, heightened points of emotional empathy at moments of self-evident injustice and, controversially, modify the ending of the novel, changing the defeat of revolution, when animal becomes indistinguishable from humankind in its greed and brutality, into the victory of the re-mobilisation of the animals in further challenging their oppressive leaders. Halas claimed this was crucial in stressing the anti-authoritarian and humanitarian message of the film and sending the popular audience home with a note of optimism. The US would clearly endorse such a perspective in the Cold War period, but it does offer the alternative possibility of reading the film as a recognition of permanent revolution and ideological instability.

In many ways *Animal Farm*, while indisputably the studio's masterpiece, was also a highpoint that both previous and subsequent work has been measured against and marginalised by. This negates films of high quality but, perhaps more significantly, undermines the recognition for the studio's continuing efforts in remaining pioneering and progressive in their outlook. The *Poet and Painter* series, cited earlier, was followed, for example, by experimental work in stereoscopic animation in *The Owl and the Pussycat* (1952) and the Pal-like three-dimensional puppetry of *The Figurehead* (1953). *Little Ig* (1956), a playful story of a little boy living in the stone age, long anticipates Hanna & Barbera's *The Flintstones* in exploring a similar narrative terrain. *History of the Cinema* (1957) self-consciously pays tribute to, yet parodies, film culture in a way that the Hollywood 'Movie Brats' of the 1970s were to make their stock in trade. The studio's signature educational and instructional films, especially those made for BP, including *As Old as the Hills* (1950), *The Moving Spirit* (1953), *Speed the Plough* (1956) and *The Energy Picture* (1959), were praised by Dudley Knott, one of the senior officials of the company, as 'having a timeless quality in the sense that they do not age as films of actuality tend to age [and have] another timeless quality in that the passage of time itself can be squashed and squeezed and pulled at will.'[35] These films were the forerunners of the 8mm concept film loops, made by Halas and Batchelor throughout the 1960s, to enable the flexible delivery of most subjects in the schools' national curriculum at the time. Particularly effective were the films dedicated to showing anatomical movement and biological functions, prompting Dulwich College's biology master, Brian

Jones, to suggest that 'Loops on aspects of the behaviour of the amoeba have led the way in the field of microcinematography.'[36] Serge Kornmann was also to praise the studio's loops about La famille Carré in the teaching of modern languages, because they facilitated the teaching of conversational and contextual French, rather than the more traditional methods based on grammatical and textual idioms.[37] Joy Batchelor, in several papers written when acting as Director of the Educational Film Centre in the 1970s, stressed the need for this kind of visual literacy in young learners, admonishing the retrograde stubbornness of those committed to text-based learning; the technophobia of many deliverers; and the short-sightedness of educational policy makers, arguing also that a cross–disciplinary integrative approach was necessary: 'To the essential de-sign discipline must be added familiarity with those of drama, ballet and mime, together with social and literary studies.'[38]

Such thinking did not merely characterise the studio's approach to the field of education, but also to the entertainment cartoon. *Foo Foo* (1964), *Hamilton the Musical Elephant* (1961) and *Dodo the Kid from Outer Space* (1964), the latter being the company's first television series in colour, all spoke to the children's audience and the international market place by concentrating on visual humour and physical slapstick, deriving their style from sources as varied as Jacques Tati, Marcel Marceau, Dario Fo and animators from Eastern Europe and Japan. *Snip and Snap* (1960), featuring a pair of scissors and an origami figure, is also a fondly remembered and original children's entertainment. In this once more, Halas and Batchelor remained progressive, resisting the approach of Hanna & Barbera in the US – arguably, equally important in sustaining the economy and out-put of the American animation industry in the post-theatrical era – who concentrated on humorous scripts and bravura vocal performances in cartoons like *The Huckleberry Hound Show*. Further, Halas and Batchelor preserved their artistic integrity in two made-for-television projects – seven highly amusing *Tales from Hoffnung* (1964), based on the musical caricatures of Gerard Hoffnung, and the first animated opera, an adapta-tion of Gilbert and Sullivan's *Ruddigore* (1964). Joy Batchelor embraced the challenge of the latter film – actually a one-hour television special – recognising the profound difficulty of reducing the opera by over half of its original length, while responding to the condition that no words or songs could be altered or rewritten. The result resembled a combina-tion of the drawings of Ronald Searle and the more decorative work of

the Fauvist, Raoul Dufy; the exaggeration in the minimalist caricaturial design suiting the performance style of the piece, dramatising the often static aspects of traditional operas and enhancing the parodic and melodramatic aspects.

The *Tales from Hoffnung* were based on the humorous musical cartoons of graphic artist and musical clown, Gerard Hoffnung. Working in the tradition of Wilhelm Busch, the creator of Max and Moritz, and Zille, the pre-war chronicler of Berlin's social mores, Hoffnung became the master of the graphic pun, allying German tradition with English whimsy. Halas and Batchelor undertook the series of films with long-time associate, Francis Chagrin, who had collaborated with Hoffnung in his interplanetary music festivals described as 'extravagant evenings of symphonic caricature'. Chagrin was to write specific scores for the series, played by a six-piece ensemble, each characterised by pieces from a range of composers in a variety of idioms. It was the versatility of Chagrin and Matyas Seiber as composers in many of Halas and Batchelor's films which gave them a distinctive quality, largely because the pieces, in being written as scores, and not merely as clichéd 'visual accompaniments', self-consciously drew upon a wider vocabulary of classical references, exhibited great care in the composition, orchestration and arrangements and sought to make the emotional statement of the music as important as the animation itself. Even in the comic idioms of *Palm Court Orchestra* (1964), in which the ensemble carry on playing undeterred by a series of bizarre and escalating misfortunes, or *The Hoffnung Symphony Orchestra* (1964), in which the orchestra improvise as they await their very late conductor, the music functions as key determining element of the narrative and, crucially, a major element in redefining the codes and conventions of the cartoon.

In *Birds, Bees and Storks* (1964), Peter Sellers voices an embarrassed father in his attempt to communicate the facts of life to his off-screen son, amusingly stumbling, procrastinating and ultimately avoiding the issue altogether. The piece is characterised, too, by a tour de force piece of character animation as the father plays with his glasses, pipe, handkerchief and watch, as he flushes, sweats and prevaricates. At the very time when all the major American studios had closed their animation units that produced cartoons for theatrical distribution and were coming to terms with the crisis of adapting to creating what many industry veterans felt were inferior cartoons for television[39], Halas and Batchelor trusted their approach, foregrounding the high cultural idioms and artistic preoccupations of

their work as the tools by which they could once more modernise and extend the life of the cartoon form.

Since its inception the studio had always been forward thinking and remained dedicated to both the art of animation and its social and cultural applications. In 1969, John Halas wrote a 'state-of-the-art' piece for *Films in Review*, talking about 'Tomorrow's Animation', noting five key reasons why the language of animation would continue in its long history of adapting to new technologies and fresh cultural contexts, suggesting:

1. Animation has become an international activity and is no longer a monopoly of Hollywood.

2. The development of computer-generated film will alter the form, as well as the content, of film animation.

3. Animation is no longer an arcane profession limited to animators. Painters, designers, graphic artists, students in applied arts and scientists are now probing its esthetic [sic] and technical potentials.

4. In addition to supplying entertainment in theatres and on television, and advertising spots for TV, animation has become an essential teaching aid in education and industry; a pleasant mode of varying the opening credits of feature-length theatre films; an extension of the effects inherent in art mobiles, light paintings and kinetics; an unparalleled means of representing anything involving both time and motion.

5. The four foregoing causes engender a fifth: animation is no longer looked down upon as the poor relation of live-action cinema.[40]

This highly prescient and insightful summary marks out Halas and Batchelor's place in the field as creators and champions of all types of animation; innovative approaches to cross-disciplinary enhancement of the form; and polemical activists on behalf of the medium, best exemplified in Halas' role in the development of ASIFA. Despite having to temporarily sell the studio franchise to Tyne Tees TV, in which time vast amounts of 'Saturday morning cartoons', including *The Lone Ranger* (1967), *The Jackson Five* (1972), *The Addams Family* (1972) and *The Osmonds* (1973), were made for the American market, Halas and Batchelor continued to

make more personal and collaborative works. For example, the production of short films by Lee Mishkin and philosophical and technically progressive works like *Automania 2000* (1963), *The Question* (1967), *Autobahn* (1979) - the now cult video for Kraftwerk - and *Dilemma* (1981), all of which in some respects dealt with the relationship between technology and progress, and its effect upon humankind. Further, there were collections celebrating art - *The Great Masters* series (1984-86), animation - the *Masters of Animation* series (1987), and culture - the sadly aborted *Know Your Europeans* series (1995). Through all the personal, economic and social vicissitudes of the modern era, Halas and Batchelor survived and continued to define the animated form. In 1990, the studio made a film called *A Memory of Moholy-Nagy*, a tribute to Halas' one-time mentor and friend. It is a fitting tribute not merely to an artist but a commitment to the expression of the relationship between past and present; art and technology; abstraction and configuration; vision and achievement and is fitting testimony to John Halas and Joy Batchelor's lifetime investment in animation as the most progressive, democratic and liberating form of artistic expression.

References

1. Quoted in 'Kine Supplement', *Kinematograph Weekly*, 18 May 1961, un-paginated.

2. See T. Brode, *From Walt to Woodstock* (Texas, University of Texas Press, 2004).

3. J. Batchelor, 'Educating Image Makers', Halas & Batchelor Collection, Personal paper, p. 2.

4. J. Halas, 'The Animated Film', *Art and Industry*, Vol. 43, No. 253, July 1947, pp. 2–7.

5. Ibid., 1947, p. 2.

6. J. Halas, 'First Cartoon Festival', *Film and Television Technician*, Sept 1966, p. 429.

7. M. Sarkozi, 'Animation Doesn't Exist Solely to Make You Laugh: John Halas 1912–1995', *The Hungarian Quarterly*, NHQ, No. 36, Spring 1995, p. 145.

8. The assured opinion of reviewer 'R.S' in celebrating *As Old as the Hills* in *Film Sponsor*, Vol. 4, No. 3, November 1950, p. 22.

9. S. Hayward, 'The Universal Linguist', *The Guardian*, 30 January 1995.

10. J. Halas, 'Animated Film - New Applications', *Management: Films In Industry*, December 1949, pp. 30-31.

11. See P. Wells, *British Animation: A Critical Survey*, London, BFI 2006 (forthcoming).

12. D. Peters-Corbett, *The Modernity of English Art 1914–1930* (Manchester & New York, MUP, 1997), p. 18.

13. M. Garlake, *New Art, New World: British Art in Post War Society* (New Haven & London, Yale University Press, 1998), p. 64.

14. W. Gropius, 'Manifesto of the Bauhaus', April 1919, from V. Kolocontroni *et al.*, (eds), *Modernism: An Anthology of Sources and Documents*, Edinburgh, EUP, 1998, p. 301.

15. L. Moholy-Nagy, 'Constructivism and the Proletariat', 1922, in *ibid.*, 1998, p. 300.

16. N. Pevsner, *The Englishness of English Art* (London: Penguin Books, 1956), p. 125.

17. R. Holliss, *Graphic Design: A Concise History* (London and New York, Thames and Hudson, 1994), p. 104.

18. E. Gill, 'All Art is Propaganda', 1935, in V. Kolocontroni *et al.* (eds), 1998, *op. cit.*, p. 530.

19. See P. Wells, 'Dustbins, Democracy and Defence: Halas and Batchelor and the Animated Film in Britain 1940-1947' in P. Kirkham & D. Thoms (eds), *War Culture: Social Change and Changing Experience in WW2*, (London, Lawrence & Wishart, 1995), pp. 64-65.

20. J. Halas, 'Continental Studios Tell Story With Pictures Not Words', *Advertisers' Weekly*, 10 July 1947, p.64.

21. *Ibid.*, p. 64.

22. *Ibid.*, p. 66.

23. *Ibid.*, p. 67.

24. D. Morgan, 'Films Little But Important', *Everybody's Weekly*, 30 April 1949, p. 10.

25. W. Beveridge, *The Pillars of Security*, Government Papers, London, 1943, p. 81.

26. M. Garlake, *op. cit.*, 1998, p. 5.

27. J. Batchelor, 'Scriptwriting for Animation', Halas & Batchelor Collection, Personal paper, p. 3.

28. *Ibid.*, p. 3.

29. *Ibid.*, pp. 3–4.

30. *Ibid.*, p. 4.

31. *Ibid.*, p. 4.

32. M.M. 'Charley's Black Magic', *Film Sponsor*, May 1945, p. 175.

33. Philip Stapp was also an established filmmaker. Born in 1908, he was one of President George Bush's teachers at Connecticut's Greenwich Country Day School. After a period overseas, Stapp worked at Bennington College with the choreographer Martha Graham on her 'Every Soul Is a Circus' performance, but ultimately worked within the realm of educational and public-service films, combining abstract works with commonplace messages such as 'Watch your blood pressure' and 'War is bad', in a similar fashion to the way that Len Lye's film for the GPO *Boundary Lines* (1946) employs the metaphor of the 'dividing line' and the 'circle' to comment upon the divisiveness of one and the inclusiveness of the other. Stapp worked on the Marshall Plan films, contributing to scripts for a number of the projects. His film, *Symmetry* (1966), engages with the formal and aesthetic issues in symmetrical forms, looking at metamorphosis through abstract illustrations, while *The First American (Part 1): And Their Gods* (1969) about Mesoamerican history, explores different sacred codes and principles. Stapp's last film, made for the American Heart Association, has *A Game of Chance* (1979), warning of the perils of poor diet and excess.

34. J. Batchelor, 'Scriptwriting for Animation', Halas & Batchelor Collection, Personal paper, p. 7.

35. D. Knott, 'Cartoons Last and Last and Last', Halas & Batchelor Cartoon Animation Film Unit 25 Years Supplement, 1965, p. iv.

36. B. Jones, 'Biology Loops in the Classroom', *ibid.*, p. vi.

37. S. Kornmann, 'La Famille Carré', *ibid.*, p. xiii.

38. J. Batchelor, 'Educating Image Makers', Halas & Batchelor Collection, Personal paper, p. 3.

39. See M. Furniss (ed), *Chuck Jones: Conversations* (University Press of Mississippi, 2005).

40. John Halas, 'Tomorrow's Animation', *Films in Review*, May 1969, p. 293.

The vision

Left John Halas with
the bronze which was
presented to the BFI.
The head was sculpted
and cast by Birgitta Ara
(Finland).

Right Cannes 1956, Joy
Batchelor, John Halas, Paul
Grimault and Jean Image.

One of the most distinctive defining characteristics of John Halas, and to
some extent, Joy Batchelor, was the way in which both saw animation as
a vehicle not merely to create and communicate ideas, but as a universal
language which could actively bring about a real community of peo-
ple, able to transcend the boundaries of nationality, politics and cultural

specificity. Halas, particularly, was a champion of animation as an art, but
also an advocate for genuinely democratic endeavour through collabora-
tion and consultation. This led him to not merely produce work in tan-
dem with other practitioners but to be the driving force behind ASIFA
(Association Internationale du Film d'Animation), the International An-
imated Film Association. This section seeks to examine the importance
of this now long-standing and influential initiative, by embracing many
of the viewpoints and opinions of those who worked with Halas and
engaged with his vision.

Pat Raine Webb, Halas' former assistant, is still a highly active participant
in ASIFA's activities, writing about animation initiatives and judging on
Festival juries throughout the world. Here, she offers a perspective on
Halas and the evolution of ASIFA:

Animation's ambassador

John Halas was a remarkable man. He was unique inasmuch as he probably did more to promote the art of animation than anyone else. Animation was his passion.

My love for animation became a professional interest when I began working at the Halas and Batchelor studio in 1977 as John's assistant. I was already aware of some aspects of his contribution to the art of animation before I worked with him but did not realise just how much animation owed (and still owes) to his pioneering spirit and that of Joy Batchelor. (I did not actually work with Joy as she had left the studio by that time and was teaching at the London International Film School). I soon

Cannes Festival 1958. An international group of animators including Alexandre Alexeieff, Paul Grimault, Claire Parker, Bruno Bozzetto, Norman McLaren, Jean Image, Joy Batchelor and John Halas.

discovered John's deep interest in art and artists. Names that were new to me soon became familiar, among them Wilhelm Busch, the great German comic illustrator, and Moholy-Nagy, the Hungarian artist/designer, who was one of the founders of the Bauhaus movement. During my time in the studio John directed two series based on the Wilhelm Busch comic strips and produced a film about the work of Moholy-Nagy for the Museum of Modern Art in New York. John also introduced me to the world of animation festivals when I represented him at Zagreb in 1988, a festival I have worked closely with ever since, organising an exhibition of Halas and Batchelor's work and a British animation retrospective.

Film production was not the only area where John made a considerable impact. Another was his passionate involvement with the International

Animated Film Association which he helped to form. Founded in France in 1960, ASIFA came about when, in 1956, a few artists involved in animated film met during the Cannes Film Festival.[1] A meeting was organised in 1958 on the fringe of the Cannes festival and those taking part included such animation luminaries as Jiri Trnka (Czechoslovakia), Norman McLaren (Canada), Alexander Alexeieff and Paul Grimault (France), John Hubley (USA), Ivan Ivanov-Vano (USSR) and John Halas. During their discussions an idea took root. Why not form an association which would strengthen the position of animation throughout the world and give animation artists some sort of official recognition? In those days, very little screen time was given to animation at Cannes. The group's efforts finally bore fruit when, in 1960, the very first all-animated film festival was held at Annecy in France, an event that continues on an annual basis to this day and which has become the major event in Europe for animated film. After

Annecy 1960.
Raymond Maillet, Ivan
Ivanov-Vano, John Halas,
Joy Batchelor, Pierre
Barban and Paul Grimault.

that first festival the links forged between animators grew and spread and a draft structure of ASIFA was drawn up with one of animation's 'greats', the Canadian Norman McLaren, being appointed as its first president. ASIFA was set up as an association governed by French law with the aim of 'establishing links between all those who work in animation film throughout the world: to inform governmental bodies and the public of the importance of animation film'. The very first official function was a General Assembly held in September 1961 where a meeting of the Board of Directors took place with the name of John Halas being on the list of founder members. The first Secretariat was established in Paris, moved to Budapest in the 1970s and then to Annecy where it remained for several years before relocating to Zagreb in Croatia. ASIFA is also chartered under UNESCO as a membership organisation devoted to the encouragement and dissemination of film animation as an art and comunication form.

THISS ISS ONE OF
OUR ANIMATORS...

Left One of the more
printable drawings that
the animators would pin
up on the notice board.
This one was included
in the ASIFA tribute
to John.

Right John Halas in the
studio

(I once had a dog called
'Fips'. She loved John Halas
very much. Sometimes
he let her come to
his studio. Alison deVere)

Significantly, all this began to happen in the 1960s during the Cold War when East and West were divided, the Iron Curtain was still in place and the idea of a Russian animator and an American animator meeting face to face was not on the cards. It was ASIFA that enabled artists from every

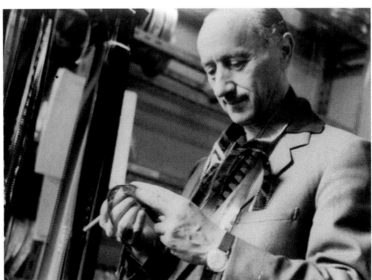

part of the world to become involved in the first steps taken to create an organisation dedicated to the art of animated film. John Halas was in the forefront of those pioneering days and instigated some of the very first meetings between Russian and American animators across the conference table. Animation artists from Israel and Russia visited each other's countries, something unheard of at the time.

John acted as Treasurer for a few years, then as Director General and Vice-President until he was elected President of the Association in 1976, a position he held until he retired from ASIFA in 1985 (when he was voted Honorary President). 1985 was also notable as being the Year of Animation - another idea that emerged from John's active imagination. Although he was officially no longer ASIFA's president he continued to promote animation in the way that he knew best, by getting artists and filmmakers together. As well as directing and producing some 2,000 animated films over the years (along with Joy Batchelor), he travelled widely as a representative of ASIFA and as an advocate of animation as an art form. Among the honours he received, one he treasured most was the Life Achievement Award presented to him by the Zagreb Animation Festival, one of the very first animated events to take place in the former

Yugoslavia in 1972 and still thriving today. His travels also took him to China for the first Shanghai International Animation Festival in 1988. Now there are literally hundreds of animation festivals all around the world, not only in Europe and America but also in Canada, Russia, Japan, Korea and India where studios have also been set up as a result of the exchange of animated film from different countries and between animation artists from all corners of the globe. Through ASIFA close contact is maintained with festivals in order to protect the rights of the filmmaker and, based on experience of these events, ASIFA has drawn up guidelines for festival organisers. ASIFA's support for festivals helps with mailing lists, securing film retrospectives and animated artwork exhibitions. All this has been inspired by that tiny beginning in the minds of a few people like John Halas.

Left John Halas with Bob Godfrey at a Zagreb Festival.

Right John Halas in Annecy. Cafés are very often the best place for meetings.

ASIFA has always played an important role in the support of animation - for example the development of the Shanghai based group in 1984 helped to introduce Chinese animation to the world. In 1995, ASIFA was instrumental in bringing the revered Chinese animation artist, Te Wei, to the Annecy Festival where he was interviewed and his films screened, revealing the extraordinary and totally original technique he had created.

Today the Association is represented in over 50 countries, as far afield as Japan, Korea, USA (with several groups), Mongolia, India and Cuba, with a world-wide membership of more than 3,000. ASIFA publishes an international magazine that began as a modest newsletter printed in Paris, followed by a bulletin printed in Bucharest. Later it was produced in magazine form in Hungary, Poland, Italy, Belgium and the Czech Republic. For the last few years it has been edited and printed in Canada and negotiations are currently taking place with a leading publisher for the next version. Many of the national groups also have their own publications.

Over the years many other activities have evolved. These include ASIFA's archive of animated film that has amassed some 500 titles of the finest animation from around the world. In 1982, an ASIFA Workshop Committee was set up and now there are 30 workshops in different countries

where children are helped to make animated films. ASIFA also created a label certifying the authenticity of graphic and three-dimensional works from animated films, and has served as an agent for its members with galleries and private collectors. There are ASIFA booths at all major festivals at which members' artworks are offered for sale.

As well as his activities for ASIFA, John Halas was also a prolific writer with around 20 books bearing his name on the art and technique of animation. He was a regular contributor to the German graphics magazine *Novum,* who also published his book, *Graphics in Motion* in 1981, an exploration of the art of animation from special effects to holographics. Always an innovator, John was very much aware of the experiments that had been going on in computer graphics and he was one of the first to promote computer animation when he made *Dilemma* in 1981, a short film tracing the history of mankind and asking whether technology would be used for good or ill. The film was launched at the UK's first computer graphics conference held at the Café Royal that same year; an

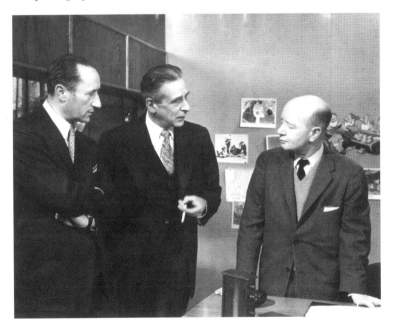

Right John Halas with Alexander Alexeieff *middle* and Richard Huemer right.

(After a worldwide e-mail search to identify him, John Canemaker wrote to say 'I believe it is animator/writer Richard Huemer, who collaborated on *Fantasia* and *Dumbo* with Joe Grant. This looks like Halas and Alexeieff were visiting the WD studio in Burbank in the mid-1950s - it might actually be a set for the Disneyland TV series Huemer wrote the script for, *The Story of the Animated Drawing* - a truncated history of animation for television).

event which John instigated, and I organised. *Dilemma* was distributed theatrically with the Star Wars feature *Return of the Jedi* and I recall that at the time the studio was inundated with phone calls from the British public wanting to know more about *Dilemma* and how it was made.

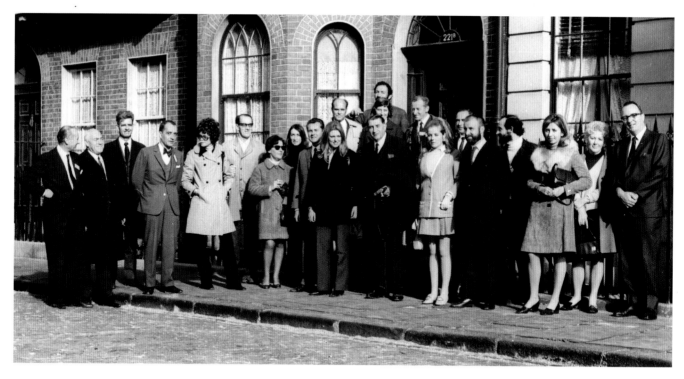

His energy was phenomenal. Even after his eightieth birthday he was still planning the next project, *Know Your Europeans*, a series introducing the European Community countries (and their foibles) to each other. Only ill-health finally forced him into semi-retirement in 1993 and the world of animation was saddened to learn of his death the following year. Tributes flooded into ASIFA from all corners of the globe and some are quoted opposite.

The tribute I love best, for it sums up how so many people felt about John, is the one from Edward Nazarov (opposite).

John was truly an international man. He loved animation and communicated that love throughout the world. Animation was his life and he was one of its greatest ambassadors. I will always have an abiding love for animation and for John, who taught me what a wonderful medium it truly is.

Pat Raine Webb

The first ASIFA meeting in London, Baker Street. October 1969. *From left to right* John Halas and guests including Fedor Khitruk (USSR), Karlssen (Sweden), Max Massimiso Garnier, (Italy) Gyula Macskássy (Hungary) Françoise Jaubert (Canada), Dick Rauh (USA East), Todor Dinov (Bulgaria), Katja Georgi (East Germany) György Matolesi (Hungary), Jerzy Kotowski (Poland), Ivan Ivanov-Vano (USSR), Joachim Kreck (West Germany) Manuel Otéro (France), Annie Debilde (interpreter), Sandy Fleet (USA West).

Right Pat Raine Webb, John's assistant from 1977 to 1992.

John Halas was one of the most
outstanding animators in the world and he
was also a good friend to
Chinese animators. He devoted all his life
to international animation. All the
members of ASIFA China will cherish the
memory of him.
Yan Ding Xian, President ASIFA China

John was a unique figure. He achieved that
rare combination of being an artist and a
politician at the same time.
His tremendous commitment in matters of
culture and to animated film in particular,
however, set him apart.
I always admired his enthusiasm and his
openness to all new ideas and
developments that might add to the
advance of the art of animation.
Jerzy Kucia, Poland

He embodied ASIFA as a symbol of unity
for animators in the whole world.
Fedor Khitruk, Russia

Gentle father left his crazy family ...
But all of us, silly animated kids, we have to
be together and we must
remember. He spent so many years to
create this huge and beautiful family. Thank
you John. Thank you father.
Edward Nazarov, Russia

For me he will always be the man who
created a bridge between East and West in
the era of the Cold War.
The man who brought animation to the
awareness of many.
Yoresh, Israel

John Halas's passion to elevate the
animation industry represented the
pride of animation artists. When he was
President of ASIFA he supported us
strongly and generously to realise the first
Hiroshima Animation Festival.
Renzo Kinoshita, Japan

The Legacy of John Halas

Halas clearly felt the strongest imperative that animation as a form deserved proper recognition, and that animators should be seen as distinctive artists. It is clear that he knew the factors that mitigated against animation receiving its proper acknowledgement as an art – the prominence of the American cartoon tradition and its assumed place within 'popular' or 'low' culture; the prevailing idea that animation is merely a children's entertainment, or intrinsically 'comic'; and the lack of significance attached to the short form, especially in regard to mainstream distribution and exhibition. He noted 'The domination of cheaply made Japanese and American animation began to do real harm to the young generation and the gradual advances of animation in arts and adult entertainment required a centre where such advances could be propagated, helped, seen and found an outlet.'[2]

From very early in his career, Halas had championed animation as an international, high cultural activity for adults, which could be used for serious purpose and which should find its place and be shown in as many contexts as possible. In the contemporary era, the core issues which Halas was preoccupied with are still of concern but, through the Halas and Batchelor studio's work and the efforts of ASIFA, all that he championed is now established and accepted. This was largely because the core principles he and others valued so much found dissemination through increasing numbers of Festivals and the ways by which animation became important in the business, art and educational spheres as well as in the entertainment field. At the end of Halas' ten-year tenure as President of ASIFA in 1985, the United Nations approved 'The Year of Animation', to celebrate the anniversary of the inception of cinematic practices.

British animator Graham Ralph called Halas 'the filmmaker, the innovator of technique in animation, the statesman of World Animation, the author of books', but remembered him best 'for all the first chances he gave animators to work in the business. The likes of Oscar Grillo, Geoff Dunbar, Ian Emes, Brian Larkin, and myself, a twenty-year-old inexperienced student who found his first job under [his] auspicious eye.' Ralph's colleague, Brian Larkin, remembers: 'After leaving art school I applied and was accepted for a place on an animation training course in Stroud, Gloucestershire. This was organised and run by Harold Whitaker and funded by Halas and Batchelor. We were actually paid to be taught.

The main object of the course was to train assistant animators for the main studio in London, which was at that time working on *The Addams Family* series. I soon realised that, although I enjoyed animation, I found it creatively dull as I was being trained as a traditional 'cartoon' animator. I left and joined an advertising agency. Big mistake. So I wrote to John Halas in London and explained that I was more interested in the creative and graphic aspects of animation rather than the cartoon side. He wrote back straight away explaining that was exactly what he was always striving to achieve in his work.

'I obviously had struck the right note. To my surprise John asked me in to the studio and offered me a position as an animator. I had skipped the technical assistant stage. It was sink or swim. John placed his trust in me

John Halas in the 1970s when Graham Ralph and Brian Larkin worked on *Max and Moritz.*

so there was no way I was going to let him down. I owe it to John that he gave me that first opportunity, as indeed he did with many other young animators in the animation industry. Halas and Batchelor, and particularly John, will always be regarded as one of the main pioneers of British animation but I think it was his promotion of young talent and the embracing of new ideas that he will be equally remembered for.

'A few years later I particularly remember one occasion when I was working on a very difficult production and a very tight deadline. I went to see him in his office and told him it was hopeless; we could not do it within the time. He paused, slowly removed his glasses and said to me, "Just give me one glimmer of hope." Ever the optimist. I left and promptly finished the job within the schedule. Another time I asked him for more help on a short film I was animating. He looked at me quite painfully and put both his hands inside his empty pockets. He pulled the linings out completely with his thumbs and forefingers saying, "But I have no more money." A well rehearsed trick that always had the desired effect that I had to carry on and get it done somehow!'

It is clear from such recollections that Halas' vision was played out from 'the grass roots', in the sense that in some ways it is easy to have a grandiose idea about something, but to find an infrastructure by which it could be achieved necessitated that Halas trust the raw talent which passed

through his studio, nurture it, encourage high standards, and create outcomes. Only this would give Halas and Batchelor a place on the world stage, and consequently, a voice in how the form itself should progress and grow. Veteran animator, Derek Lamb, notes 'John had a unique vision of the animation business and his place in it. A major ambition of his was to make ASIFA an international force, which he did. He taught us that talent alone is nothing without perseverance. Determination and tireless commitment were his most remarkable strengths. They allowed him to achieve a great deal and influence a great many people.' This Halas did, throughout his whole career, sometimes operating as a guarantor not necessarily for the financial aspects of a project, but for its progressive nature or its artistic necessity.

Tamas Waliczky, creator of *A Memory of Moholy-Nagy* (1990) remembers: 'The first problem was that the game-computers we used could not produce images to fit the broadcast or film standards. The honorarium John Halas had offered me was not enough to buy a professional computer animation system. (At that time they were terribly expensive!) But at this point his well-known name helped. My boss, Andras Csaszar (director of Novotrade Computer Game Studio), who was a very careful businessman but also liked me a lot, took John Halas' name as a guarantee: he believed that if John Halas was interested in making a computer animation with me, then this should be the starting point of a new international business, and therefore it was worth investing in it. He (Novotrade Company) gave me the rest of the amount we needed to buy the necessary professional equipment. (A few years later, when I won the Golden Nica prize in Ars Electronica Festival, Linz, I gave half of my prize money to them, trying to reimburse their generous help.) John Halas came to Budapest again, signed the contract, and gave me the storyboard of the animation he wanted me to produce. John Halas' idea was a computer animation based on Moholy-Nagy's constructivist paintings and sculptures. He included a catalogue of Moholy-Nagy's works, and in his hand-drawn storyboard he described which painting should be transformed into another, what kind of movements should be designed to which forms, and so on. He was patient, understood my problems with the technology. He was wise, listened to my suggestions, sometimes let me change elements in the storyboard, but sometimes explained to me why he wanted to keep others. He did not behave as a producer. He behaved like an old artist to a young one. It took me two years to finish the animation. He then added some documentary parts to it, and sold it to large public collections, like

Számítógép-tervezés

Stamp to celebrate computer animation dipicting John Halas. Designed by Janos Kass for the Hungarian Post. This was the first time that a living person was depicted on a postage stamp in Hungary.

the Rolland collection. He let me edit and use a different version of *A Memory of Moholy-Nagy:* My version contained only the computer animation scenes I did with the music of my Hungarian friend, Llaszlo Kiss. John Halas even let me send this version to different festivals. It was quite successful: it won four international prizes.'

In the view of French master animator, Michel Ocelot, this attitude and approach made Halas 'a Hungarian and a Briton and a citizen of the world', and someone who 'defended a slightly despised medium as a major art and made undeterred statements on it, (never afraid) of swimming upstream', concluding that the work of ASIFA in his light was 'a moral adventure'. This observation is perhaps the most important insight into Halas, and the fundamental relationship he saw between animation as a form of uninhibited creative expression in the service of representing the most affecting and penetrating aspects of the human condition in a way not possible in any other form. For all the ambition and artistry of Halas and Batchelor's achievements it is this intrinsic morality in the use of a progressive art form that marks out the man and the studio as hugely significant in the growth, development and contemporary omnipresence of animation in the modern world. As another animation master, Jerzy Kucia, confirms, 'His high regard for the medium of animation was shocking even to us who worked within it. A few years ago he publicly announced that it would become the most prominent of all the arts'. Few would disagree that Halas was right. His prescience, foresight and artistic gifts - coupled with the complementary talents of his wife and creative partner, Joy Batchelor - have ensured that animation will have a permanent and influential place in world culture for years to come.

References

1. Halas recalls the initiative as being led by Pierre Barbin and André Martin, and that early approaches to animators like Jurica Peruzovic, Steve Bosustow and Bruno Bozzetto about the development of an organisation received favourable responses. J. Halas, Personal paper on ASIFA, Halas & Batchelor Collection, p. 20.
2. J. Halas, Personal paper on ASIFA, Halas & Batchelor Collection, p.20.

A tribute to John from Borivoj Dovnikovic, Croatia.

Halas and Batchelor 1936 -1995

This following list covers the principal productions of John Halas, Joy Batchelor and the Halas and Batchelor studio from 1936.

1936
Nikotex

1938
The Brave Tin Soldier
Music Man

1940
Train Trouble
Carnival in the Clothes Cupboard

1941
Dustbin Parade
Filling the Gap

1942
Digging for Victory
The Fable of Fabrics

1943
Abu series
Abu's Dungeon
Abu's Poisoned Well
Abu's Harvest
(Khahil Builds a Reservoir)
Abu Builds a Dam
Jungle Warfare
Compost Heaps
Model Sorter
I Stopped, I Looked
Early Digging

1944
Cold Comfort
From Rags to Stitches
Blitz on Bugs
Mrs Sew and Sew
Christmas Wishes

1945
The Big Top
Tommy's Double Trouble
Six Little Jungle Boys
Handling Ships

1946
Old Wives' Tales
Radio Ructions
Brtain Must Export
Export or Die
Export! Export! Export
Road Safety
The Keys of Heaven
Good King Wenceslas
A Modern Guide to Health

1947
Charley series
Charley in the New Towns
Charley in 'Your Very Good Health'
Charley's March of Time
Charley's Black Magic
Farmer Charley
Charley Junior's Schooldays
Robinson Charley
Dolly Put the Kettle On
This is the Air Force

1948
Heave Away My Johnny
Water for Fire Fighting
Oxo Parade
Magic Canvas

1949
First Line of Defence
Fly About the House
What's Cooking?
The Shoemaker and The Hatter

1950
As Old as the Hills
Earth in Labour

1951
Moving Spirit
Poet and Painter series
Twa Corbies
Spring and Winter
Winter Garden
Sailor's Consolation
Check to Song
In Time of Pestilence
The Pythoness
John Gilpin

1952
The Owl and the Pussycat
We've Come a Long Way
Linear Accelerator

1953
The Figurehead
Power to Fly

1954
Animal Farm (1951-54)
Down a Long Way
The Sea

1955
Animal Vegetable Mineral
Popeye series

1956
The World of Little Ig
The Candlemaker
To Your Health

1957
History of the Cinema
Midsummer Night's Dream
All Lit Up

1958
Christmas Visitor
The First 99
Follow That Car
Best Seller
Paying Bay
Dam the Delta
Speed to the Plough
Early Days of Communication

1959
How to be a Hostess
Man in Silence
For Better for Worse
Energy Picture
BP Piping Hot

1960
Foo Foo series
Habatales series
Snip and Snap series
The Monster of Highgate Ponds
The History of Inventions
(Bruno Bozzetto)
Wonder of Wool
Guns of Navarone (excerpts)

1961
Hamilton the Musical Elephant
Hamilton in the Music Festival
8mm Concept Films (1961-69)

1962
The Showing Up of Larry the Lamb
(Toytown)
Barnaby series
Father Dear Father
Overdue Dues Blues

1963
Automania 2000
The Axe and the Lamp
The Tale of the Magician
(Toytown)

1964
Tales from Hoffnung series
The Carters of Greenwood
series
Martian in Moscow
Evolution of Life
DoDo series
Ruddigore
Paying Bay
Follow that Car
Les Aventures de la Famille Carré
teaching series

1966
Classic Fairy Tales
Flow Diagram
Linear Programming,
Matrices and Topology
Dying for a Smoke
Deadlock

1967
Lone Ranger series
The Question
What is a Computer?
Girls Growing Up
Mothers and Fathers
The Colombo Plan
The Commonwealth

1968
Bolly
Functions and Relations

1969
Measure of Man
To Our Children's Children

1970
Flurina
Short Tall Story
The Five
Wot Dot
Tomfoolery series
This Love Thing

1971
Children and Cars
Football Freaks
The Condition of Man

1972
The Addams Family series
The Jackson Five series

1973
The Osmonds series
Children Making Cartoons
Contact
Making Music Together
(Lee Mishkin)
The Glorious Musketeers
The Twelve Tasks of Asterix

1974
Kitchen Think
(Lee Mishkin)
European Folk Tales series
Butterfly Ball
(Lee Mishkin)
Carry on Milkmaids

1975
How not to Succeed in Business
Life Insurance Training Film

1976
Max and Moritz series
Skyrider

1977
Making it Move
Noah's Ark

1978
Wilhelm Busch Album series

1979
Bravo for Billy
Autobahn
Dream Doll
(Bob Godfrey, Zlatko Grgic)

1980
Bible Stories

1981
Dilemma

1983
Players

1984
Great Masters series
Botticelli

1986
Great Masters series
Leonardo da Vinci
Toulouse-Lautrec

1987
Masters of Animation series
1 United States
2 NFBC Canada
3 CBC Radio Canada
4 Japan
5 USSR/Russia
6 Great Britain
7 Former Yugoslavia
8 Hungary
9 Italy
10 France
11 Poland
12 Computer Animation part 1
13 Computer Animation part 2

1989
Light of the World

1990
A Memory of Moholy-Nagy

1995
Know Your Europeans, UK
(Bob Godfrey)
Know Your Europeans, Germany
(Christoph Simon)

For further information and film
credits please consult:

The Halas & Batchelor Collection
Southerham House, Southerham,
Lewes, East Sussex BN8 6JN
www.halasandbatchelor.com
www.halasandbatchelor.co.uk

Animation Research Centre
University College for the Creative Arts
Farnham, Surrey GU9 7DS
www.ucreative.co.uk
www.surrart.ac.uk/arc

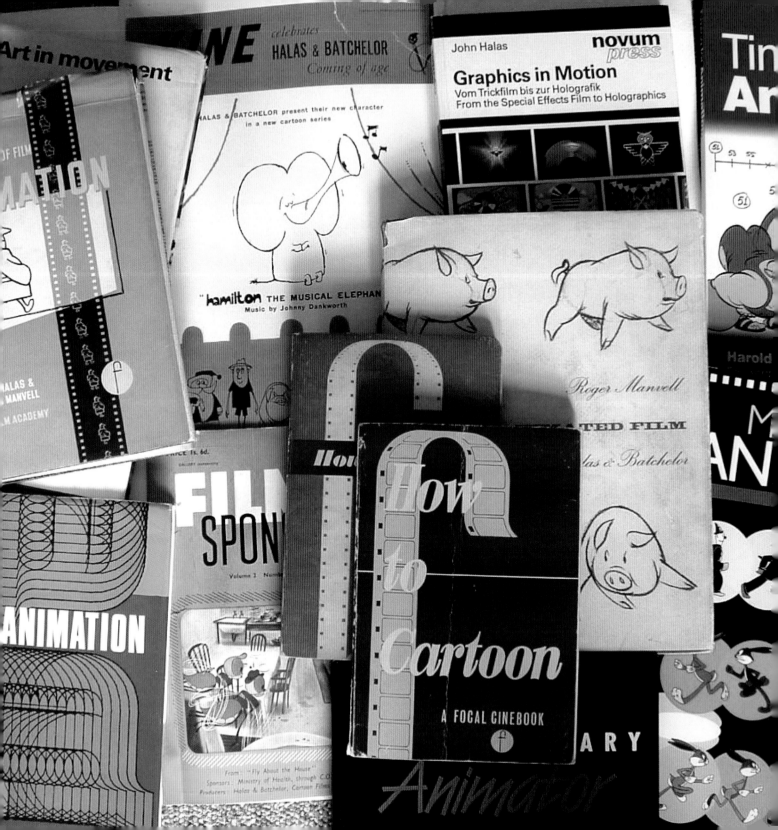

Bibliography

The following bibliography is not exhaustive but an indication of work undertaken about the studio.

J. Canemaker, 'Animation: First Cambridge Festival', *Film News*, Winter 1979, pp. 26-28.

J. Canemaker, 'Halas and Batchelor', *Funnyworld*, 23, Spring 1983, pp. 3-12.

K. Clark 'What Makes the Brain Tick ?', *Animator*, Issue No. 21, Oct/Dec 1987, pp. 27-28.

K.F. Cohen, 'Animated Propaganda During the Cold War', http://mag.awn.com/index.php?ltype=search&sval=Animal+Farm&article_no=1611, 21 February, 2003.

E.Coulter-Smith, 'Halas and Batchelor, Animation and Persuasion' in 'Wartime Propaganda to Animal Farm', section in K. Rockett & J. Hill (Eds.) *National Cinema and Beyond: Irish Film Studies*, Four Courts Press. In Press.

B. Edera & J. Halas, *Full Length Animated Feature Films*, London & New York: Focal Press, 1977.

D. Gifford, *British Animated Films 1895-1985: A Filmography*, Jefferson, N.C. : McFarland & Co, 1987.

J. Halas, 'The Film Cartoonist', in O. Blakeston (ed), *Working for the Films*, London & New York: Focal Press, 1947, pp. 161-168.

J. Halas, 'The Animated film', *Art and Industry*, July 1947, pp. 2-7.

J. Halas, 'Continental Studios Tell Story With Pictures, Not Words', *Advertiser's Weekly*, 10 July 1947, pp. 64-67.

J. Halas, 'Animated Film - New Applications', *Management*, Dec 1949, pp. 30-31.

J. Halas, 'The Latest Developments in Animated Film', *British Kinematography*, January 1952, pp. 4-7.

J. Halas, 'The International Animated Film', *Journal of the British Film Academy*, Winter 1956, pp. 1-10.

J. Halas, 'Not For Fun!', *Films and Filming*, Vol. 3 No. 2, Feb 1956, p. 6.

J. Halas, *Design in Motion*, London: Studio Vista, 1962.

J. Halas, 'First Cartoon Festival', *Film and Television Technician*, Sept 1966, pp. 428-431.

J. Halas, *Graphics in Motion*, Munich: Novum Gebrauchs-Graphik, 1982.

J. Halas, 'Tomorrow's Animation', *Films in Review*, May 1969, pp. 293-296/307.

J. Halas, *Computer Animation*, London: Focal Press, 1974.

J. Halas, *Visual Scripting*, New York: Hastings House, 1976.

J. Halas, *Film Animation: A Simplified Approach*, UNESCO, 1976.

J. Halas, *Masters of Animation*, London: BBC Books, 1987.

J. Halas, 'Animation and Art', *Animator*, Issue No. 25 July 1989, pp. 21.

J. Halas, *The Contemporary Animator*, London & New York: Focal Press, 1990.

J. Halas & J. Batchelor, 'Producing "Animal Farm" ', *British Kinematography*, Vol. 24 No. 4, pp. 106-110.

J. Halas & J. Batchelor, 'Approaches to Cartoon Film Scripts', *This Film Business*, December 1948, pp. 12.

J. Halas & R. Manvell, *The Technique of Film Animation*, London & New York: Focal Press, 1st Ed 1959 (subsequently reprinted).

J. Halas & R. Manvell, *Art in Movement; New Directions in Animation*, New York: Hastings House, 1970.

J. Halas & B. Privett, *How to Cartoon*, London & New York: Focal Press, 1958.

J. Halas & D. Rider, *The Great Movie Cartoon Parade*, New York: Bounty Books, 1976.

J. Halas & H. Whitaker, *Timing For Animation*, London & New York: Focal Press, 1981 (subsequently reprinted).

A. Hemsing, 'The Marshall Plan's European Film Unit 1948–1995', *Historical Journal of Film, Radio and Television*, Vol. 24, No. 2.

W. Herdeg & J. Halas, *Film & TV Graphics: An International Survey of the Art of Film Animation*, Zurich, 1976.

J. Huntley, 'Animation in Britain', *Journal of the British Film Academy*, Winter 1956, pp. 1-10.

A.E. Jeakins, 'A Film Technician's Notebook', *Cine Technician*, May 1955, pp. 70-72.

D. Jefferson, 'The Masters of Animation', *Animator*, Issue No. 18, Jan/Mar 1987, pp. 24-25.

D.J. Leab, 'Animators and Animals : John Halas, Joy Batchelor and George Orwell's 'Animal Farm', *Historical Journal of Film, Radio and Television*, Vol. 25, No. 2, 2005, pp. 231-250.

R. Manvell, *The Animated Film: With Pictures from the Film 'Animal Farm'* by Halas & Batchelor, London: Sylvan Press, 1954.

R. Manvell, *Art & Animation*, London: Tantivy Press, 1980.

D. Morgan, 'Films Little But Important', *Everybody's Weekly*, 30 April 1949, pp. 10-11.

M. Sàrközi, 'Animation Doesn't Exist Solely To Make You Laugh', *The Hungarian Quarterly*, No. 36, Spring 1995, pp. 144-149.

T. Shaw. *British Cinema and the Cold War: the State, Propaganda and Consensus*, London: I.B. Tauris, 2001.

J. Southall, 'Cartoon Propaganda and the British School of Animation', *Animation Journal*, Vol. 8, No. 1, Fall 1999, pp. 74–87.

P. Wells, 'Dustbins, Democracy and Defence: Halas and Batchelor and the Animated Film in Britain 1940-1947', in P. Kirkham & D. Thoms (eds), *War Culture: Social Change and Changing Experience in WWII*, London: Lawrence & Wishart, 1995, pp. 61-72.

Author Not Stated, 'From White Paper to Colour Cartoon', *COI Review*, 1949, pp. 27-29.

Author Not Stated, 'Halas and Batchelor', *Supplement to Kinematograph Weekly*, 18 May 1961.

Awards

Here are just a few of the 200 international awards nominations and prizes won at film festivals over the years by Halas and Batchelor.

Handling Ships
Cannes 1946

Modern Guide to Health
Brussels, First Prize 1947

Charley in New Town
Edinburgh 1948
Cannes 1948

Farmer Charley,
Charley's March of Time
Edinburgh 1949

British Army at your Service
Edinburgh 1950

Magic Canvas
Edinburgh 1950
Cannes 1950

As Old as the Hills
Venice, First Prize 1950

The Shoemaker and the Hatter,
John Gilpin (Poet and Painter)
Edinburgh 1951

Coastal Navigation
Venice, Second Prize 1952

The Owl and the Pussycat,
Moving Spirit
Edinburgh 1953

The Figurehead
Cannes 1953
London Royal Film Performance 1953
Berlin 1953

Power to Fly
Edinburgh 1954
Venice, First Prize 1954

Animal Farm
Berlin Diploma 1955
Durban Diploma of Merit 1956

The World of Little Ig
Venice, First Prize 1957

History of the Cinema
London Royal Film Performance 1957
Milan, Grand Prix 1958

The Cultured Ape (Habatales)
Venice, First Prize 1959

The Insolent Matador (Habatales)
Melbourne 1961

Top Dogs (Snip and Snap)
Venice, First Prize 1960

The Stowaway (Foo Foo)
Venice, First Prize 1962

Automania 2000
Oscar nomination 1963
Moscow, First Prize 1963
Locarno, First Prize 1963
Barcelona, First Prize 1963
Oberhausen, First Prize 1964
Tel Aviv, First Prize 1965

The Symphony Orchestra
(Tales from Hoffnung)
Vienna, First Prize 1965
Chicago, Diploma 1965
British Film Academy Nomination 1966
Montevideo 1968
Barcelona 1969

Birds Bees and Storks
(Tales from Hoffnung)
British Film Academy Nomination 1966

Butterfly Ball
John Grierson Award 1975

Autobahn
Zagreb 1980

Dilemma
Moscow, Best Short Film 1981
Thessaloniki, Grand Prix 1981
London, Outstanding film of the year 1981

Players
Montreal, Special Jury Prize 1982

A Memory of Moholy-Nagy
London IVCA Award 1991
Monte Carlo 1991

Awards to John Halas
OBE 1972
The Queen's Award for Industry 1974
Annie Award Hollywood 1986
ASIFA Prize 1986
Life Achievement Award Zagreb 1990
Pro Cultura Hungaricus Budapest 1992

Appendices

Appendix I

Animated propaganda during the Cold War (Extract)
Karl F. Cohen, 2002

Our country's use of animated propaganda during WWII is fairly well known, but propaganda made after the Iron Curtain went up is rarely seen or discussed. Animation scholars have been aware of a few pieces of a strange looking puzzle, but nothing began to make made much sense until Frances Stoner Saunders published *The Cultural Cold War: The CIA and the World of Arts and Letters* in 1999. (Published in England as *Who Paid the Piper?* Granta, 1999.) Even with the publication of her book it wasn't clear that animation had much of a role in an organized effort to defeat Communism as she only discusses one animated film, Halas and Batchelor's *Animal Farm*. It isn't a cute Disney product for kids, but a handsome intelligent dramatic feature for adults that include a strong anti-Communist message.

While Saunders' book received many favourable reviews and most mentioned the CIA having a hand in the creation of *Animal Farm*, the information seemed trivial compared to more sensational revelations including the CIA financing the publication of several fine art books, and their using Nelson Rockefeller and the Museum of Modern Art in New York to present art exhibits of Jackson Pollock's paintings and other abstract expressionists to counter the social realism being advanced by Moscow!

Saunders' book is the result of 6 years of meticulous research using records made available to her through to the Freedom of Information Act, papers in private hands and interviews. The CIA did not cooperate with her research, but the Dwight D. Eisenhower Library, John F. Kennedy Library and other private and public institutions with special collections made formerly classified documents available.

It may seem odd that Hollywood movies, progressive magazines, books, modern paintings, jazz, pop music and other segments of American culture could somehow be used as tools of a secret CIA anti-Communist

propaganda war. Saunders explains that as early as August 18, 1945 an intelligence officer with the US Office of Strategic Services (the OSS was established during WWII and was the forerunner of the CIA) wrote, 'Without atomic weapons the Soviets would be using unconventional "peaceful" tactics to propagandize, subvert, sabotage and exert... pressures upon us, and we ourselves shall be more willing to bear these affronts and ourselves to indulge such methods – in our eagerness to avoid at all costs the tragedy of open war.'

The report Saunders says, 'Offers a definition of the Cold War as a psychological contest, of the manufacturing of consent by "peaceful" methods, of the use of propaganda to erode hostile positions. And, as the opening sallies in Berlin amply demonstrated, the "operational weapon" was to be culture. The cultural Cold War was on.' (The opening sallies included our government using Germany/Nazi entertainers for propaganda/cultural events in the mid-1940s.)

By the late 1940s the CIA was spending our tax dollars creating culture as a secret weapon to combat Communism and to promote our way of life around the world. Their choice of George Orwell's *Animal Farm* as an animated film to produce almost makes sense. Almost, because the book's ending shows both the pigs and humans joined together as corrupt and evil powers. They probably bought the rights assuming that the ending could be changed to better serve their purposes.

To use *Animal Farm* for their purpose, the CIA's Office of Policy Coordination (they directed covert government operations) had two members of their Psychological Warfare Workshop staff obtain the screen rights to the novel. Howard Hunt, who became infamous as a member of the Watergate break-in team, is identified as head of the operation. His contact in Hollywood was Carleton Alsop, brother of writer Joseph Alsop, who was working undercover at Paramount. Working with Alsop was Finis Farr, a writer living in Los Angeles. It was Alsop and Farr who went to England to negotiate the rights to the property from Sonia Orwell. Mrs. Orwell probably already knew Farr as she moved in literary and artistic circles as assistant to the editor of *Horizon* magazine. This is well documented in *The Girl from the Fiction Department* by Hilary Spurling, Hamish Hamilton 2002. Mrs. Orwell signed after Alsop and Farr agreed to arrange for her to meet her hero, Clark Gable. 'As a measure of thanks'

a CIA official named Joe Bryan made the arrangements for the meeting according to *The Paper Trail*, edited by Jon Elliston.

Hunt selected Louis de Rochemont to be the film's producer at Paramount. He had created *The March of Time* in 1935. It was a new form of screen journalism that combined the newsreel and documentary film into 15 to 20-minute entertaining shorts that went behind the news to explain the significance of or reason for an event. *The March of Time*, sponsored by the Time-Life Company, was a popular monthly series for over a decade. The series ended in 1951.

Hunt probably chose de Rochemont because he had once worked for him on *The March of Time* series. De Rochemont had also worked on socially/politically sensitive films for many years. He produced the anti-Nazi spy film *The House on 92nd Street* (1945) and *Lost Boundaries* (1949), one of the first racially conscious films (it is about a black doctor who passes for white until he is unmasked by the black community).

A recently published book suggests de Rochemont chose Halas and Batchelor to animate the film as production costs were lower in England and because he questioned the loyalty of some American animators (*British Cinema and the Cold War: the State, Propaganda and Consensus* by Tony Shaw, I.B. Tauris, 2001). The House Committee for Un-American Activities hearings on Communists in the film industry began in earnest in 1951 (Disney testified at short-lived hearings that were held in 1947) and as I've shown in my book *Forbidden Animation* several people in the animation industry were blacklisted, careers were ruined or disrupted, Columbia forced UPA to purge suspected individuals from their ranks and a successful studio making animated TV commercials in New York had to close when conservative journalists identified the owners as two men denounced by Disney in 1947 as probable Communists.

While Shaw has proposed an interesting theory, Vivien Halas suggests the reason Halas got the contract was that Louis de Rochemont was a Navy buddy and good friend of screen writers/producers Philip Stapp and Lothar Wolf. De Rochemont had worked with them in the Navy's film unit and Vivien's mother had worked closely with Stapp in 1949 on *The Shoemaker and the Hatter*, a Marshall Plan film produced by Halas and Batchelor. Eventually Stapp and Lothar would be hired to work on *Animal Farm*'s script.

Although the decision on what firm to hire came at a bleak moment for some American animation companies, the film could have been produced in Los Angeles by a studio whose reputation was beyond reproach. I suspect Halas and Batchelor's reputation, personal friendships and budgetary restraints were important factors in the decision to award them the contract.

The animation firm was awarded the contract to do the feature in November 1951 and it was completed in April 1954. It is logical to assume that before the contract was signed de Rochemont made it quite clear that the film would not be identical to the book and he may have had a rough script or other guidelines.

The production employed over 70 animators. In Halas' book, *The Technique of Film Animation* (1959), he has little to say about the production, but he does state the film's target audience was adults rather than children and that they needed to simplify the plot. After reading a draft of this paper Vivien Halas says that the film wasn't shown in Paris until the 1990s as it was considered too anti-Communist. When it finally premiered in Paris about 1993, the Mayor of Aubervilliers (a suburb of Paris) 'introduced it as a tribute to communism! My father said no, this is not communist or anti-communist. It is a fable for all time. It is anti-totalitarian and it has a humanist message.' In a letter to the animation historian Giannalberto Bendazzi in 1981 Joy Batchelor told him they wanted to make a film about freedom.

To meet the CIA's objectives the ending was changed to show that only the pigs had become totally corrupt. The film ends with other animals mounting a successful revolt against their rulers. There is no mention of the humans in the film's conclusion.

Vivien recalls, 'The changes came about as the film evolved. There were at least nine versions of the script and heated discussions about the end. My mother especially felt it was wrong to change the ending.' She has a tape recording of her father saying that the ending they used offers a glimmer of hope for the future. In an interview on Granada TV (UK) in 1980 he defended the ending as being necessary to give the audience hope for the future. 'You can not send home millions of audience being puzzled.'

The film's script was by Batchelor, Philip Stapp and Lothar Wolf. Also involved was Borden Mace a colleague of de Rochemont from their days in the Navy's film unit. He became president of the company set up to produce *Animal Farm* by de Rochemont, his mentor. Borden told Vivien in an interview earlier this year that de Rochemont had the ultimate say about script changes. While it isn't clear who suggested the ending used, it was certainly what the CIA needed.

While the film was in production Fredric Warburg, the book's publisher, visited the studio several times and he viewed work-in-progress. Saunders thinks he may have suggested that Old Major, 'the prophet of the Revolution, should be given the voice and appearance of Winston Churchill.' More importantly, she reveals earlier in her book that Warburg had dealings with the British intelligence group MI6. He fronted for them by taking their cheques, depositing them and then writing personal cheques that he gave to *Encounter*, an anti-Communist liberal literary publication. He may or may not have been a 'consultant' helping to ensure that the film would be a successful propaganda tool.

In a recent e-mail from Howard Beckerman (animator and author of *Animation, the Complete Story*, 2001) he writes, 'About the ending in *Animal Farm* (1954). I saw it in its initial US release in 1955. At that time the only reason for the upbeat ending seemed to be that the film was very dark and the negative ending of the book would have had the audience leaving the theatres in a depressed mood. Remember, this was a film with animals, at a time when Disney films were the accepted norm. Disney changed Bambi, leaving out much of the realism of animal life in the woods as shown in the book, even though Bambi's mother's death was the dramatic high point of the feature. The Disney live-action animal films like *Seal Island* purported to show life in the wild with all its harshness, but even here cartoon sentimentality intruded. Animation was expected to be pleasant and happy. Disney's *Peter Pan* and *Lady and the Tramp* from the '50s reflected the pleasant, nostalgic qualities that had become the norm at that time. There seemed to be a concerted effort to avoid the darkness that had been very obvious in *Snow White*, *Pinocchio* and in *Fantasia's* "Night on Bald Mountain" sequence.'

'The team of Halas and Batchelor, backed by the American producer Louis de Rochement of *The March of Time,* had to compete in the world

market with Disney, so a few cartoon gags were introduced into the film to lighten its heaviness, and I believe that whatever the CIA's influence might have been, the choice for an upbeat ending came out of the animators' wish to succeed with the audience. All this might seem naive now, what with the new information being presented. There were movies of the period like the live film, *My Son John* (1952), which attacked the menace of communism head-on in a contrived and obvious fashion, so I guess anything is possible. If Orwell had lived longer, I suspect he would have vetoed any effort to translate his work into such a film.'

The film did well at the box office and the reviews were favourable, but some critics suggested people should read the book to find out what was left out. The United States Information Agency (USIA) through their overseas libraries later distributed the film around the world. An article in the *Guardian* (London, July 1996) suggests the film and book were excellent propaganda in Arab nations 'in view of the fact that both pigs and dogs are unclean animals to Muslims.' On the other hand a French farmer told Vivien Halas 'pigs are the most intelligent animals in the farmyard.'...

... *Animal Farm* is a film experience you will remember. It is an intelligent work for adults with strong characters, powerful emotional moments, and vivid images. It has a lighter side that includes some humour, but what I remember most about it is how well it captures the drama inspired by the book. I'm not a purist and while I was aware it wasn't faithful to the book when I first saw it over 40 years ago, the changes didn't bother me. I look forward to seeing it again soon on DVD, now that I know why it is more upbeat than the book...

... On a few occasions the CIA's failures have been disclosed to us by the news media, but their successes are almost never made public. No matter how you feel about their meddling with feature films, it appears their involvement in the making of *Animal Farm* was a successful covert operation and it was kept a secret from the public for almost 50 years.

Appendix 2

Orwell Subverted: *The CIA and the filming of Animal Farm* (Extract)

Dan Leab, Professor of History, Seton Hall University, USA, January 2005

That the CIA paid for much of the Halas and Batchelor production of George Orwell's *Animal Farm* is gospel. What is not as well known is the level of the agency's input on the production which went well beyond just the much discussed transformation of the ending, and of the financial input of the film's producer, Louis de Rochemont - a necessary investment because the CIA did not put up any funding beyond what it originally supplied him, even though the agency continued until the end of the production to insist on changes, for example, *Animal Farm* itself had to be shown as the then popular image of a satellite country with barbed wire fences and vicious looking guards. Louis de Rochemont was probably at the peak of his fame at the end of the 1940s, when discussion began on filming *Animal Farm*. He was known as the father of the innovative *March of Time*, and after a ten year run, de Rochemont, who always felt slightly stifled by Time Inc, moved on to Hollywood. He had considerable success with his features for 20th Century Fox, which included *The House on 92nd Street*, a 1945 paean of praise to the anti-espionage efforts of the FBI, which was filmed with the agency's cooperation. By the end of the 1940s, chafing under studio restrictions, he had moved on to become an independent filmmaker, later working with the *Reader's Digest* on socially engaged projects. Just exactly why the CIA was interested in a film version of George Orwell's bitterly anti-Stalinist satire, or 'fairy-story' as he called it, is obvious. The US government was fighting a *Kulturkampf* as part of the Cold War, and there is no question that the CIA was at the centre of the covert activities, which were part of the American cultural offensive. Financing movies such as *Animal Farm* was just one aspect of these activities, which ranged from buying a newspaper editor a dinner to underwriting a paramilitary effort. The branch of the CIA, which undertook these activities, was the Office of Policy Coordination (OPC), a very anodyne name for an often vicious but certainly extremely ambitious undertaking. OPC had a Psychological Warfare Workshop headed by a well to do, socially prominent newspaperman and writer J. Bryan, and whose participants included the journeyman writer, Finis Barr. Both Bryan and Farr were 1920s Princeton graduates and part of the socially upscale group which had led the CIA's World War II predecessor, the Office of Strategic Service (OSS), to be called 'Oh, So Social'. Farr was a great Orwell fan and was involved in the

scripting process for the film. Bryan played a more prominent role and came to the UK to confer with Halas and Batchelor on various aspects of the different scripts that were drafted in order to meet the agency's demands. The CIA's involvement was kept quiet for years; initially there were not even rumours, but it is probably the case that the final narration for the film was in large part undertaken in early 1954 by John Martin, a former Time Inc staff member and de Rochemont associate, and by Bryan, though both remain uncredited. There is an 'official' version about how Halas and Batchelor came to make the film. Having worked with government agencies throughout the war and its aftermath, they were hired by Lothar Wolff, a long time de Rochemont associate and Head of the European Recovery Programme's (ERP) information arm, to make *The Shoemaker and the Hatter* as part of the ERP's sales pitch for free trade and an end to tariff barriers. In July 1951, at the Museum of Modern Art in New York, Wolff, who had returned to work with de Rochemont in 1950, showed a selection of Marshall Plan films, and supposedly de Rochemont saw the Halas and Batchelor short and chose them to make what would be the UK's first animated feature (at a time when fewer than twenty-five such films had been produced worldwide, and most of those by Disney). The paper trail, however, even though including many of the same characters, presents a different story. It would seem that the OPC people, who wished to make *Animal Farm* part of the propaganda effort – and that includes Farr and Bryan – had approached de Rochemont. He, in turn, was advised by Wolff that Halas and Batchelor could do the job. Aided by Philip Stapp, who had worked for the ERP in Paris, the studio won Sonia Orwell's approval to make a film of the book with a range of preliminary sketches and layouts, first as an option, and then to the point of contract. Halas and Batchelor were already paid to do the work necessary to win the option before Wolff showed their film at the Museum of Modern Art. The final contracts were signed by the end of 1951, but well before then the OPC had advanced de Rochemont the initial funding which ultimately would amount to a quarter of a million dollars. Halas and Batchelor were instrumental in advising de Rochemont about winning over Sonia Orwell to the project, when Halas met with him and his associates in October 1951. Though the film was comparatively straightforward to get off the ground, there would be some serious delays, over nine scripts (not counting Martin's effort to inject more Cold War arguments into the final version), and some re-shooting (an onerous task given the state of animation at the time). The film was scheduled for release initially in early 1953, and was premiered in the US at Christmas 1954.

Appendix 3

Halas and Batchelor, *A Visit with England's Leading Producers of Animated Films*
John Canemaker

London, November 5, 1979. I am sitting in John Halas' high-ceilinged office on one of the three floor-throughs he owns in a former banana warehouse on Kean Street off Drury Lane. "This is theatre-land," a cheery milkman informed me about the area when I asked directions to the studio. No, I thought, it is really animation-land. The vital London animation industry, consisting of some seventy-two studios employing nearly 1,500 people, is concentrated mostly in the small Soho and Strand areas of the West End.

John Halas will be sixty-eight in April. He sits at a large wood desk that holds two grey telephones, a grey intercom, various papers, books and magazines that silently demand his attention, and a leather-bound Economist Diary monogrammed with the initials 'J.H.' Behind him rest oriental rod puppets, and a huge Tutankhamen calendar covers the wall next to an unshaded window that allows in a rare appearance of the sun. Mr Halas is dressed in a grey business suit with a white kerchief shyly peering over a breast pocket, black socks and shoes, and a powder-blue turtleneck. He languidly sips hot coffee prepared by his energetic secretary, Pat Webb, as the morning sun back-lights his thinning white and silver-grey hair combed straight back over his large forehead. Uncompromisingly blue eyes peer intently over half-specs perched safely on a generous nose. He has the elegance and air of a deposed Hungarian count, but if there exists a royal family of British animation, surely it must be John Halas and Joy Batchelor, and Mr Halas is no mere count but a king.

The king speaks: "As a madman myself, who feels animation in my blood circulation and thinks animation as at least 70 percent of my consciousness, I would say it was forty years of fight to put animation on the map." Mad like a fox. 1980 marks the fortieth year the Halas and Batchelor Studio has been in continuous production. All told, this remarkable husband and wife team has produced seven animated feature films and about 2,000 shorts.

They began modestly by making theatrical advertisements, then during World War II the various British ministries of information and defence kept them busy producing dozens of training and propaganda films,

followed in the late forties by industrial films. In the fifties they adapted with ease to the production of TV commercials and 1951-54 saw the H&B studio pioneering with the production of England's first entertainment animated feature, *Animal Farm*, based on George Orwell's tale of social revolution expressed in terms of farm animals. This film anticipated both *Yellow Submarine* and Ralph Bakshi's features in its bold appeal to mature audiences and the sophistication with which it approached the subject matter.

The New York Times, in its review on December 30, 1954, said:

"the drawing of this cartoon is very close to what is known as the Disney style....But the theme is far from Disney, and the cruelties that occur from time to time are more realistic and shocking than any of the famous sadisms that have occurred in Disney films.

The shock of straight and raw political satire is made more grotesque in the medium of cartoon. The incongruities of recognizable horrors of some political realities of our times are emphasized and made more startling by the apparent innocence of their surrounding frame.

The cartoon itself is technically first-rate. The animation is clean, the colour fine. The Halas-Batchelor team knows its business. But don't make the mistake of thinking it is for little children, just because it is a cartoon."
Bosley Crowther

During *Animal Farm*, H&B employed seventy people in both a London studio on Soho Square and a second unit 120 miles west in the small town of Stroud. Currently, there are eight people working on educational films at Stroud and about thirty-two employees in the London Kean Street studio turning out TV commercials and informational films on child care, energy, et cetera. In the offing are two theatrical films Mr Halas is "contemplating". One is based on Wilhelm Busch's *Max and Moritz* comic strip, the other film is *Heavy Metal*, "an adult space fantasy." Halas is "exploring" a puppet TV series for German television, and in storyboard stage is a French/English co-production educational series "re-writing the Ten Commandments." He recently produced and directed *Autobahn*, a surreal personal film on travelling designed and animated by Roger Mainwood, a young H&B worker. The studio was (and still is) a place

where young talents are welcome and can break into the animation industry. Among the established artists who have passed through H&B are Geoff Dunbar, Ian Emes, Alison de Vere, Bob Godfrey, Bruno Bozzetto, Peter Foldes, and Gerry Potterton, among others.

In 1968, Trident [Tyne Tees] Television bought out Halas and Batchelor for a tidy sum. "It was our most prosperous year," recalls Halas. "They wanted us because we were the golden studio." John and Joy devoted their attention to their educational film company, Educational Film Centre, formed in the early sixties, which developed classroom information films and loops. Tyne Tees, with ATV (Lord Grade's company), had by 1971 swollen the company's wage bill with 260 employees and concentrated on producing Hanna & Barbera Kidvid series - *The Addams Family, The Jackson Five, The Osmonds*. After six years of steadily losing money, they asked Halas to buy back H&B. "They made a mistake," Halas says with a slight grin, "by appointing a managing director who was, as usual, not an animation or film man but a marketing expert." How did Halas make out financially, selling high and buying back low? "I never complained," he says, then breaks into laughter. "No, no," he continues, "it was only a modest means of survival, a means to achieve an end. If I were only a businessman I would have sunk decades ago!"

Joy Batchelor, who is two years younger than John Halas, retired in 1973, but John consults her constantly and she lends her expertise part-time to the animation students of London's International Film School. John Halas continues vigorously on, clearly not the type to even consider retirement, but able, he says, to devote only one-half of his time to his smoothly running studio. The other half is "absorbed in wearing four different hats."

Mr Halas holds his head in his hands as he figuratively throws invisible hats all over the room. He is, first of all, chairman of the Federation of Film Societies (a group set up in the 1920s by G.B. Shaw and H.G. Wells), "a force in influencing alternative cinema in over 700 film societies in Great Britain."

Halas covers his eyes as he drops another hat. Since 1975 he has been President of ASIFA, an international network of individuals interested in animation. "Our continuous struggle, I shiver to think," he says dramatically in a deep voice and a Hungarian accent, "is to advance a status for

animation and fight a position for it alongside other more established art forms. To get better exposure for world animation." Extensive travelling to various countries and animation festivals is an important part of the ASIFA president's duties. At the time we speak Mr Halas has just returned from festivals in Varna, Bulgaria, and Yorkshire, England.

His two other hats include film advisor to ICOGRADA, an association of 26,000 graphic designers, and contributing editor and film/TV correspondent to *Novum*, an international monthly journal for visual communication and graphic design, published in four languages in Munich. (Halas is also a prolific writer/editor of books on animation, including the now-classic *The Technique of Film Animation*, written in 1959 with Roger Manvell.)

John Halas was born in Budapest iin 1912. As a boy of fifteen, he relates, "I applied to a small advert for the only animation place in the city looking for an apprentice, somebody who could sweep the floors and clean the paintbrushes. One of the key artists was George Pal, who was eighteen, freshly out of art school." Halas prides himself on "never forgetting anything" and he proceeds to spell out, with his index finger tracing out the letters on his desk top, Gorge Pal's family name: "M-A-R-C-Zed-I-(um)…Marce…Marczincsak! It was not until he went to Berlin and Holland that he mercied [sic] his bosses and changed his name to Pal."

Halas continues his story: "George was used by the studio owner to do local advertising spot films for the cinemas, paper cut-outs. I learned from George Pal how to sew together the limbs of characters and how to cut out eyeballs and move them under camera. Gradually I absorbed a sense of timing in relationship with the passing from frames. You could see the finished work the next morning. By evening it had been projected in the cinemas. To make a film in forty-eight hours was pretty impressive to start with, but also to shoot it under the camera, usually between 6 p.m. and 12 midnight, and being left on one's own to do that, was a lesson not to be forgotten. The skill with which George Pal carried out this instant performance was also something to be remembered."

After two years, the ambitious Halas left for France. "My life seems motivated by small adverts. I saw a notice advertising for a young artist who would serve as an apprentice to a window-dressing designer who

was on his way to Paris. The offer was for very little money but for the experience and pay to Paris. And I got the job! We arrived in Paris and I found out next day that really he was not window-dresser but a salami agent for Hungarian salami! And he walked out on me. I was penniless, losing my assumed job. I don't know even to this day why he needed an assistant. Halas could not speak French or English then and so, he says, 'I starved!' But not for long. The resourceful young man looked up in the phone book every Hungarian restaurant in Paris and in exchange for food he offered his services as a menu designer. Two restaurants out of thirty 'pitied on me.' Next, he had to 'fight myself into a graphic design studio.' Doubtless these early struggles as a naïve youth have been a factor in Halas' practice of 'pitying' young un-proven talents and hiring them to cut their cinematic teeth at his studio.

He returned to Budapest after eighteen months. "I felt I should continue my work in graphics and in order to progress I should learn more." He became an assistant at the Atelier, a graphic design school that employed a couple of teachers from Germany's legendary Bauhaus, the most influential school in the history of architecture and design. The Atelier's faculty included the Hungarian Laszlo Moholy-Nagy, an important propagandist for abstract art, constructivism, functional design and film experimentation. Halas assisted artist Alexander Bortnyik, who he found "a very impetuous man who only played with the film media. I did his in-betweens, trace-paint on six or seven figurative films, none have been completed." Another Hungarian, Victor Vasarely, later a master of optical art and a perception theorist, preceded Halas as an assistant to Bortnyik. The liberating Bauhaus theories appealed to young Halas, particularly the idea of learning by doing, of developing an aesthetic based on sound craftsmanship, and finding "simple, imaginative solutions to a visual problem."

In 1934, John Halas joined two associates to open his first animation studio; it was called Halász, Macskássy and Kassowitz, which sounds more like a Hungarian law firm than a cartoon studio, but Halas found "there was a market. That was the miracle of that period. We made at least thirty or forty commercials over two years for cinemas all over Hungary."

On his own, Halas made a pencil test with colour rushes based on Lizst's *Hungarian Rhapsody*, a film that was seen and taken to London by filmmaker Jean Image. (Halas offhandedly spells Image's Hungarian

name on the tabletop with his finger: "H-A-J-D-U!") The film was viewed with interest by a small documentary film organization eager to break into the theatrical entertainment cartoon market. Halas was invited to London to finish the film: "I wanted to get out," he says, "get some further experience. I arrived October 11, 1936," he recalls effortlessly. Soon the moneymen decided *Hungarian Rhapsody* would "have no mass appeal" so the film was abandoned, uncompleted, for a new project, *Music Man*, which "allegedly had a greater appeal for theatrical release."

In February 1937, a young woman named Joy Batchelor answered a Halas newspaper ad calling for animators to join his small studio. She had three years' experience animating on an ill-fated project and considerable talent as a designer, and to Halas "she appeared to me so much better in every respect than I was, that is to say in animation, in design drawings." *Music Man* was completed by John, Joy and five other artists and was shown in newsreel theatres and some cinemas, but "the moneymen pulled," says Halas, because "the Disney influence in theatrical films was too strong for a British studio to survive at that time trying to compete."

"Once again, I starved. Joy starved with me this time. I decided to return to Budapest in the latter half of 1937 to develop an idea based on Anderson's *Brave Tin Soldier*. Joy came with me."

A Berlin financier put £500 (about $2,000) into the film's budget, which Halas explains was "quite all right for a ten-minute cartoon at that time. Joy and I started work. After five months, one pay day the money did not arrive: Suddenly, the carpet was pulled out of that studio's feet and once again we found ourselves without any resources whatsoever. Hitler arose and the political situation began to be very hot, so we decided to return to London. And through great difficulties we got back during the autumn of 1938 and struggled to set up an animation studio without success."

"Joy was good as a designer-artist and I had something. I had some thing," Halas says with intensity. He began doing spot illustrations and cartoons for magazines, while Joy worked as a fashion illustrator for *Vogue* and *Harper's Bazaar*. They were both turned down by Anson Dyer, a British animation pioneer, and the only London animation studio at that time. Halas and Batchelor rented space in a small design studio and soon developed a clientele. "We were crawling up gradually, making our way as individual graphic designers and illustrators."

In 1940 the J. Walter Thompson advertising agency asked to see a sample reel of John and Joy's film work. Out came the unfinished *Hungarian Rhapsody* and *Music Man*. J. Thompson was impressed and "immediately absorbed us and made us a part of their film unit. That's how Halas and Batchelor started!" Housed in the ad agency in Bush House in Central London, H&B's first assignments were two colour cartoon film advertisements *Carnival in the Clothes Cupboard* (1940), a five-minute ad for Lux toilet soap, script by Alexander Mackendrick (who also worked on design), animation and design by John and Joy; and *Train Trouble* 1940, an eight-minute cinema advert for Kellogg's Corn Flakes.

The Thompson agency was also parent to a second important British animation company besides Halas & Batchelor; this is the W.M. Larkins studio, which started, Halas says, when "Bill Larkins, an agency promotion man, looked over our shoulders, fell in love with what he saw and decided to open his shop."

Came the war and Halas and Batchelor were suddenly in demand. Through an introduction from John Grierson, the Ministry of Information hired H&B to produce seventy propaganda films in four years. The War Office, Home Office and Admiralty soon followed suit with their film needs. "I never worked harder in my life!" exclaims Halas.

One evening soon after John and Joy were married in April 1940 ("We decided it was high time."), their Chelsea home was destroyed by German Bombs. John was injured slightly, but Joy was hospitalized for six weeks. "We had to move the studio to Watford outside London," says Halas. Production continued with a staff of twelve.

Dustbin Parade, one of two shorts prepared in 1941 for the Ministry of Information, is a good example of H&B's earliest work. The nine minute black-and-white cartoon is an entertaining appeal to patriotic Britishers to save their waste scraps. The anthropomorphic characters include a used tube of toothpaste, an empty tin can, a spinning toy top, and a rather chatty bone, all designed in a cute Disney-ish mode. The backgrounds are more painterly and impressionistic than Disney's and each lay-out contains a pleasing distortion in perspective and camera point-of-view. The animation is quite full, well-tiimed and snappy. The short looks American but sounds British.

Animator Richard Taylor has written:

It is worth noting that the films of both Halas and Batchelor and Larkins share a definite brotherhood with the films of UPA in the States. Both grew out of the need to make lively the sort of films government and the armed services need in war-time. Both reflected the style of the Bauhaus and the School of Paris more than cartoon films had in previous years. This was not mere art-lovers' whim. The style suited the function, and animation is a functional art... All the arts were enriched by refugees from the Continent but animation in Great Britain owes a great deal to the impetus given by John Halas and Peter Sachs [of Larkins]. They brought to the cartoon world the qualities which - on a more sumptuous scale - Steinberg, Ophuls and Fritz Lang took to Hollywood.

At lunch at Edward's, a restaurant on Aldwych around the corner from his studio, John Halas tells of a visit to the Disney studio in 1954 soon after the release of *Animal Farm*. "I was introduced to Walt Disney in the cafeteria after lunch. First, we had to explain to him who George Orwell was. Then he asked, 'Do they make films in Great Britain?'"

It is the evening of November 5th, Guy Fawkes Day, a British national holiday commemorating the infamous "Gunpowder Plot" of 1605 against King James I and parliament. As I leave the Underground to walk the half mile to the Halas home, the damp, chilly night sky is illuminated every few minutes with sky rockets set off from the backyards of surrounding homes. The Halas' live in the highest point of London, a decidedly "up market" (or as Joy Batchelor would say: "pricey") area known as Hampstead. Their comfortable, spacious house, which they have owned for over twenty-five years, is surrounded by old leafy chestnut trees and lime trees - the kind you see beautifully gnarled and bony in Arthur Rackham illustrations. An eight-foot-high brick wall guarantees privacy.

A small bonfire in the Halas' backyard gives a bit of warmth to the Guy Fawkes revellers, who include Paul Halas, a thirty-year-old screen writer, three of his friends (two of whom have brought a child), John Halas, Joy Batchelor and myself. (The Halas' daughter lives in Paris.) For the next hour, a series of sky rockets will be set off and will fly to their doom, exploding as hot snowflakes, golden rain or red, white and blue twisters. Pops, whistles, and whizzing noises are heard from all over the

neighbourhood. Smoke from the explosions rises into lime tree branches silhouetted by street lamps and forms beautiful vaporous shapes in a dozen shafts of light.

John Halas, hands in coat pockets, kicks his legs and flaps about like an egret trying to keep warm. "Oh! That went to Paris!" he exclaims with admiration as a whistling rocket disappears into the black sky. Joy Batchelor stands quietly under a chestnut bough near the bonfire. She is wearing a short overcoat and smokes a cigarette. Watching the noisy celebration with detachment, an expression of patient amusement registers on her delicate features, seen in the glare of the frequent rocket flare-ups. Drops of rain slip between the chestnut leaves and reach Joy's soft white hair.

"Shall we adjorn…" she starts to say before a loud whistler cuts her off. Rose, a child of eight going on twenty-eight, is having a bum time. Sitting on an empty rocket box, she holds a sparkler at arm's length with unmistakable fear and loathing. Paul and friends continue to explode every rocket. John Halas retires to the house to change into a red wool sweater. Joy takes Rose in to watch the increasingly wet celebration through the bedroom window.

At the end, as the rain becomes more insistent, everyone returns to the yard to ignite the last sparklers in the bonfire and to swing their arms vigorously as they write their names in white light. Joy has prepared a hearty dinner of beef stew in tomato sauce with cabbage, boiled potatoes, and vegetables.

Later, over cheeses and red wine, she answers my questions in a quiet voice and a clipped British accent. Joy Batchelor has a wonderfully sharp and wry sense of humour - "subversive," she terms it – that can cut off the unwary at the ankles. More often her wit is self-directed. After a bon mot she will often invert her lips till they disappear, raise her eyebrows and hunch her shoulders, striking a pose that says, "Aren't I naughty to have said that?"

She was born, she tells me, "sixteen miles outside of London in a place called Watford, which is now a big joke 'cause they say anywhere north of Watford is in the sticks. I first went to art school there," she continues rapidly, "then Polytechnic, and then to St. Martin's, but by that time I was already working in animation in London.

"I was an inker, but it was all so primitive that when you were inking you were also animating straight onto cel. Can't remember the name of the company but the man was an Australian cartoonist who thought he was going to make his fortune with a couple of koala bears but he didn't. He just lost other people's money." Eyebrows up. Naughty look. "Ten of us worked there for three years and we learned to animate after a fashion. After that I did a little…stint in a silk-screen place because I had no money and that was the only job I could get. Then I met John and we worked on a film for jolly nearly a year and that folded, so I went into an architectural designer's set-up, so all together I had a lot of very varied useless experience! All those inbetween jobs lasted about nine months and that was it. Either they got fed up with me or I got fed up with them.

"I met John when I was, I suppose, twenty-two and a half, just back of the Windmill Theatre of evil fame in Piccadilly Circus, but," she laughs, "it was a perfectly straight set-up." Was the team called Halas and Batchelor from the first? "Oh no, oh no," Joy protests, "I was very humble. I was supposed to be the animator and he was supposed to be the director. That's how it worked. When John decided to go to make a film in Hungary soon after, then I started poking my nose into the scripts 'cause I thought they were deplorable. It was such a waste of time to spend weeks, hours and months animating and come out with a non-story at the end of it. That really depressed me. So that's where I got interested in scripts. But I was a good animator for what it was worth at that time. So we stuck together."

She takes a drag on her cigarette. "Unlike now it didn't cost much to make a film but you didn't make any money out of it….especially if it was lousy. The theatrical markets were there but they were totally devoted to Disney and the American products. We overcame that when, instead of trying to make entertainment films, we started making training and documentary animated films just after the war started. At the beginning we made, every three weeks, a propaganda-information film to implore everybody to do the right thing. What happened was we generated a new form of animation for them. In the meantime, we learned a bit more about what we were doing."

Reminded of the large number of people who learned their trade at H&B over the years, then moved on, Joy remarks, "That they did. That

they did. Well, it was good for them and good for us, I s'pose." Pause. "But we didn't think of it that way at the time." Naughty look. Soft giggle.

H&B had produced in 1945 a seventy-minute film for the Admiralty, *Handling Ships*, and in 1948 a sixty-minute film for the Home Office called *Water for Fire Safety*, both of which helped them gain experience producing long films. When *Animal Farm* came along they were ready. "It was exhilarating," Joy says of that feature. "Marvellous! For one thing it was great to be asked to do it. It was the culmination of all the documentary films, which was when we were beginning to step beyond that and make story films that were entertaining, were amusing but were strictly based on fact. It was on the basis of *The Shoemaker and the Hatter* [1949, a film against totalitarianism and for European unity paid for by Marshall Plan money] that I think Louis de Rochemont asked us to have a go at *Animal Farm*. It was just the right time, feeling you can flap your wings or else. It all came together."

The fifty-five minute feature cartoon, *Ruddigore*, which Joy Batchelor directed and wrote herself in 1964, was "quite, quite different. For one thing I had a jolly good idea of the risks. We had no idea of the risk we were taking on *Animal Farm*. Next, I was absolutely overcome by the splendour of that Orwell story. I identified with it completely and I didn't with *Ruddigore*. It was an exercise, in a way, to see whether it could be done or not. I would have made it by completely re-writing but D'Oyle Carte, the people who have held all the Gilbert and Sullivan operas in trust for seventy years so that they are practically cocooned, they had very, very grand ideas that the text was sacred. You could cut it but you couldn't change it. Well, it did need changing. Some of the jokes were so unfunny seventy years later. I think a lot of energy was wasted on that sort of old thing."

I remark that she and John have accomplished much in their long mutual careers and she responds, "Well, there's so much going on now it seems very little. All the things we hoped would happen, not all the things, but so many of them are happening so fast. I don't mean the ideas. You've only to look back to 1908, 1910, 1914, 1922. They're all there. Not a single fresh new idea. No, I mean the techniques and the attitudes. Mostly the attitudes."

On the road to Cambridge, November 9. John, Joy and I are driving in their cherry-red Volvo to the Cambridge Animation Festival. London and its rainstorm are behind us now, the dark clouds are parting for the sun, which illuminates the wet road and countryside before us.

Joy smokes throughout the journey. John, who is driving, does not. They are such dissimilar yet complementary personalities. Symbiotic. Their concern for each other is apparent in the many quick verbal exchanges and silent glances that pass between them. "When we worked together," Joy had told me, "we worked very well. But we always needed to have some separate time away from each other." John said the same thing in a separate talk.

"We had a sense of timing," John is saying, "not only as regards individual films but where the market will move to in the future. What I like to remind everybody in animation is that these markets never arise themselves. There is a lot of, um, exploration needed. A lot of foresight and the seeds must be planted in the consciousness of the users, whether it is the government or the industry or the art world or the cinemas or the TV industry. One has to…nurse tenderly along these markets. In my lifetime, somehow all these opened up as a beautiful…fan! And now, in the eighties you will see that there is not less than fifty different applications, possibilities whereby you can utilize animation. And this is obviously not the end."

After a while, Joy speaks. "Well, we've kept on, haven't we," she observes. Then, unable to suppress a jolly "subversive" comment, she announces, "We are beginning to say to one another what counts is survival."

At this point – I swear – a pair of shimmering rainbows appeared over the road before us.

Appendix 4

Below. Letter ending John Halas' contract with British Colour Cartoons. During an interview for BECTU my mother said that James Willings, one of the directors, was about to be sent to jail for selling arms to both sides in the Spanish Civil War; no doubt money that had partially been used for the companies' filmmaking ventures.

Appendix 5

Page 224. Frontispiece for a lettering manual for schools, an example of calligraphy by Joy's father, Edward Joseph Batchelor.

TELEPHONE: CHANCERY 7305 TELEGRAMS WILALUM. WESTCENT. LONDON

BRITISH COLOUR CARTOON FILMS LTD.

Directors
JOHN HALAS
(HUNGARIAN)
JAMES WILLING
(BRITISH)
RICHARD WEISBACH
(GERMAN)
FREDERICK WILLING
(DUTCH)

8, SOUTHAMPTON STREET,
LONDON, W.C.1.

16th September 1938.

John Halas, Esq.,
8, Southampton Street,
London. W.C.1.

Dear Sir,

 With reference to the Fifth Board Meeting held in these offices on the 12th inst. I am instructed by the Board to write you as follows.

 Owing to the fact that the Company is experiencing, at the moment, financial difficulties, you are hereby released temporarily from your agreement with the Company dated the 16th February 1938 in order that you may obtain employment elsewhere until such a time as the Company's position is improved.

 At the time when the Company requires your further services you will be given two weeks notice to this effect.

Yours faithfully,

BRITISH COLOUR CARTOON FILMS LTD.

Secretary.

Index

John Halas and Joy Batchelor are given individuated reference when spoke of as individuals in the text. Otherwise they are subsumed in the term 'Halas and Batchelor' as it is used to represent their collaborative identity in the studio's output.

References below include captions related to particular images as these often offer a particular insight or piece of information about a film or person not included in the main body of the text.

Film Titles are italicised.

An
INTRODUCTION
To
Plain and Ornamental
WRITING,
Consisting of seven Alphabets for the use of Schools &c.
By
E. J. BATCHELOR.
LONDON.